THE ART OF
Blue Sky STUDIOS
FERDINAND

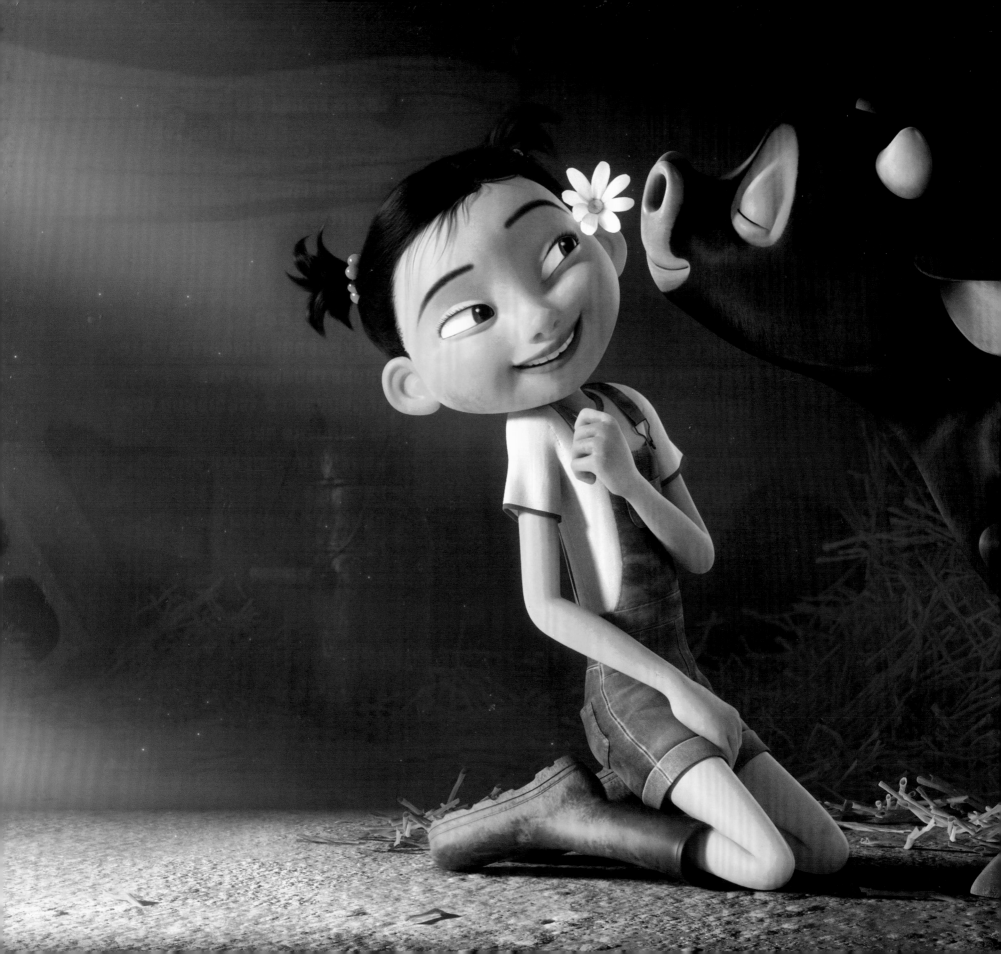

THE ART OF

Blue Sky
studios
FERDINAND

FOREWORD BY CARLOS SALDANHA
WRITTEN BY TARA BENNETT

TITAN BOOKS

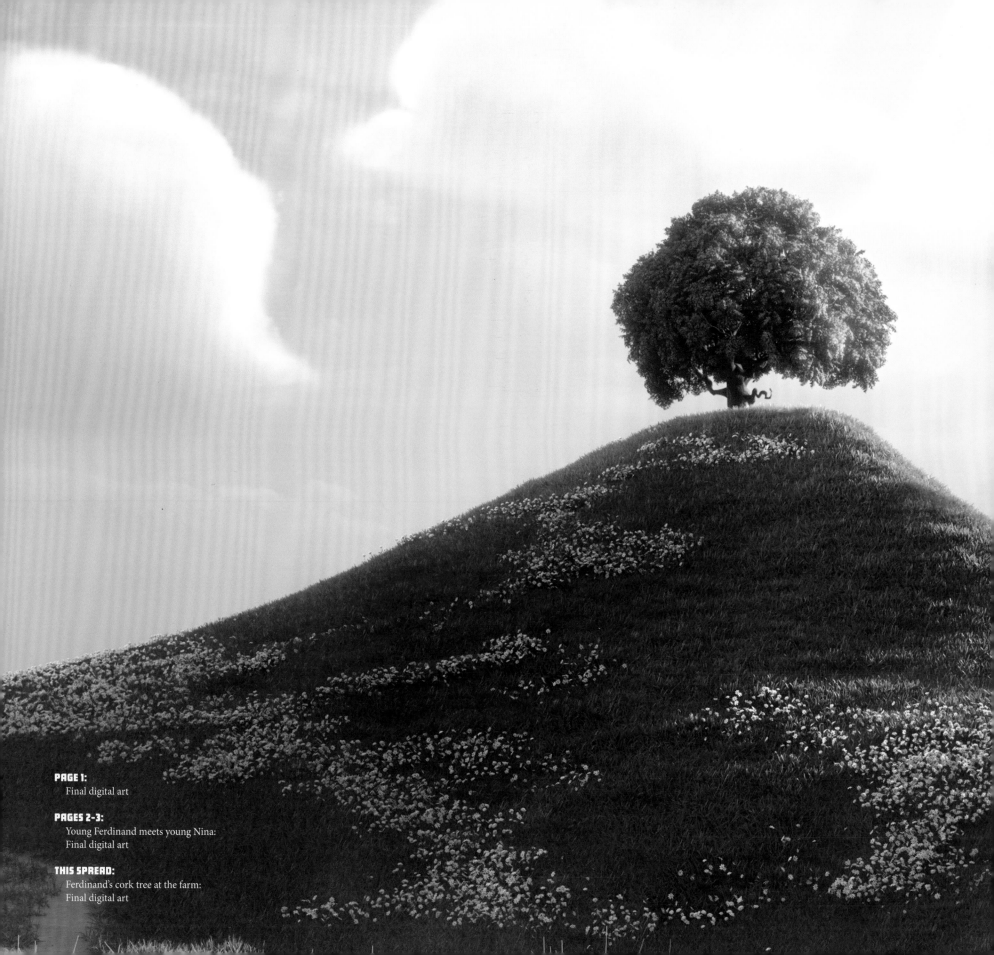

PAGE 1:
Final digital art

PAGES 2-3:
Young Ferdinand meets young Nina:
Final digital art

THIS SPREAD:
Ferdinand's cork tree at the farm:
Final digital art

CONTENTS

FOREWORD BY CARLOS SALDANHA 006

INTRODUCTION 008

CHARACTERS 014

FERDINAND 016

FERDINAND'S DAD 027

VALIENTE 028

BONES 032

GUAPO 034

ANGUS 036

MAQUINA 038

JUAN 040

NINA 041

MORENO 044

LUPE 046

UNA, DOS, CUATRO 052

PACO 058

HANS, KLAUS, GRETA 060

EL PRIMERO 064

EL PRIMERO & FERDINAND 068

SHAPE LANGUAGE 070

BACKGROUND CHARACTERS 076

PAINTINGS 086

LOCATIONS 088

REALIZING SPAIN 090

FARM 092

RONDA 102

COUNTRYSIDE 112

CASA DEL TORO 116

VEHICLES 128

MADRID 130

ARENA 138

PATTERNS & TEXTURES 148

COLOR SCRIPT 150

CONCLUSION & ACKNOWLEDGEMENTS 154

FOREWORD

ABOVE:
Ferdinand sitting under his cork tree: Ink sketch by Carlos Saldanha

Such a simple story. Such a powerful and profound message.

The Story of Ferdinand is about a bull who isn't like other bulls. Instead of fighting, as all bulls do, he finds happiness among the flowers. Rather than being who others think he should be, he stays true to who he is, even in the worst of circumstances and, in doing so, changes those around him in deep, life-altering ways.

Even though the book was written more than 80 years ago, its message is just as relevant today. We still struggle with bullying and intolerance and we still hope the world will come to celebrate our differences as much as they do our similarities.

I was inspired by *The Story of Ferdinand* the first time I read it and it continued to inspire me over the years as I read it to my children. So, when I was offered the opportunity to adapt the book into a feature film, I jumped at the chance. What a thrill it was for me to get to know this gentle giant more deeply, to have the chance to create a new cast of funny and quirky characters surrounding him and to further share the profound message of this book with movie audiences everywhere.

In this movie, I wanted to pay homage to the beautiful country of Spain with its rich history, unique traditions and dramatic landscapes. From the sinuous curves of the mountains of Andalusia to the dramatic shapes of Spanish architecture, our talented, passionate Blue Sky artists beautifully transported us to this rich country. This book shares their brilliant artistry and takes you through the amazing visual experience of creating the world of *Ferdinand*.

Carlos Saldanha, Director
June 2017

INTRODUCTION

In 1936, American author Munro Leaf published his fifth book for children entitled **_The Story of Ferdinand._** Illustrated by Robert Lawson, the gentle story tells the tale of a bull in Spain who is happiest smelling flowers, and uninterested in butting heads with others. Simple yet profound, Leaf and Lawson's book found a massive, adoring audience of both children and adults, who were moved by the book's message of embracing who you are no matter what others might think of you.

It's the rare story that has remained relevant and resonant with every generation, which is why Blue Sky Studios looked to the book as the inspiration for its twelfth feature-length theatrical release, _Ferdinand_.

As the person at the helm, Carlos Saldanha says the book's central theme remained a cornerstone of

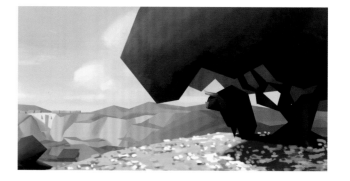

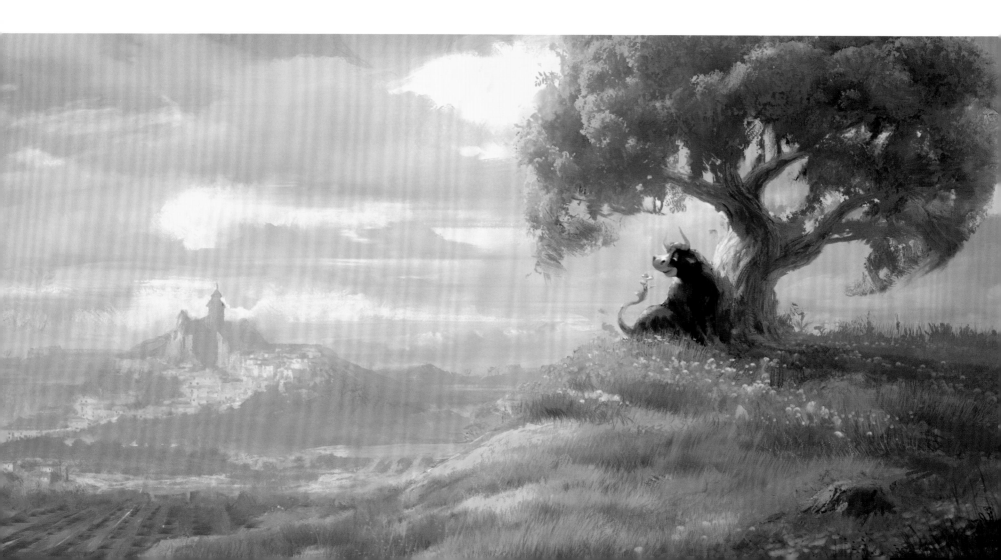

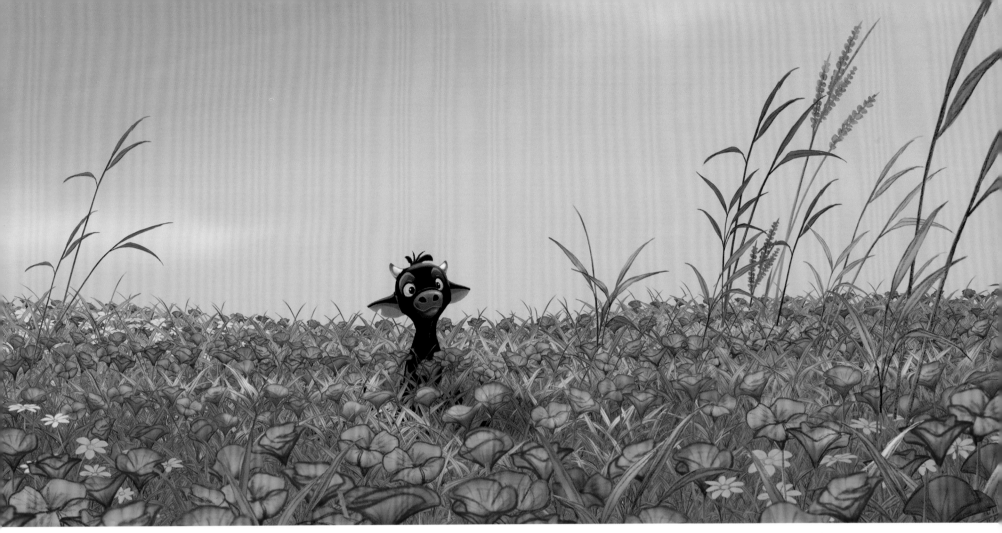

their movie. "The first thing that connected with me was the idea of 'being true to who you are,'" he says with passion. "You can be whatever you want to be. You are labeled as a bull, but you don't have to be a *fighting* bull. You can just sit in the corner and smell the flowers. Ferdinand is that gentle soul in a giant shell. From there I started to ask, 'How does that apply to my children? How does that apply to myself, to my friends, to different parts of society?' I felt the message was so widely relevant, and that hooked me right away."

Saldanha says he knew Blue Sky's film needed to stay true to the universal idea of the book, especially as they developed the cast of supporting characters who would flesh out Ferdinand's cinematic world. It was important that, like the bull at the center of the story, they too would be part of the journey of discovery. "As we developed the characters," he explains, "we tried to keep those themes relevant to each one of them, individually, showing how they too were misjudged and typecast."

However, finding a way to widen the book's narrative yet keep *Ferdinand* on point thematically, ended up being more demanding than the director anticipated. "Expanding a book that is only sixteen pages into a ninety-minute film is a big challenge", Saldanha explains. "The book itself gave me a great starting point, but I knew that I needed to fill in the gaps, and in order to do that, I had to extend the storyline into something that felt organic without losing the essence and soul that is the heart of *Ferdinand*. I had to create a structure for that expanded story.

"Usually in animated films, [the main characters] have a want that is outside of themselves, but Ferdinand has a deeper need, because all he wants is to be accepted for who he already is," the director continues. "So our script becomes an empowerment story. It's Ferdinand fighting to be who he is. It's not the literal fight of bullfighting, but the metaphor of a fight to simply be accepted and respected for who you are. We live in a world of cliques and peer pressure, and if you don't

if you don't conform to certain rules you may end up an outsider. Through the message of the movie, we're trying to encourage people to look at each other for who they truly are, and not to judge based on perception; to look beyond societal pressures and just be your true self."

Having directed multiple movies at Blue Sky Studios and developed the stories for both *Rio* films, Saldanha has established his own process of charting plotlines that enables him to craft a cohesive story. But he admits *Ferdinand* was a completely different animal (pun intended) in how he developed it than any of his previous films. "It was the first time that I started animation development with the third act," the director admits. "Usually I start the animation with a couple of set pieces in the middle, but with *Ferdinand*, I felt we needed to nail the third act, because it would be the heart and soul of how this story takes shape. I knew how it had to end, thankfully, because of the book.

"Most of the third act has very minimal dialogue," he continues. "It is all about the action and the visuals. As a storyteller and animator, I love that. So there was a lot of brainstorming with the animators and the story artists and the writers to really shape it. There was a lot of experimentation and a lot of tests. In general, it was the kind of beautiful step-by-step discovery where we were testing ourselves to find the emotional beats. I wanted that third act to represent the feeling that I had when I read the book. It was the feeling of acceptance, the feeling of being part of something bigger, without having to be heavy handed."

RIGHT:
Early concept art: Digital painting by Aidan Sugano

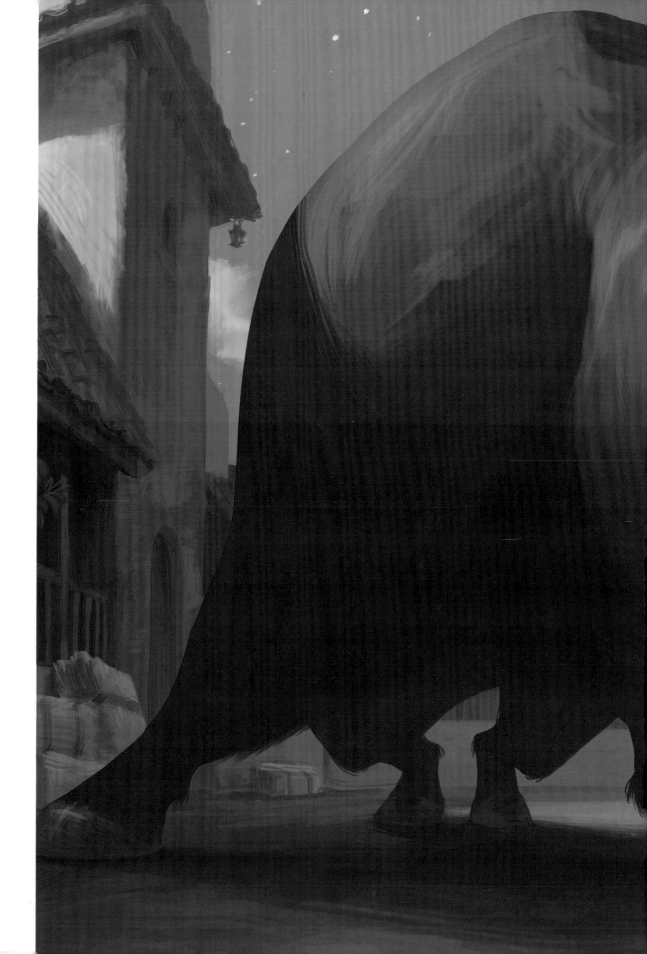

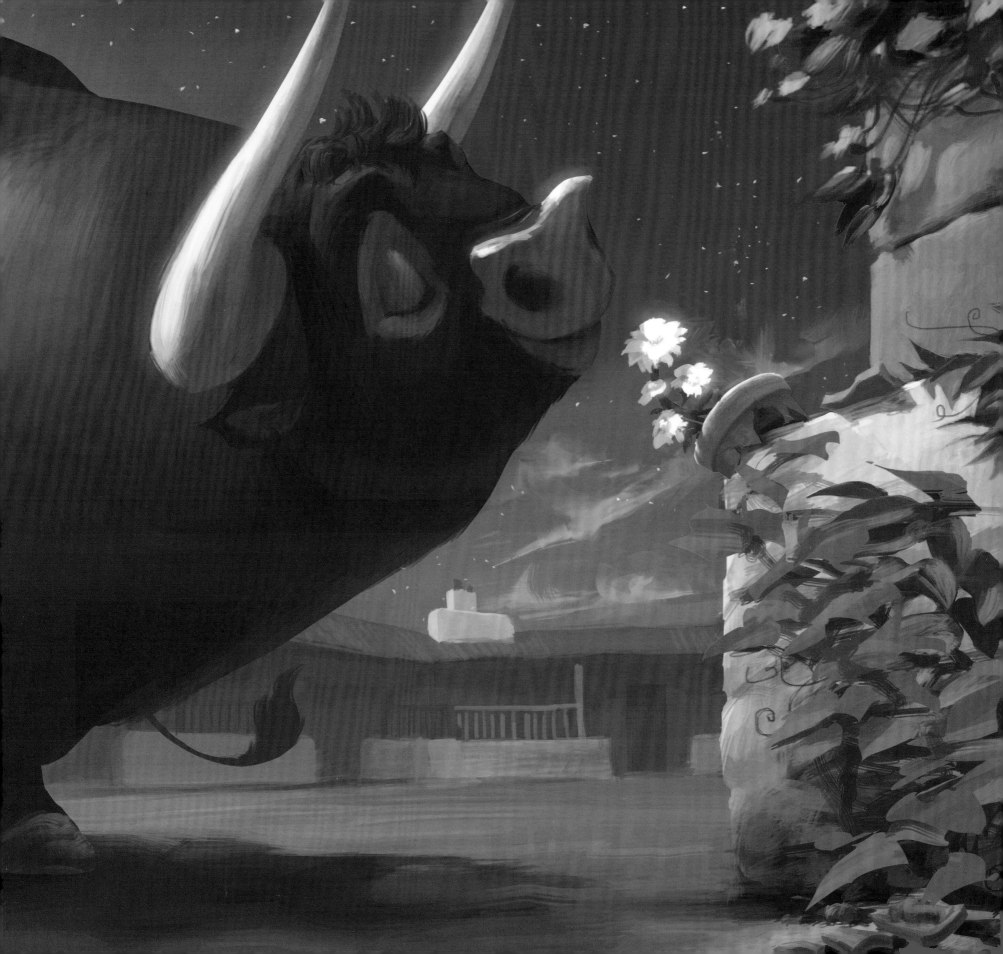

Helping Saldanha translate that emotional narrative into the film's equally evocative visual aesthetic became the job of long-time Blue Sky Studios production designer Thomas Cardone. Having art directed Saldanha's *Ice Age: The Meltdown* and the two *Rio* films, Cardone has established a shorthand in his working relationship with Saldanha that was helpful in figuring out how to hit the emotional beats of the story with the animation.

"I trust his instincts," the director says of Cardone. "He can see where I'm trying to head and sometimes he solves my problems by seeing a little bit beyond what I am seeing. Even though I think very visually, I don't have full expertise of the art direction of the story. I rely a lot on him to feed me what he feels is right for the story, so that is why he is an integral part of every step."

Hearing Saldanha's pitch for *Ferdinand*, Cardone remembers, "What attracted me was that it seemed like I had always known the original story. I knew it would have to be expanded, but I felt like it had the potential to be a big story about a small group of characters, told in a more intimate way. I thought that could be powerful."

The film is set in Spain, and for Saldanha and Cardone, that meant creating an environment that is authentic to that region and culture. "As was the case with *Rio* and its titular city," the director details, "because this movie is taking place in Spain, I owed the audience that truth. I wanted to make sure the people could feel that. In order for that to happen, I went for the little details. We visited Spain, we absorbed as much as we could and tried to capture the essence of that in our version of this beautiful country."

From that visit, Cardone says they were able to ascertain what would make *Ferdinand* visually distinct from other films. "Obviously, we like each of our films to have a unique look and be iconic in their own way," he explains. "You want to be able to show someone a frame from this movie and have them say, 'Well, that's *Ferdinand.*'

"Carlos and I knew we wanted to push the stylization more this time than we had on the *Rio* films. In finding that style, we looked to the main character and the culture where our story is set. Accuracy in that regard is important, but we also didn't want a hyper-real representation of that place. A caricature of it instead would be more appropriate for the tone of our film. We started with the real place, drawing from the culture and landscape. We looked at those elements for clues to how we might push the style away from reality while keeping the authenticity we wanted to maintain. It's not super stylized, but it is a stylized film."

BELOW:
A white stucco village in southern Spain: Final digital art

RIGHT:
Ronda's iconic Puente Nuevo bridge: Final digital art

BOTTOM RIGHT:
Still life for light, color and texture: (top) Digital painting by Thomas Cardone and Arden Chan; (bottom) Materials and Lighting by Diana Diriwaechter and Angel Camacho

NEXT SPREAD:
Early concept art of a bull pileup: Digital painting by Aidan Sugano

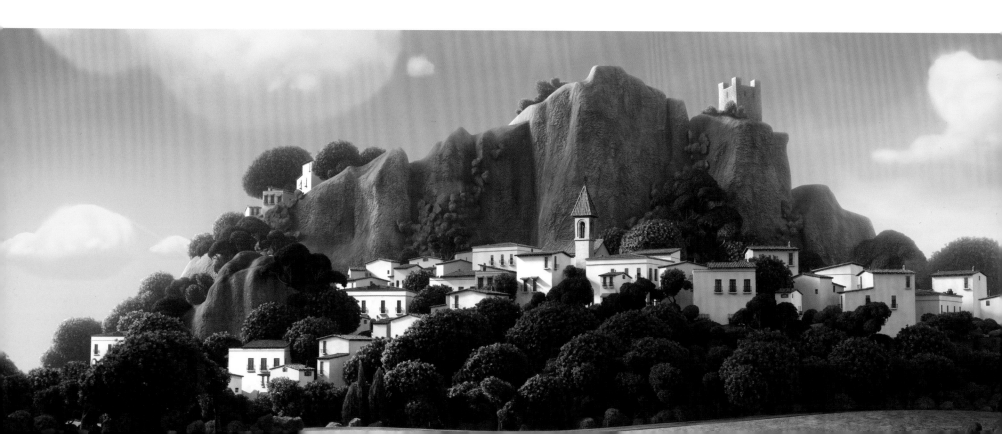

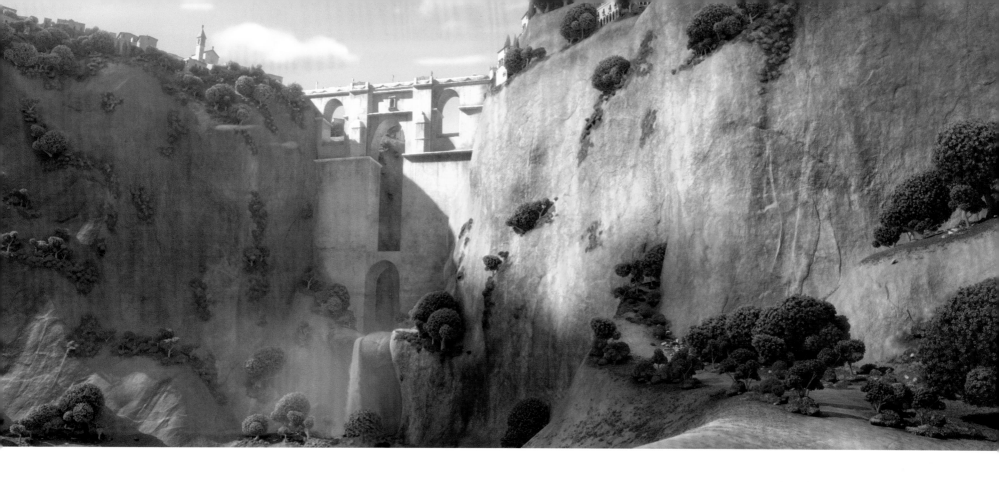

"There was a little painting that Tom [Cardone] had done. He and Arden Chan took some existing [digital] props and made a little still life of a table with a fruit bowl, books and flowers. Tom painted over the geometry in the way that he thought the color and texture should be designed for this Mediterranean light. For the longest time, I could feel the warmth of the light just by the way he painted it. We worked with Diana Diriwaechter in Materials and Angel Camacho in Lighting, who finally matched it. This was a benchmark for how we would handle simplified texture, stylized color and reduced specularity, which were the basis of the look of *Ferdinand* in Lighting and Materials."

Jason Sadler, Character Designer

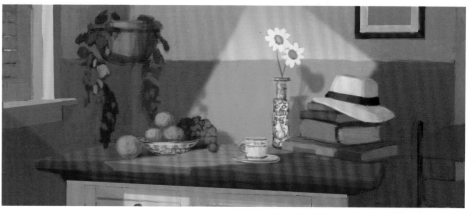

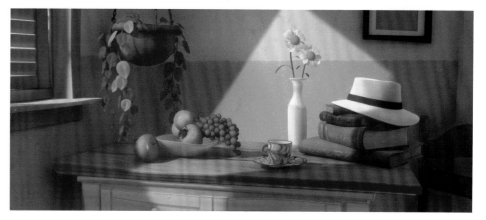

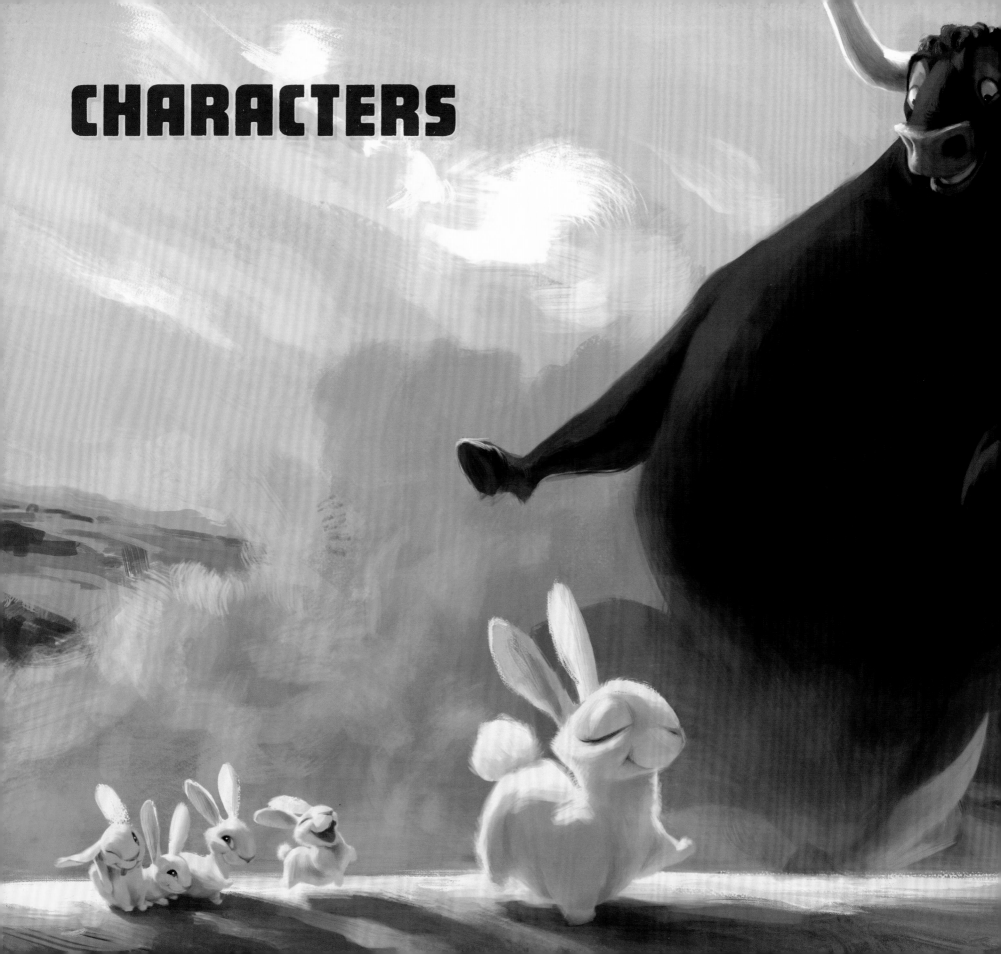

CHARACTERS

FERDINAND

Ferdinand is introduced in the first act of the film as a young calf enamored with the verdant fields and colorful flowers that make up the farm he loves. However, director Carlos Saldanha reveals that initial designs for young Ferdinand's look were changed dramatically once he figured out the film's third act emotional climax. Saldanha determined that for the ending to land successfully, they needed to connect to the very beginning, and that would be done most effectively by carrying through certain visual features of Ferdinand from birth to adulthood.

"With young Ferdinand, we wanted to make sure that he didn't look that big and was a bit awkward. We pushed him to be a little gangly and boney. The other bulls needed to look stronger than him. That was a key focus."

Sang Jun Lee, Lead Character Designer

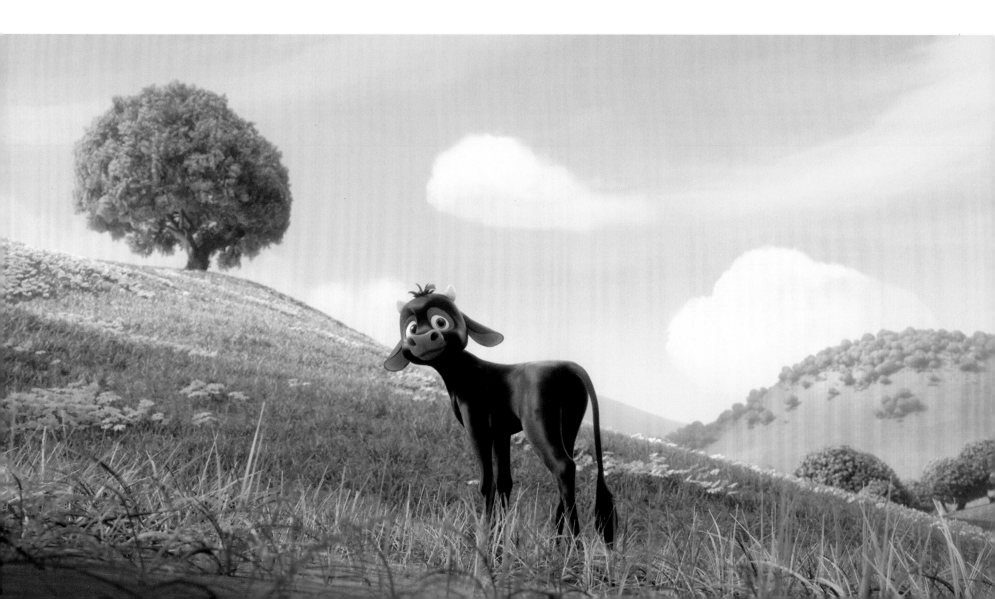

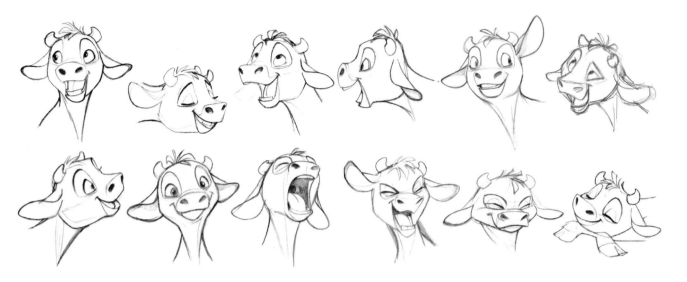

OPPOSITE:
Young Ferdinand and the cork tree: Final digital art

LEFT:
Young Ferdinand expressions: Drawings by Sang Jun Lee

LEFT MIDDLE:
Young Ferdinand gestures: Paintings by Sergio Pablos

BELOW LEFT:
Young Ferdinand: Design by Sang Jun Lee, Painting by Mike Lee

BELOW:
Young Ferdinand: Physical sculpt by Vicki Saulls

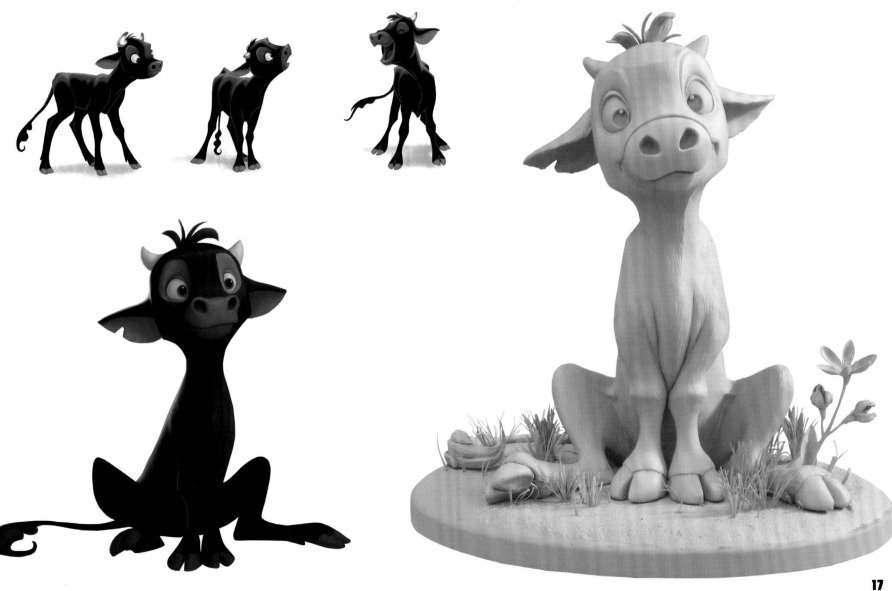

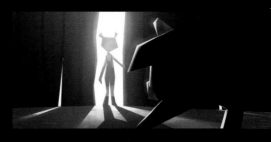

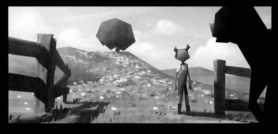
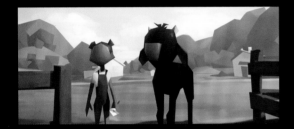

ABOVE:
Young Ferdinand awakes at the farm: Color keys by Mike Lee

BELOW LEFT:
Young Ferdinand gestures: Drawings by Sang Jun Lee

BELOW:
Young Ferdinand's head: Painting over digital model by Mike Lee

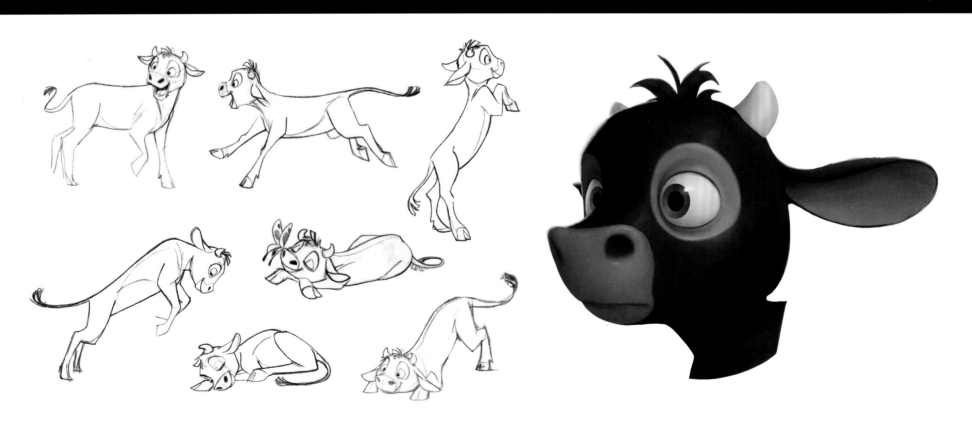

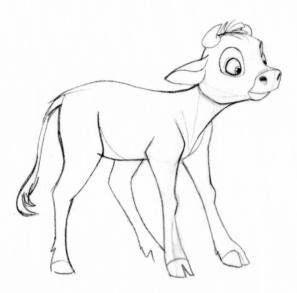
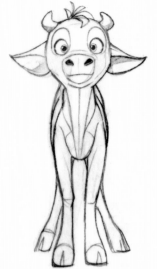
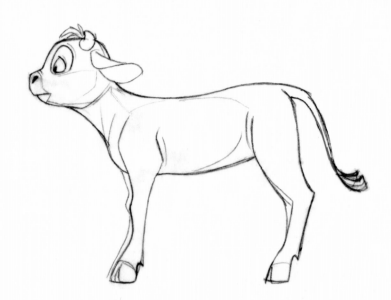

"Early on we had locked down adult Ferdinand's design, and at the same time we designed the look of young Ferdinand," Saldanha reflects. "Only after we started animating did we realize that there were adjustments that we needed to have in young Ferdinand's face in order to emote the same things that we were getting out of adult Ferdinand. The same eyes, the same nose; those things needed to be really consistent. So we redesigned him, concentrating mostly on the face. We tried to recreate the shapes and forms that allowed him to do things that we were already doing with big Ferdinand. For example, the nose was reshaped to be more prominent and similar to adult Ferdinand, so it could be more malleable, and you could use it almost as a character itself."

ABOVE:
Young Ferdinand turnaround: by Sang Jun Lee

BELOW:
Young Ferdinand: Physical sculpts by Vicki Saulls

NEXT SPREAD:
Early concept art of young bulls teasing Ferdinand: Drawing by José Manuel Fernández Oli, Painting by David Dibble

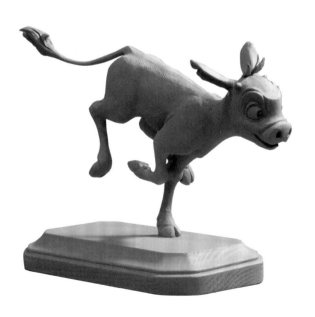
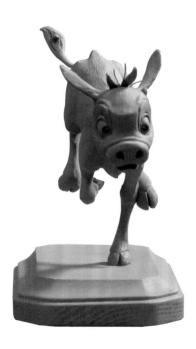
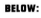
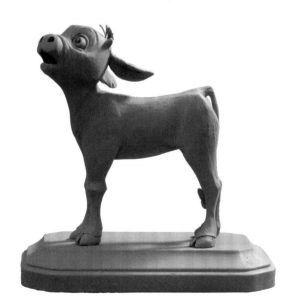

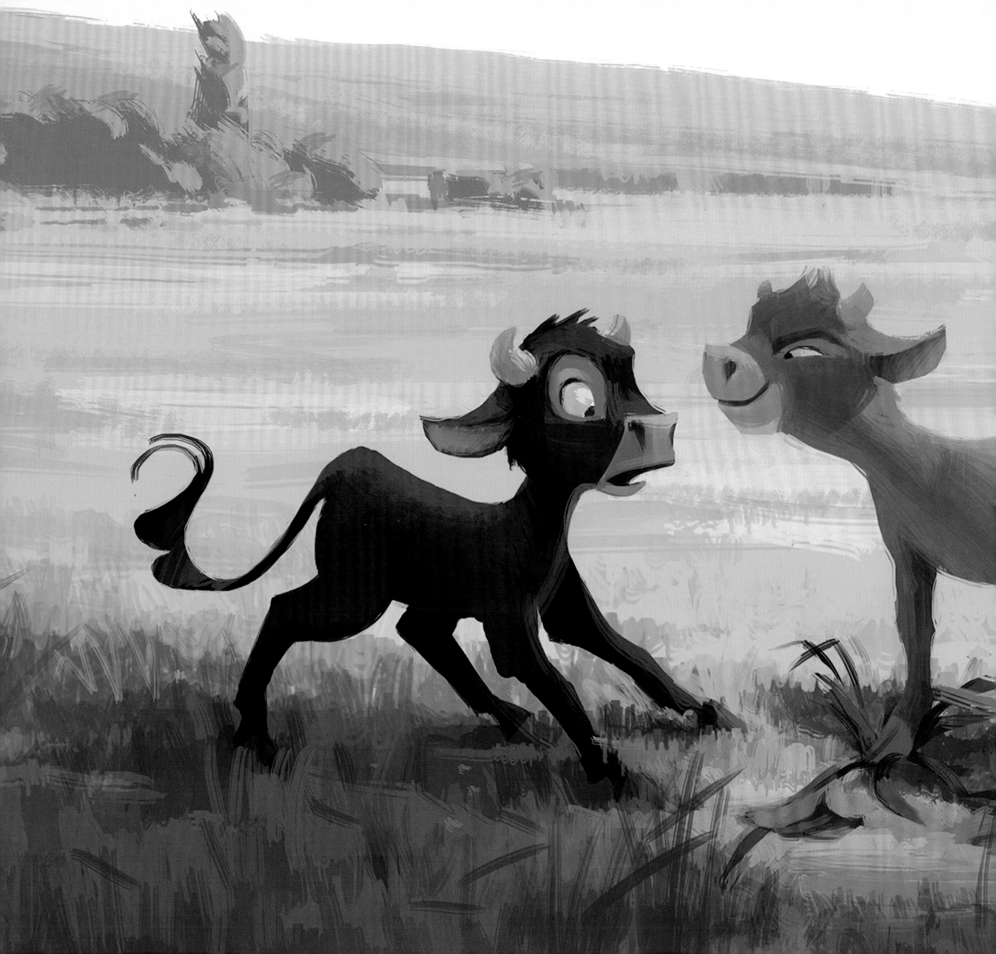

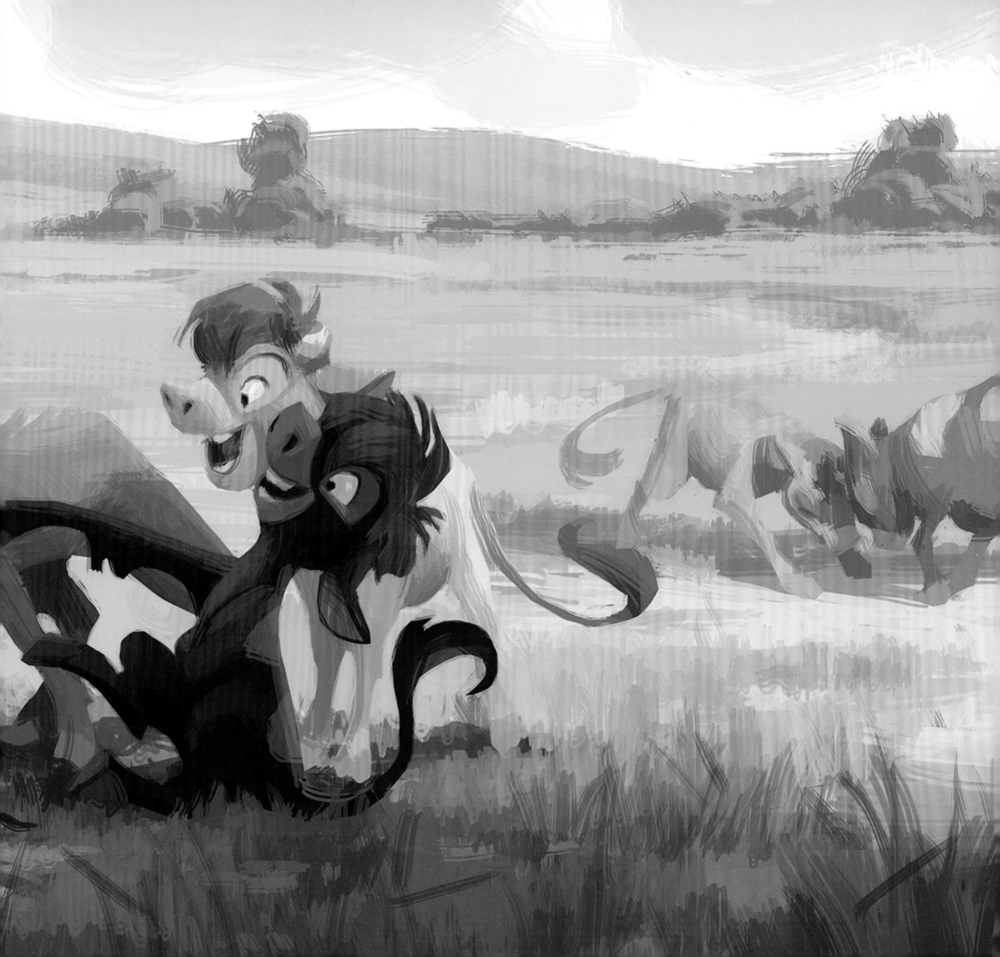

> **"My first breakthrough sketch was a simple drawing of Ferdinand smelling the flowers. Inspired by the landscape in southern Spain, I pushed the flowing lines in his silhouette. Carlos really liked that, and it became the impetus for the shape language of the film."**
>
> *Sang Jun Lee, Lead Character Designer*

The once-tiny calf matures into a massive bull before the end of the first act, which changes the entire spatial dynamic of the film. "Ferdinand is a larger-than-life bull, and proportionally he is much bigger than a real bull, and much bigger than any other bull that we have [in the film]," Saldanha explains. "But one thing that I love about Ferdinand in the movie is that he conveys a little bit of softness. We started to play with curves and his language became about flow. We tried to play him with bigger shapes and defined shapes, but everything had a curve and a gentleness about it."

Ferdinand's absence of color also created a challenge for every frame. "I wanted Ferdinand to be completely black, almost like a black stallion," the director says. "We visited a farm in Andalusia where they raise bulls. They come in mostly black and brown. The black ones are very black with a nice sheen. This sheen creates highlights which reveal the details of their anatomy."

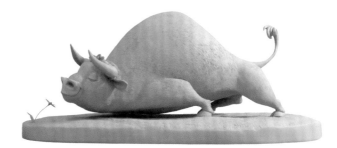

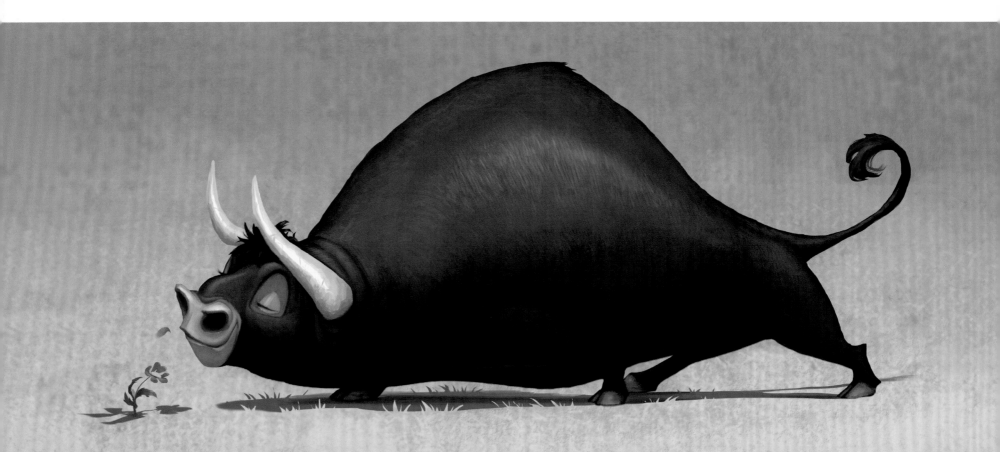

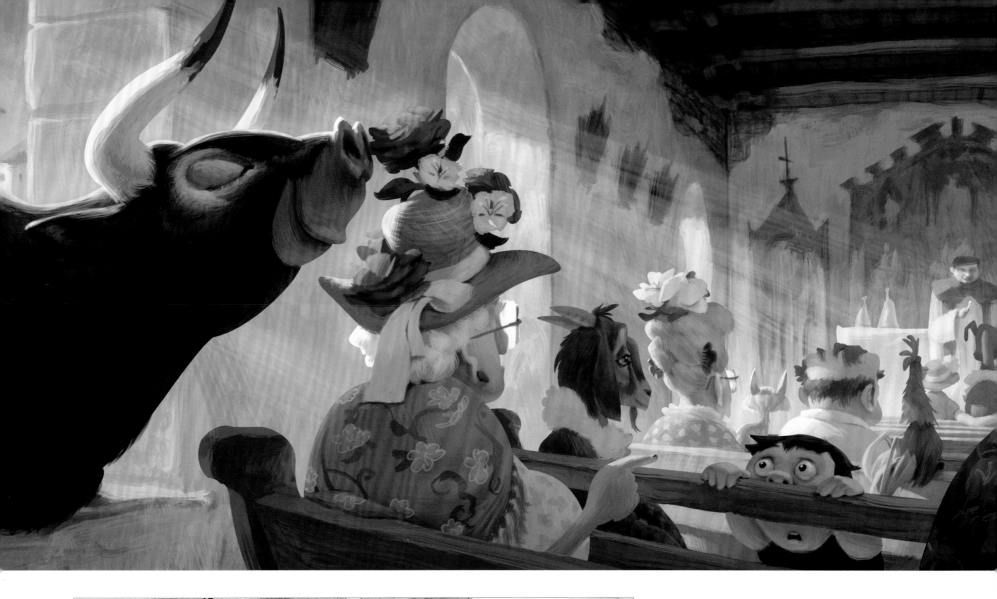

OPPOSITE TOP LEFT:
Ferdinand: Drawing by Sang Jun Lee

OPPOSITE TOP RIGHT:
Ferdinand: Physical sculpt by Vicki Saulls

OPPOSITE BOTTOM:
Ferdinand: Drawing by Sang Jun Lee, Painting by Ron
DeFelice

ABOVE:
Early concept art of Ferdinand in town: Drawing by Peter
Chan, Painting by Aidan Sugano

LEFT:
Early concept art of Ferdinand in town: Drawing by Peter
Chan

"Being the main character, Ferdinand has a lot of screen time," production designer Thomas Cardone continues. "He is a large black shape that dominates the composition whenever he is on screen. Character silhouette is always important, but even more so in this case. Most of the pose information would come from the silhouette, because the interior detail would be harder to see on this dark, monochrome bull.

"Ferdinand's beautiful flowing lines take their inspiration from the landscape in southern Spain," Cardone explains. "We embraced that idea for him and, in turn, took a more graphic approach to our film in general."

In an effort to maintain the clean graphic shapes while at the same time enhancing Ferdinand's anatomical detail, Saldanha says the Blue Sky materials and lighting teams had to spend some time figuring out a solution. "They showed me an alternative approach to creating Ferdinand's body fur texture. Instead of using our traditional fur approach, they created a texture instead. I was a little skeptical at first," he admits. "Then I saw the first test. They were able to keep the clean silhouette and create the illusion of fur with their texture. This gave us more control over the sheen and highlights. I really wanted Ferdinand's darks to be dark and highlights to shine to describe his form. I wanted him to have contrast, and pick up the influence of the sky from above. This was an unexpected solution that worked beautifully."

TOP RIGHT:
Ferdinand early concept: Painting by Peter de Sève

RIGHT:
Early concept art of Ferdinand gestures: Digital paintings by Sergio Pablos

OPPOSITE:
Ferdinand movement: Digital animation poses by Chip Lotierzo, Drawn over by Sang Jun Lee

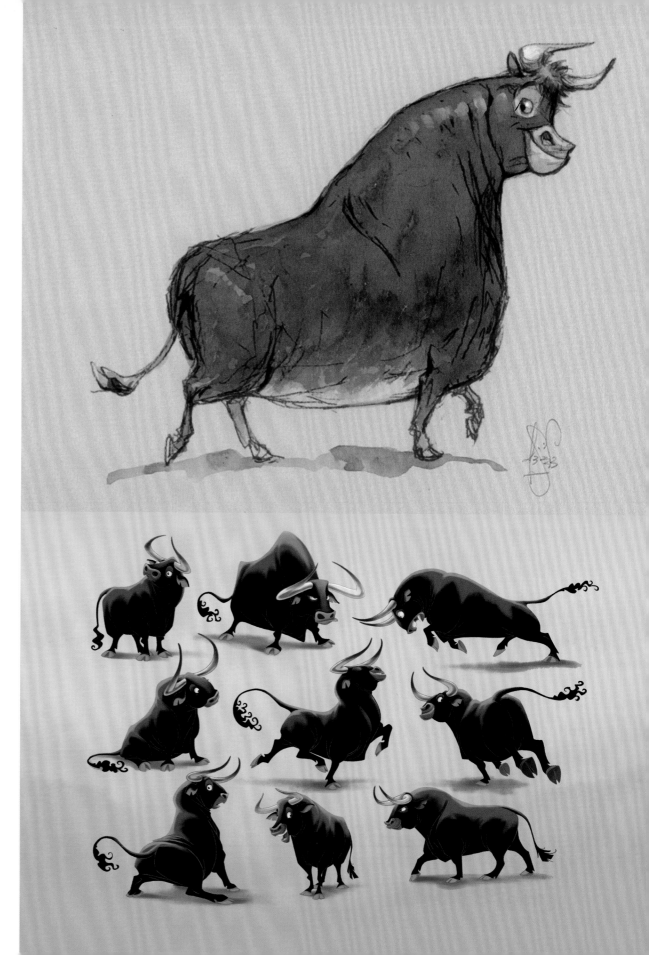

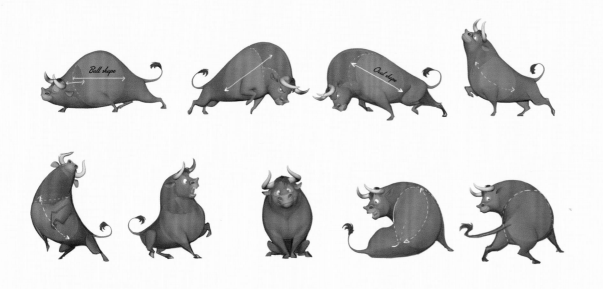

"Ferdinand was the character I started with. What we do with the main character sets the tone for the rest of the cast. We were trying to find the right level of stylization, how far to push our characters away from reality and how to do that. Making Ferdinand appealing was the most important thing. His design grew out of his personality. Friendly, simple curves."

Sang Jun Lee, Lead Character Designer

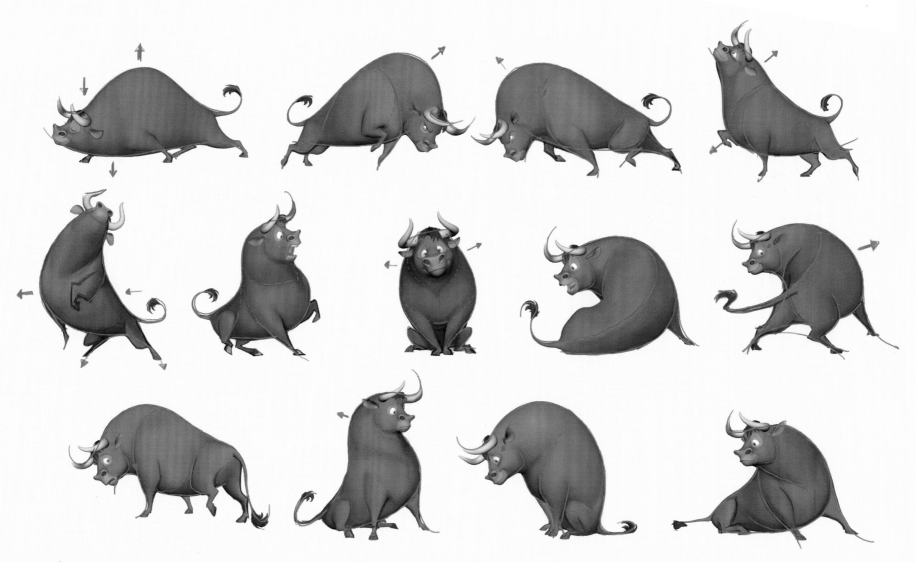

"We made sure Ferdinand never felt too heavy in the frame. We always have a main light source, like the sun, where we use either a sky light to reflect blue onto the shadows, or use bounce-light from the ground, so there is a warmer look to dimensionalize him."

Mike Lee, Color Key Artist

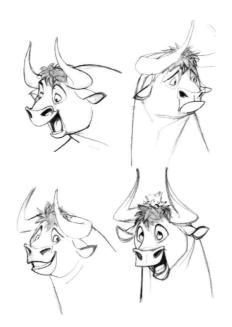

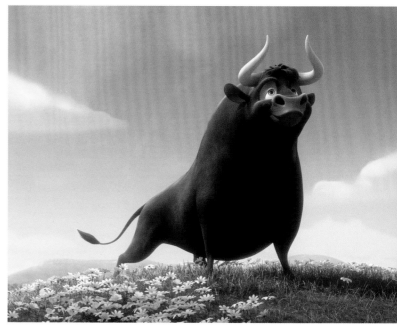

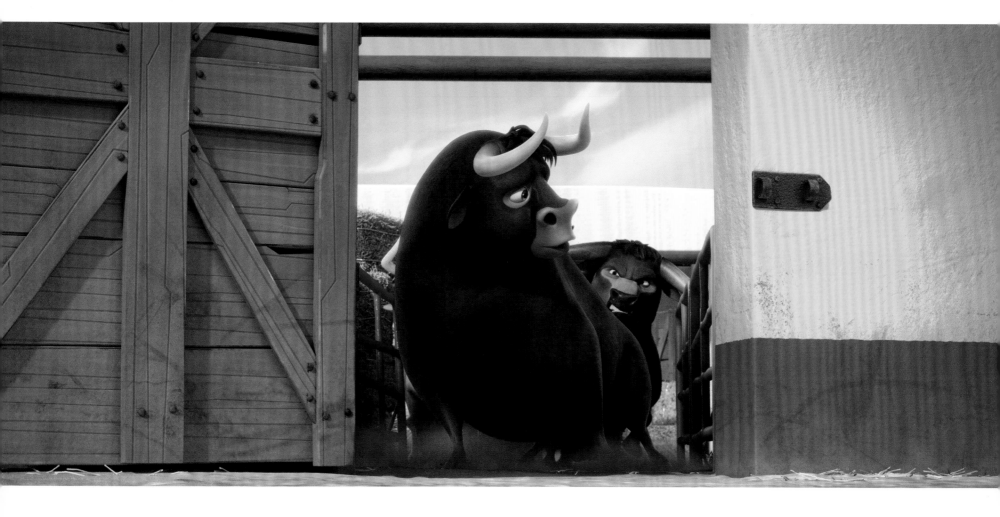

FERDINAND'S DAD

"When designing, personality is number one. So with Ferdinand's dad, Raf, though he's the alpha male of the whole ranch, we didn't want him to be too aggressive in appearance. A key moment is when he smiles at young Ferdinand as he leaves the ranch. Later on in the film, adult Ferdinand's smile is reminiscent of his father's, yet their body silhouettes are different."

Sang Jun Lee, Lead Character Designer

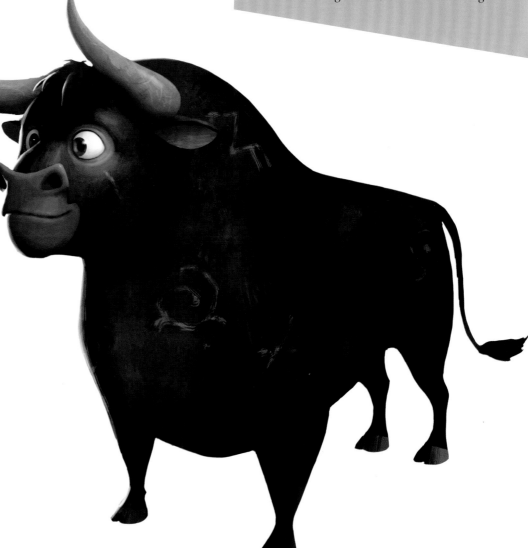

OPPOSITE TOP LEFT:
 Ferdinand expressions: Drawings by Sang Jun Lee

OPPOSITE TOP RIGHT & LEFT:
 Ferdinand: Final digital art

ABOVE:
 Ferdinand's Dad: Concept drawing by Sang Jun Lee

RIGHT:
 Ferdinand's Dad: Digital painting by Mike Lee over digital model

VALIENTE

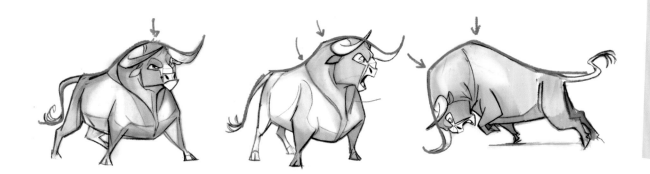

"With Ferdinand's look settled, we created a shape language for the other bulls, where their personalities would have a bit of influence on the way their physical lines would work. Valiente is now the 'alpha male' of the group, so we tried to give him more of a chiseled body. He is muscular like Ferdinand, but his shapes are much more angular."

Carlos Saldanha, Director

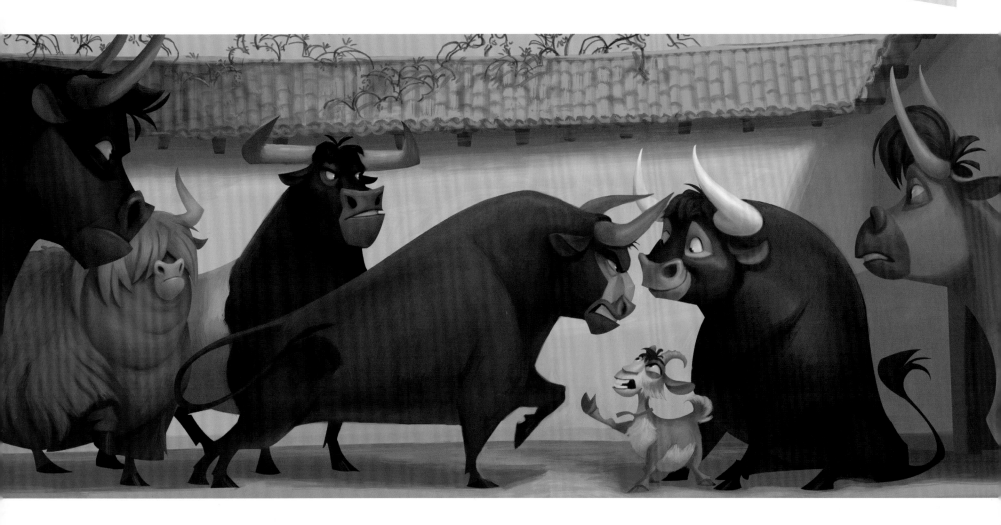

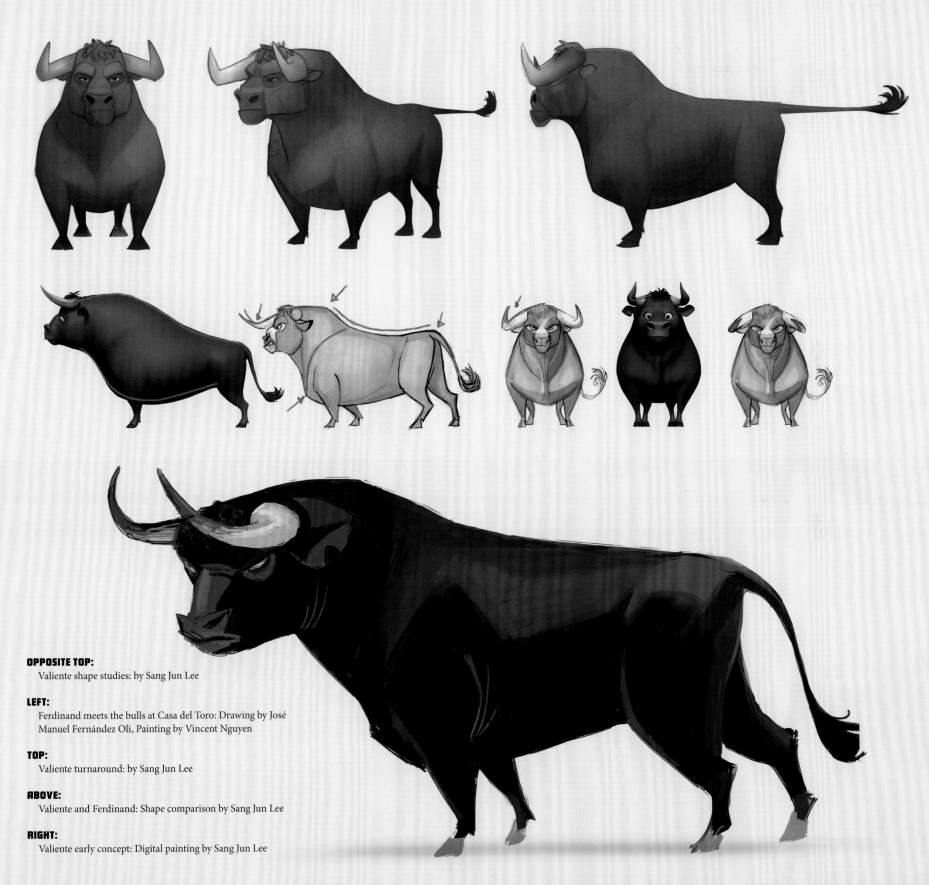

OPPOSITE TOP:
Valiente shape studies: by Sang Jun Lee

LEFT:
Ferdinand meets the bulls at Casa del Toro: Drawing by José Manuel Fernández Oli, Painting by Vincent Nguyen

TOP:
Valiente turnaround: by Sang Jun Lee

ABOVE:
Valiente and Ferdinand: Shape comparison by Sang Jun Lee

RIGHT:
Valiente early concept: Digital painting by Sang Jun Lee

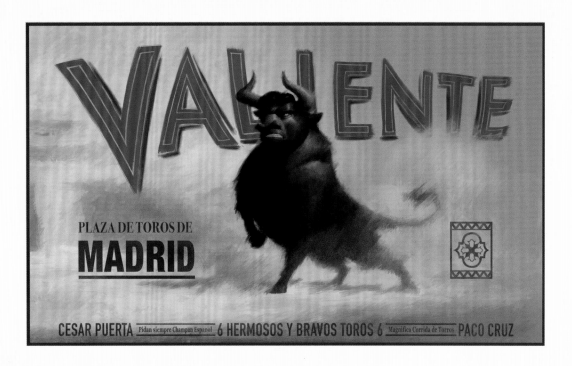

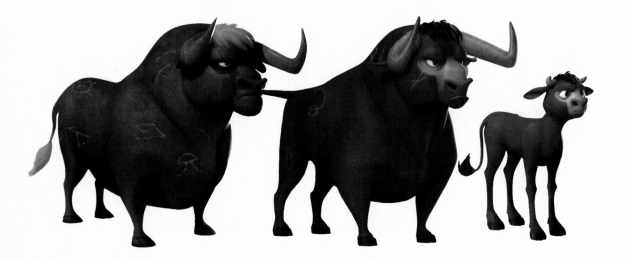

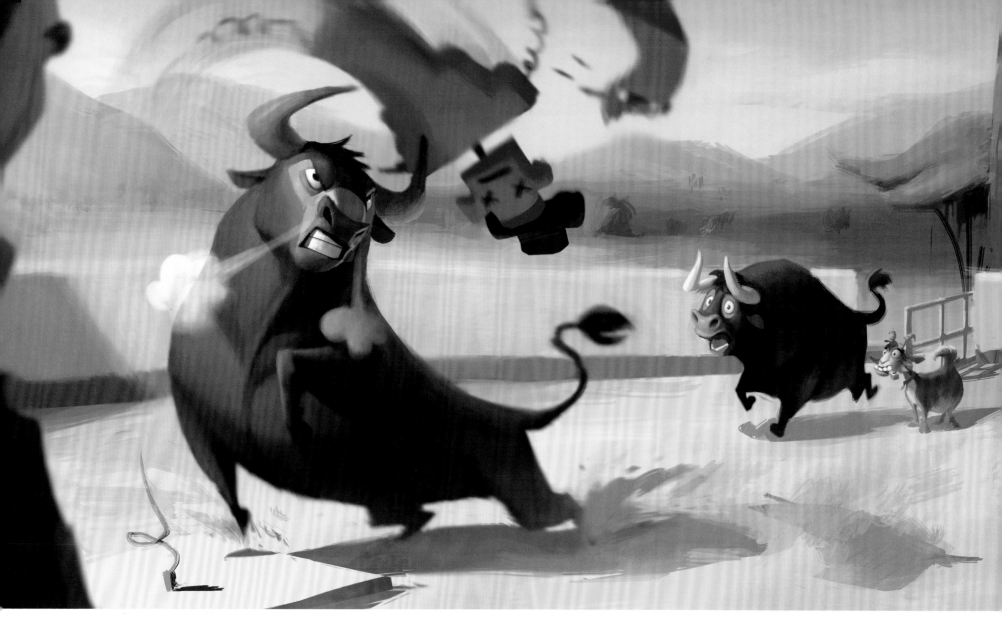

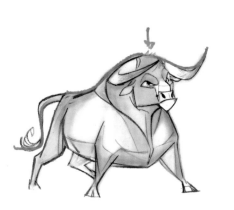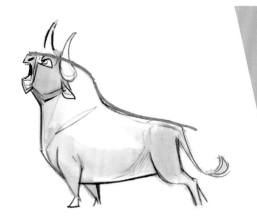

"If Ferdinand reflects the foothills of southern Spain, Valiente is the opposite. He's more like a mountain. He's really intense, so his body shape has sharper angles. I added more graphics to his face to suggest a Roman gladiator helmet, with the eye shape and his markings coming down the cheeks. His horns are straighter than Ferdinand's. He's also been in battles, so he's got scars which help the contrast with Ferdinand."

Sang Jun Lee, Lead Character Designer

BONES

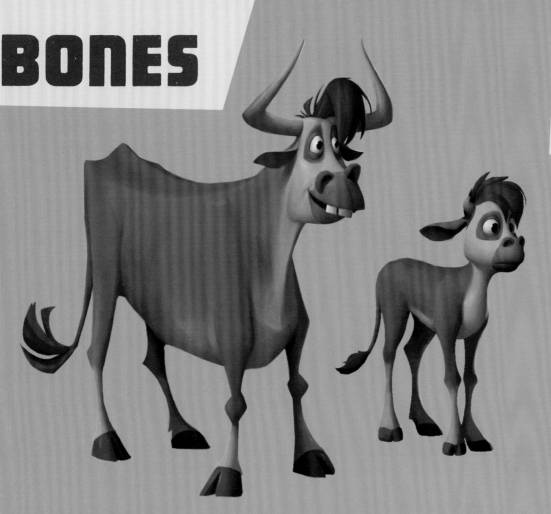

"Bones is super skinny, so the landmarks in his anatomy are much more pronounced. His body is supported by his spindly legs. He's very much a lightweight!"

Carlos Saldanha, Director

FAR LEFT:
Bones: Drawing by Sang Jun Lee, Painting by Mike Lee

LEFT:
Young Bones: Painting by Mike Lee over digital model

BELOW:
Bones gestures: Drawings by Sang Jun Lee

OPPOSITE:
Bones expressions and turnaround: Drawings by Sang Jun Lee

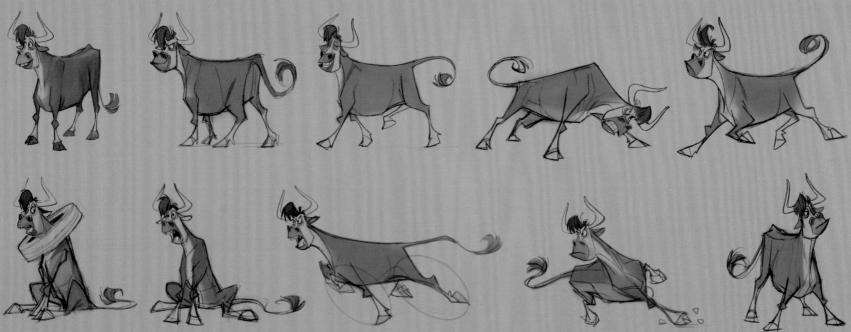

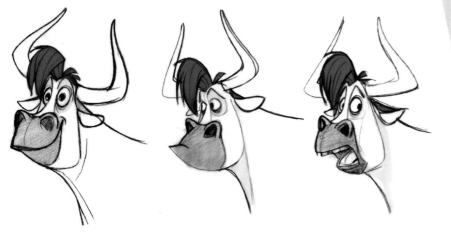

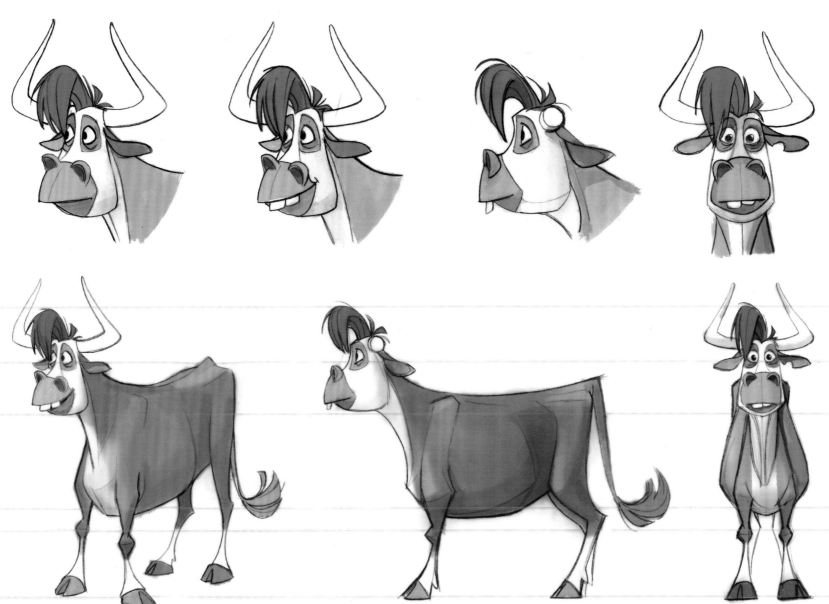

GUAPO

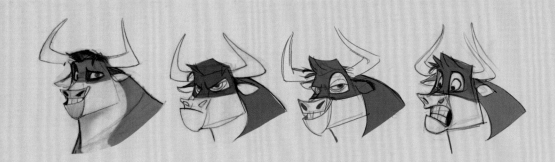

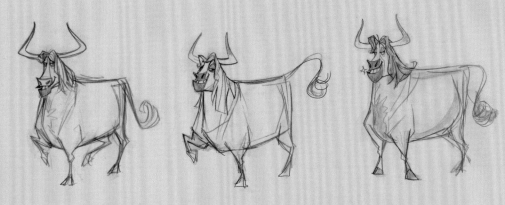

TOP RIGHT:
 Guapo expressions: Drawings by Sang Jun Lee

MIDDLE RIGHT:
 Early concept art of Guapo gestures: Drawings by Sang Jun Lee

BELOW:
 Guapo: Drawing by Sang Jun Lee, Painting by Mike Lee

BELOW RIGHT:
 Young Guapo: Painting by Mike Lee over digital model

OPPOSITE:
 Guapo: Final digital art

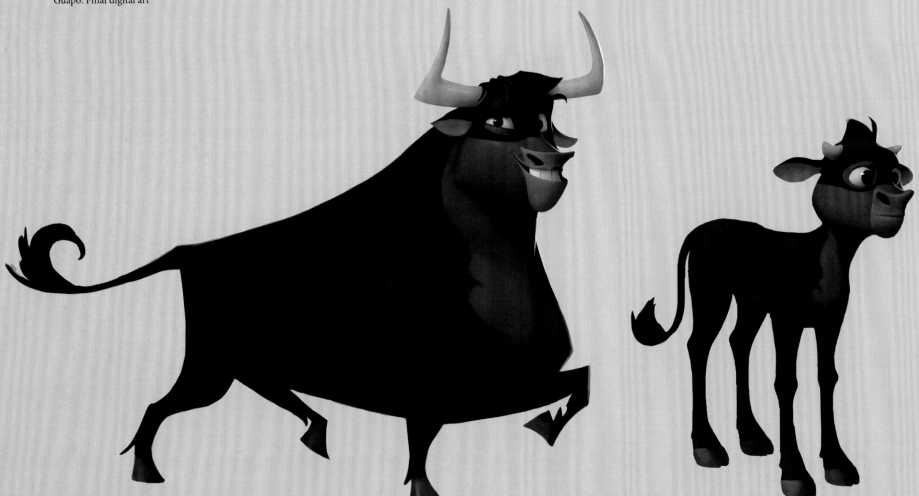

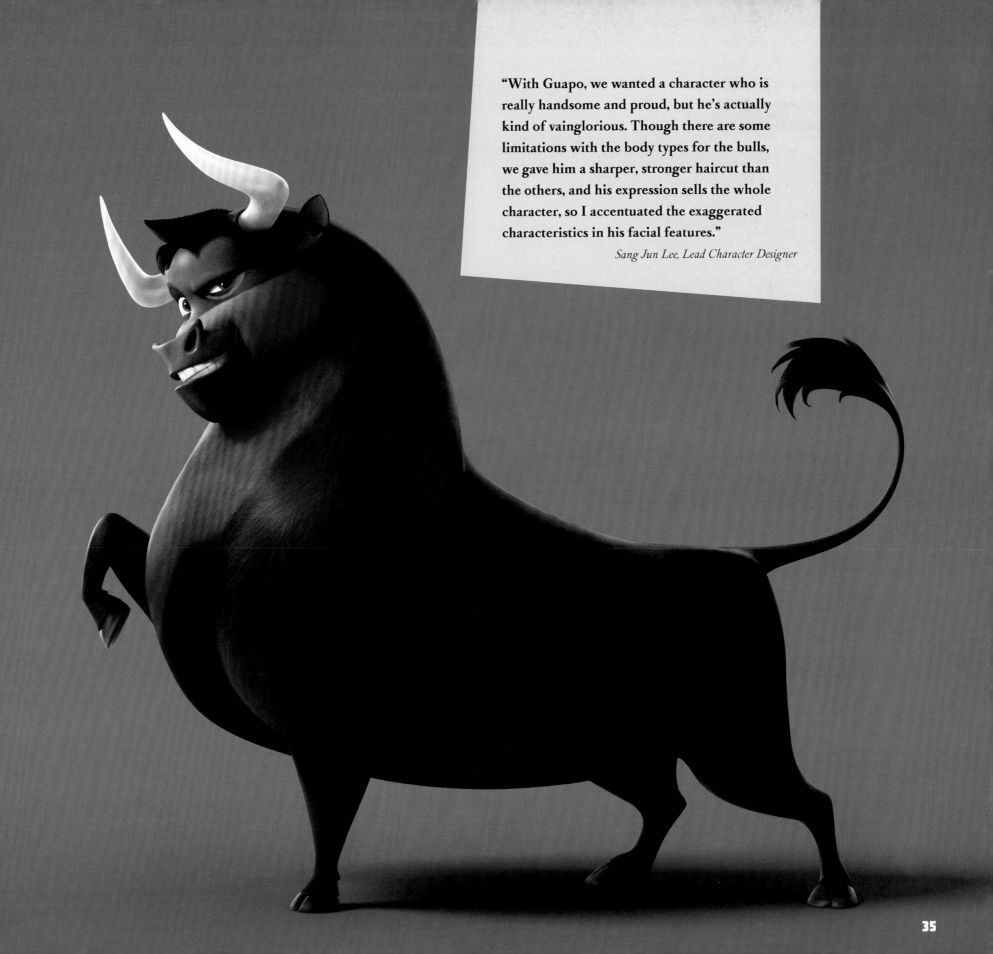

"With Guapo, we wanted a character who is really handsome and proud, but he's actually kind of vainglorious. Though there are some limitations with the body types for the bulls, we gave him a sharper, stronger haircut than the others, and his expression sells the whole character, so I accentuated the exaggerated characteristics in his facial features."

Sang Jun Lee, Lead Character Designer

ANGUS

"The fighting bulls at the ranch follow a pattern on the technical side," director **Saldanha shares.** "We can vary their colors and shapes a little bit, but the basics are similar. So, within those constraints, I wanted to see how physically diverse we could make them. For example, Angus the Highland bull (from Scotland) was created because we thought, 'What if there was an import? What if there was a bull who was not from Spain, but who was dropped into that world?' That opened it up and gave us a bit more freedom to create variety among the bulls."

Angus also serves to help augment Ferdinand's journey of self-acceptance. "The reason why Angus came about was because we wanted to create flaws within the characters or some difficulty that they had to overcome," the director continues. "We tried to use the physicality of them as a sign of their shortcomings or to suggest their challenges, which speaks to the theme. Angus, by not having been bred as a fighting bull and having more facial hair than anybody else, has a problem. He can't see very well, so he is always getting into trouble."

BELOW LEFT:
Angus early concept: Drawing by Aidan Sugano

BELOW:
Angus expressions: Drawings by Sang Jun Lee

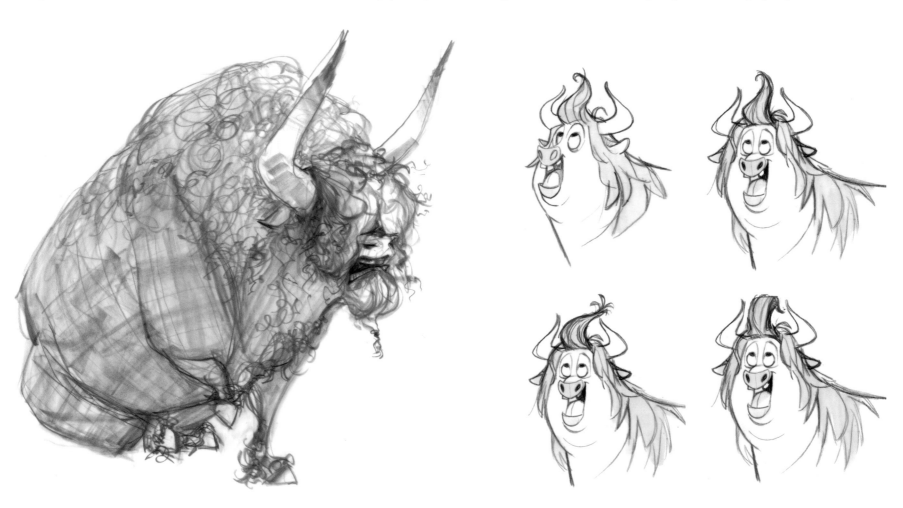

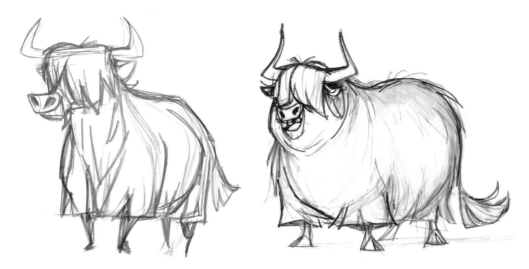

ABOVE:
Angus concepts: Drawings by Sang Jun Lee

"A fun thing in this film is that Ferdinand meets this group of bulls and after getting to know them, figures out how to help them overcome their individual issues. Angus is not a Spanish fighting breed; he's a Scottish Highland bull. The long fur that grows naturally over his eyes is obscuring his vision. He's always bumping into things, which also means he's lost some teeth. Ferdinand gives him a cowlick to help him see again. I focused more on his face than his horns to make him seem more of a funny character."

Sang Jun Lee, Lead Character Designer

BELOW LEFT:
Angus: Drawing by Sang Jun Lee, Painting by Mike Lee

BELOW RIGHT:
Angus: Painting by Mike Lee over digital model

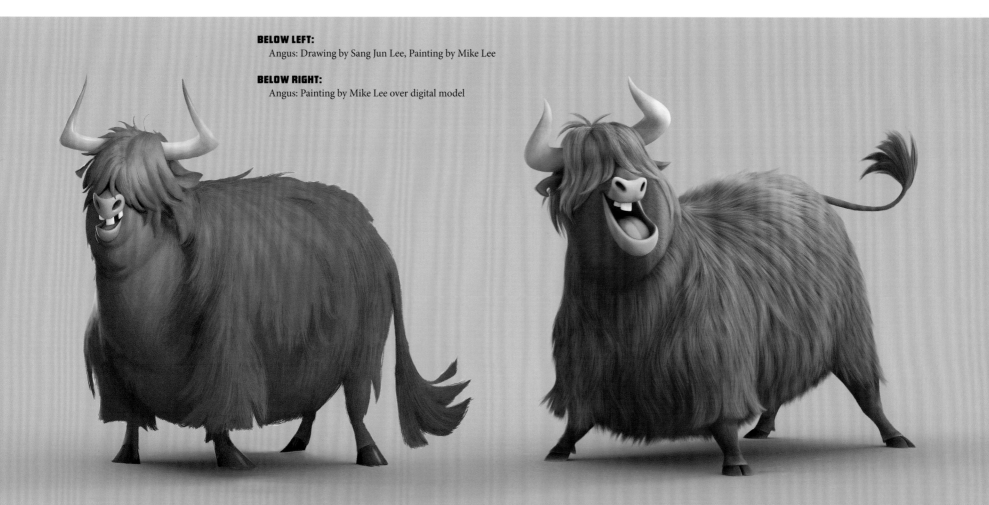

MAQUINA

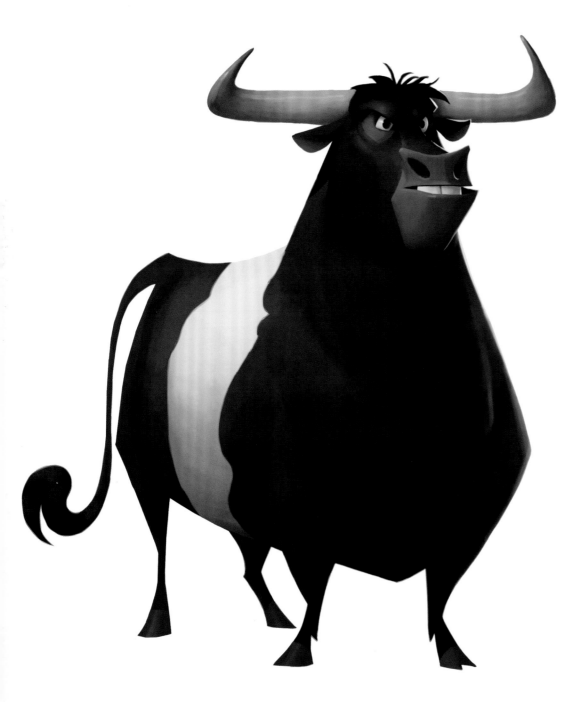

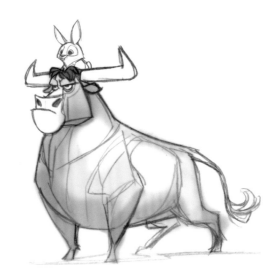

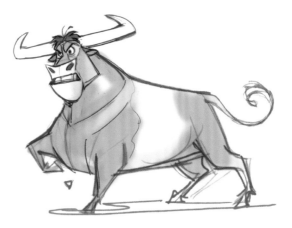

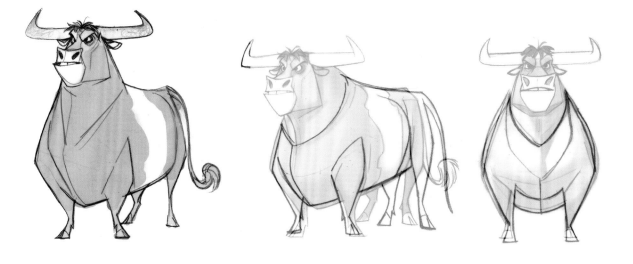

OPPOSITE LEFT:
Maquina: Drawing by Sang Jun Lee, Painting by Mike Lee

OPPOSITE RIGHT:
Maquina gestures: Drawings by Sang Jun Lee

LEFT:
Maquina turnaround: by Sang Jun Lee

BELOW:
Maquina: Final digital art

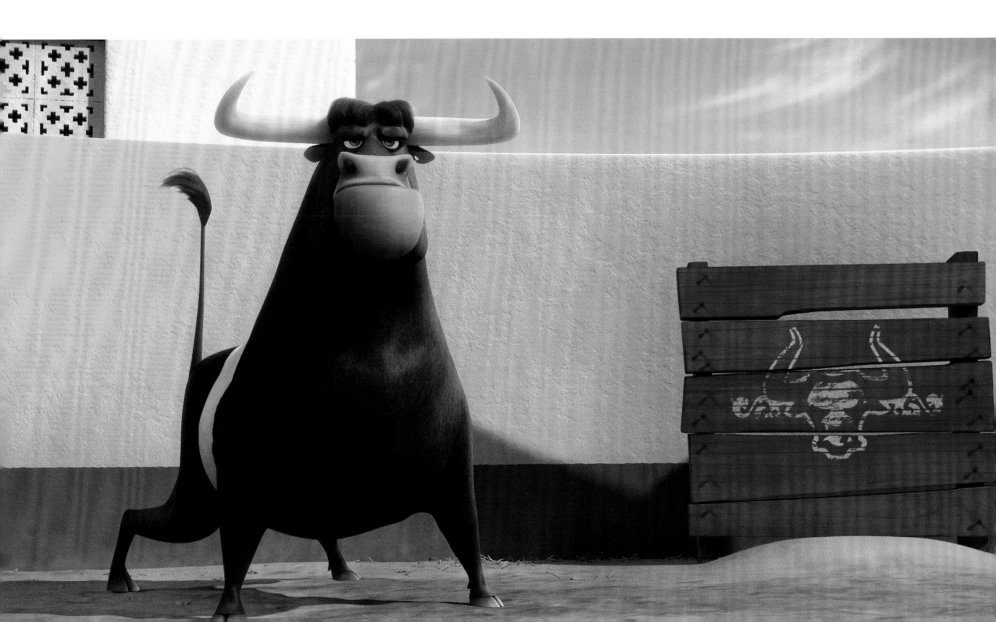

JUAN

In juxtaposition to the animals that dominate the majority of the narrative, there are also some human characters who impact or determine the fate of creatures like Ferdinand. Highly stylized like the animals, they are often defined by exaggerated physical features such as extra-long legs or sharp facial lines.

Lead character designer Sang Jun Lee says he referenced some old masters of Spanish painting to help define the look of the human characters in the film. "I looked at famous Spanish painters like Picasso and El Greco for inspiration when designing the human characters, because cubism is so close to this project. Picasso's cubism paintings have very simple lines with personality. El Greco painted many portraits with really elongated noses and shapes. I began to explore dividing the shapes of the faces in a similar style to cubism, looking at how noses connect with brows, and the sharpness of the cheeks."

BELOW:
Juan early concepts: Drawings by Jason Sadler

RIGHT:
Juan: Painting by Mike Lee over digital model

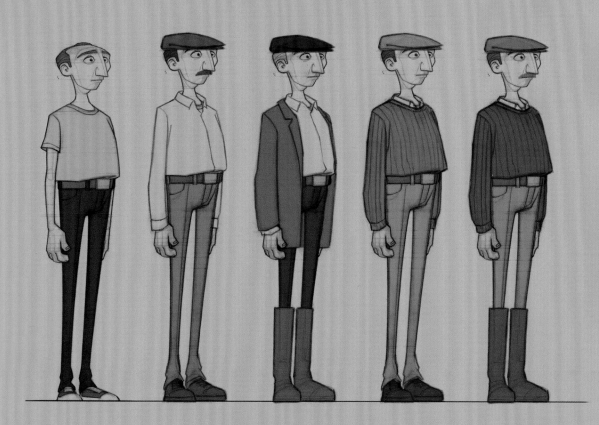

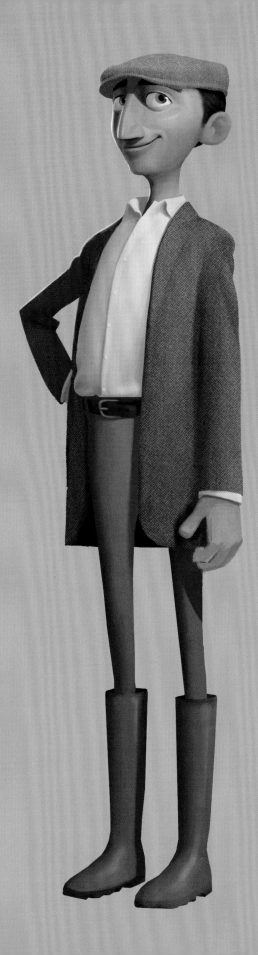

NINA

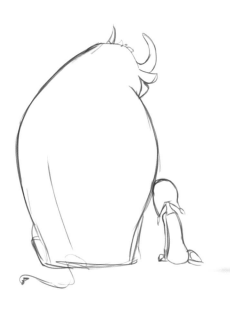

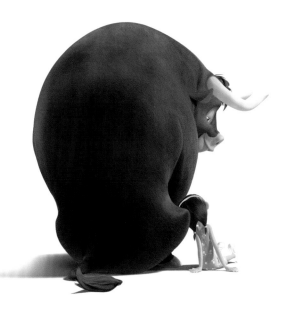

"Usually with young characters, you think of the facial mass and the cranial mass. When a baby is born, there's very little facial mass, but as you age the facial mass gets larger in proportion. Usually kids have tons of cranium and the eyeline is fairly low. I wanted to do something different by giving Nina a fairly high eyeline."

Jason Sadler, Character Designer

FAR LEFT:
Ferdinand and Nina: Sketch by Kevin Yang

LEFT:
Ferdinand and Nina: Final digital art

BELOW LEFT & BELOW RIGHT:
Nina early concepts: Paintings by Sergio Pablos

BELOW MIDDLE:
Nina expressions: Drawings by Jason Sadler

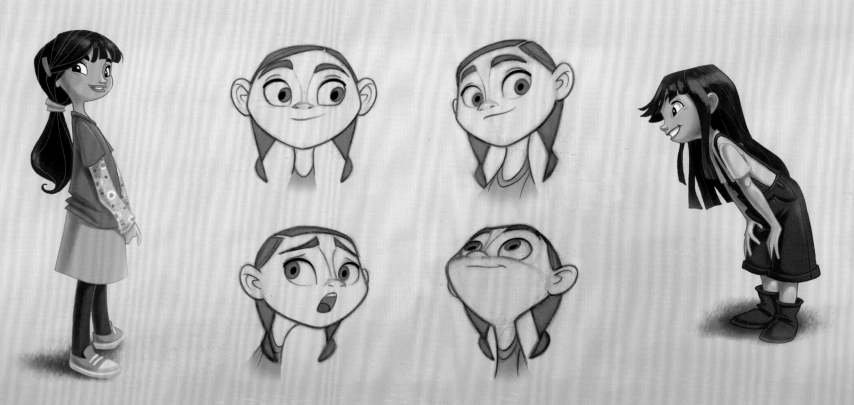

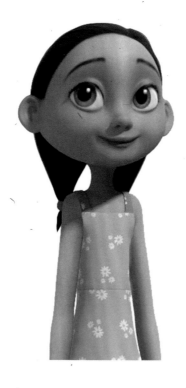

"As a color designer, I work over the character designers' drawings. They are using line work to come up with the shapes and overall design of each character. Part of my job is to then take their drawings and figure out a color hierarchy between hero characters and secondary characters. We make sure background characters don't overpower hero characters."

Mike Lee, Color Key Artist

LEFT:
Nina: Digital render

ABOVE:
Nina turnaround: by Jason Sadler

BELOW:
Young Ferdinand and young Nina: Final digital art

RIGHT:
Early concept art of Ferdinand and Nina: Drawing by Peter Chan, Painting by Aidan Sugano

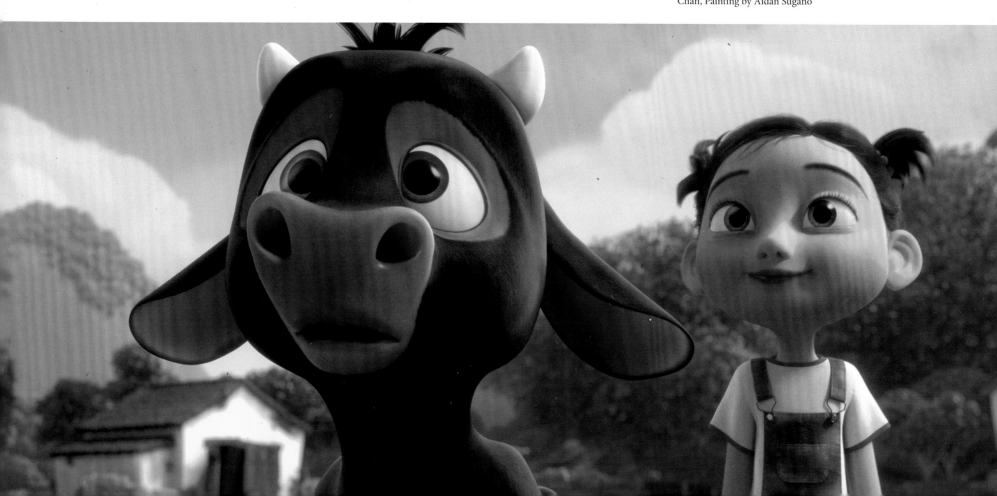

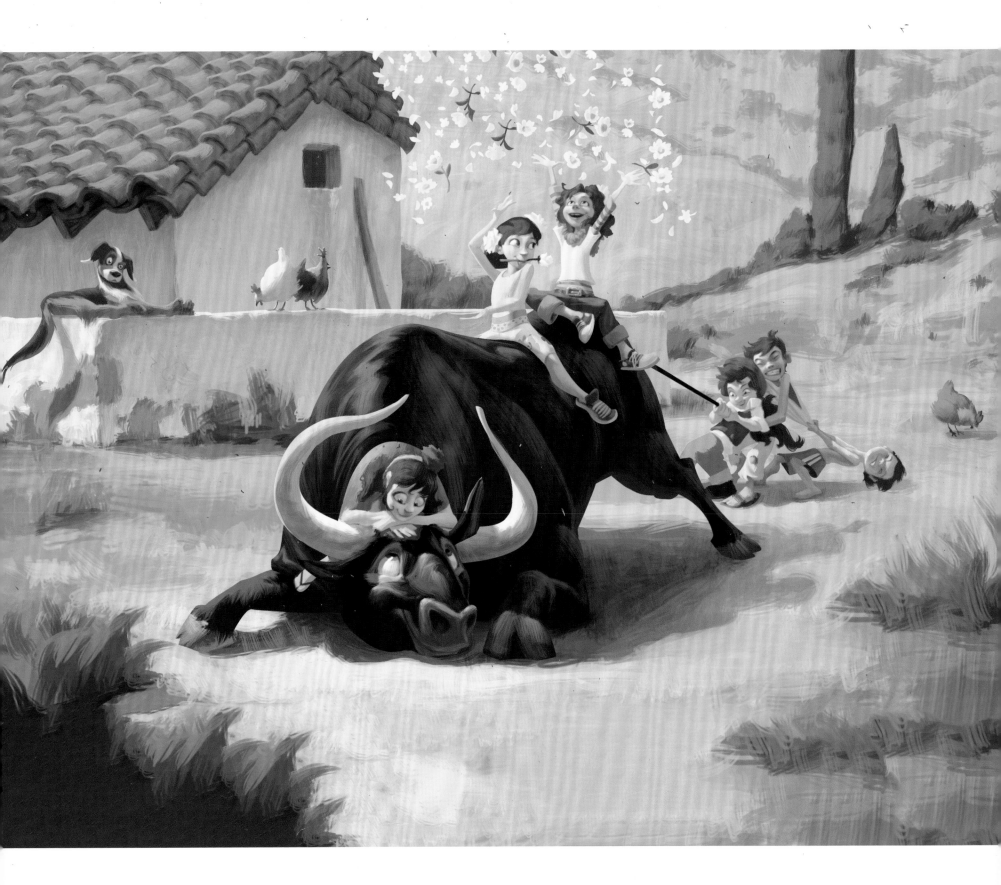

MORENO

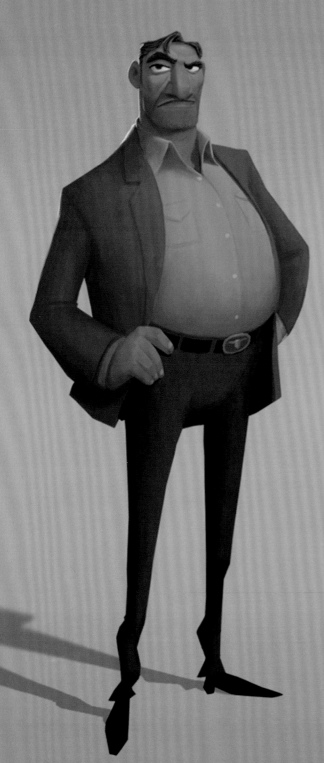

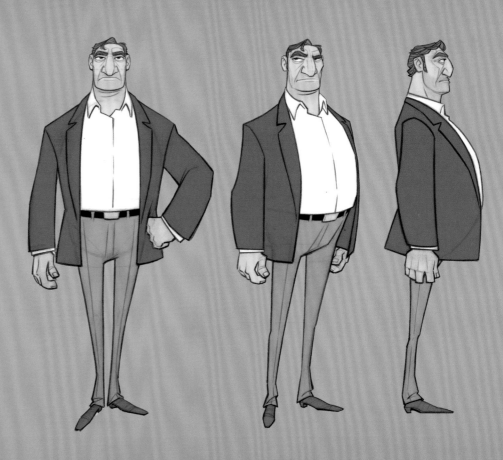

"In contrast to El Primero's lanky frame, fancy dress and flamboyant personality, Moreno was pitched to us as the strong businessman rancher. We knew these two would have many scenes together, so they had to compliment and contrast each other nicely in terms of their design."

Thomas Cardone, Production Designer

LEFT:
Moreno: Drawing by Jason Sadler, Painting by Mike Lee

ABOVE:
Moreno turnaround: by Jason Sadler

OPPOSITE TOP:
Moreno: Shape study by Jason Sadler

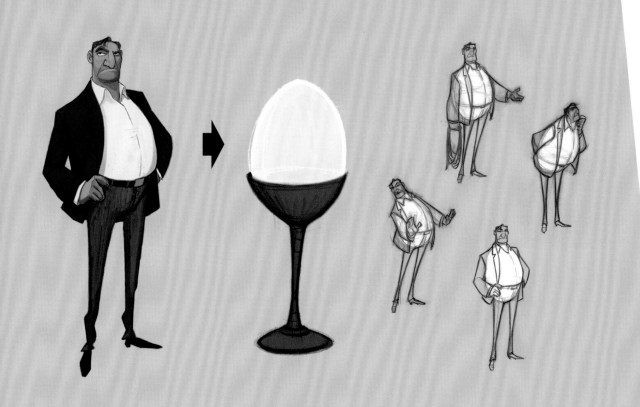

"When designing Moreno, we visualized his torso as a sort of egg cup teetering around on comparatively thin legs in tight jeans. It was a fun silhouette to draw and pose out. In terms of facial structure, he was built almost entirely with blocky, rectangular shapes to convey his stubborn resolve to cling to his deeply set values and code of conduct, but we also made sure to design his features so they could soften and express compassion."

Jason Sadler, Character Designer

BELOW:
Moreno early concepts: Digital paintings by Sergio Pablos

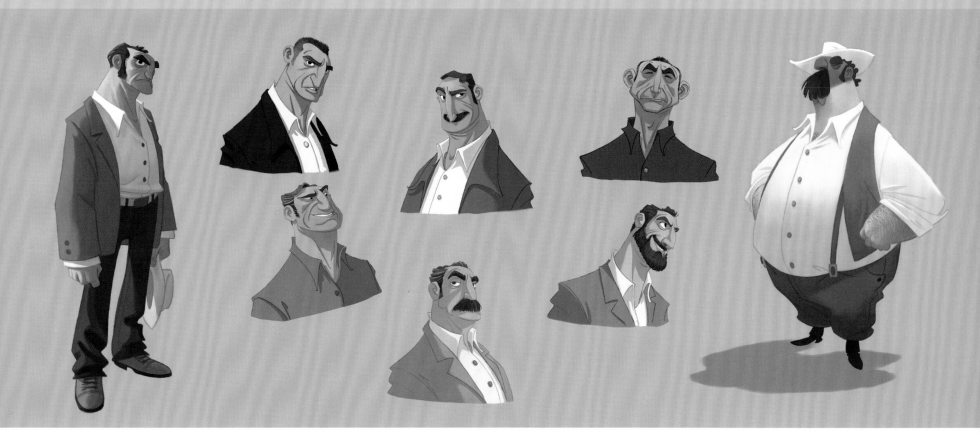

LUPE

"The first Lupe designs were from Sergio Pablos. We have worked with him before on the *Rio* films. He gave us a broad first pass with about 30 rough ideas for goats. They were all great, but there was one drawing that really stood out to us. While she was developed further from there, if you look back at it now, the essence of that character was there from the beginning."

Carlos Saldanha, Director

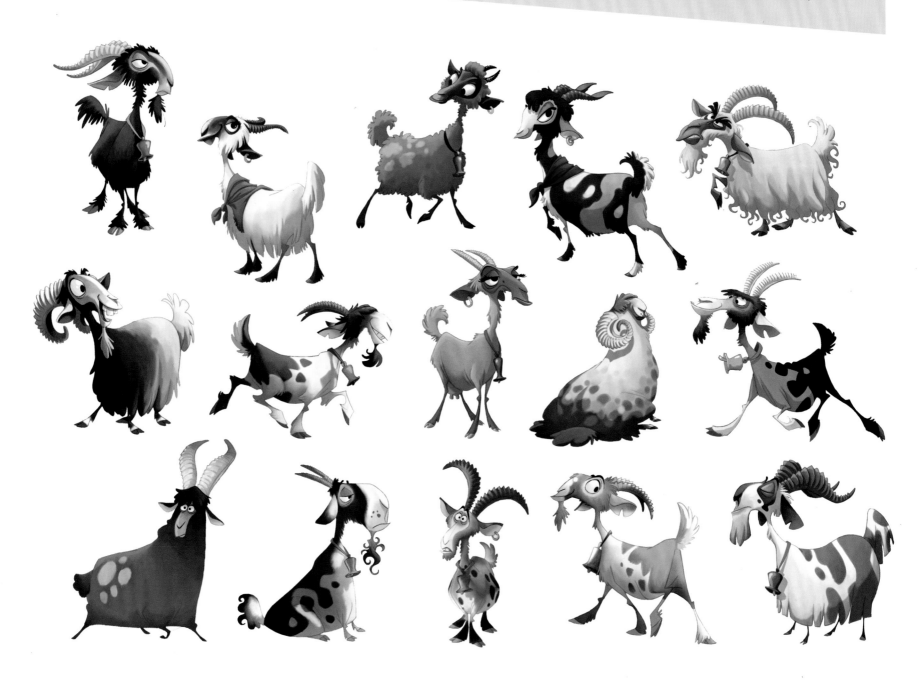

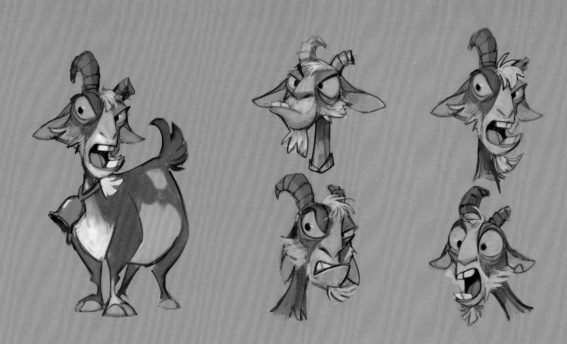

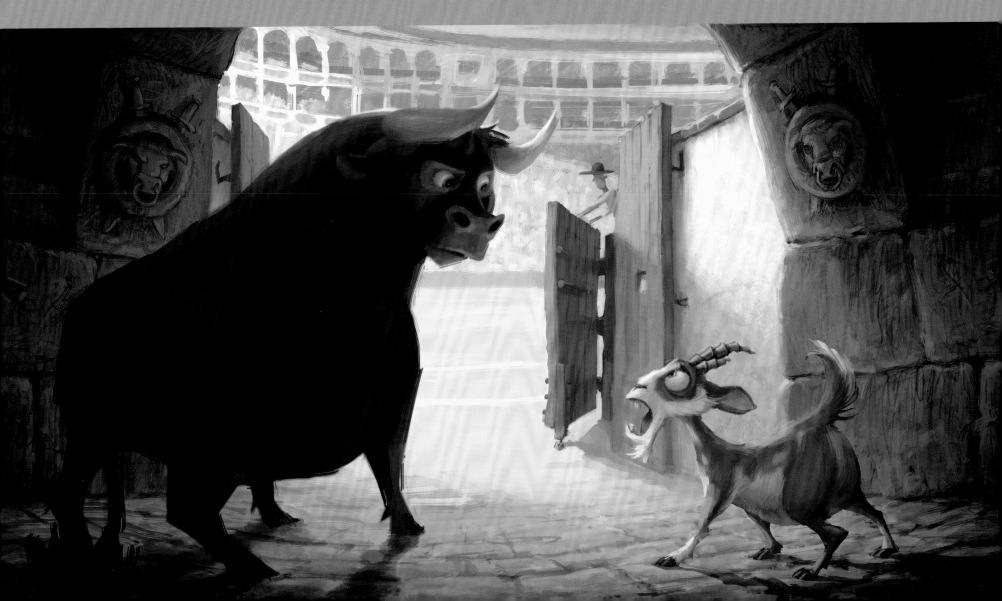

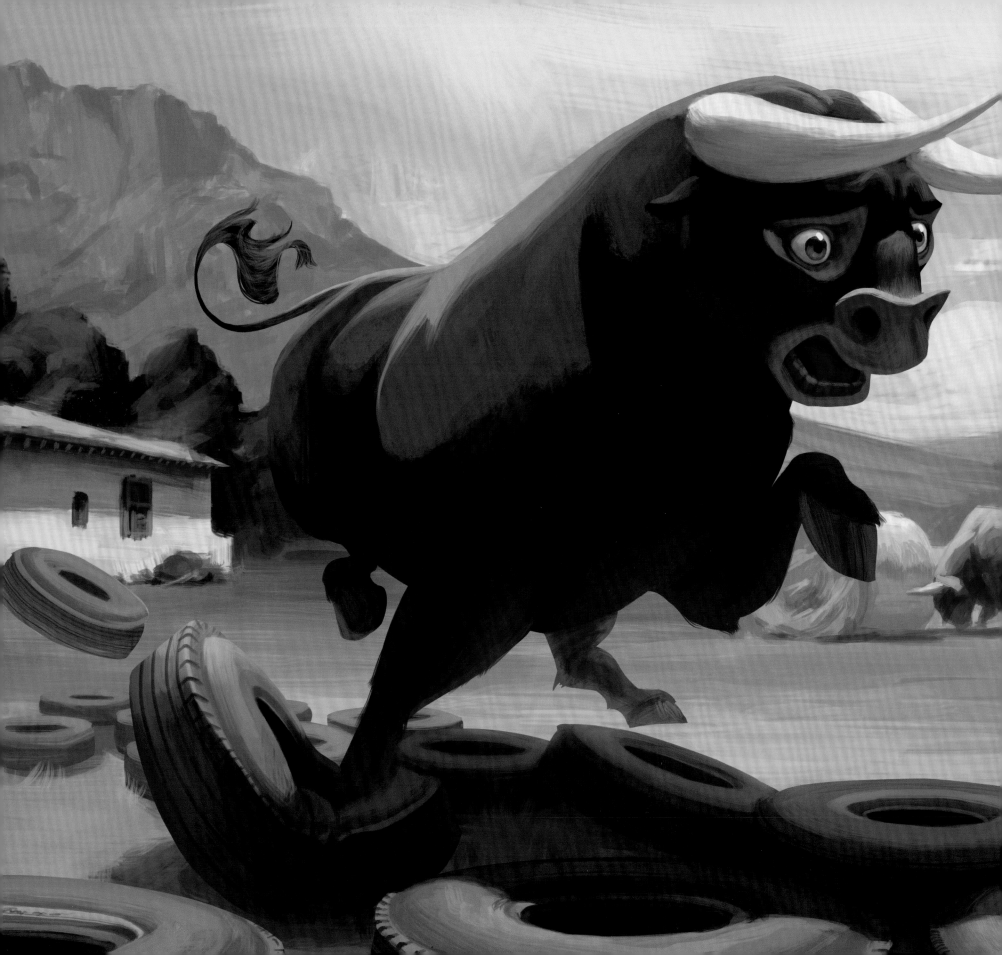

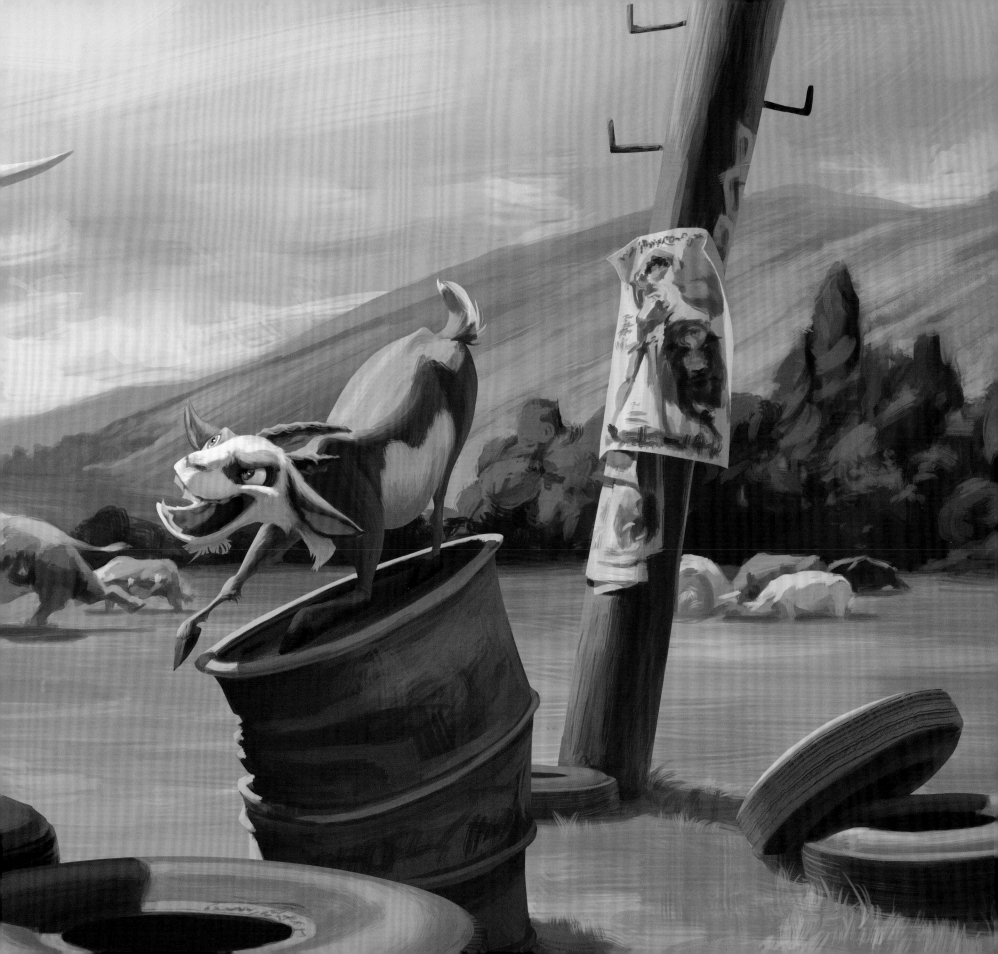

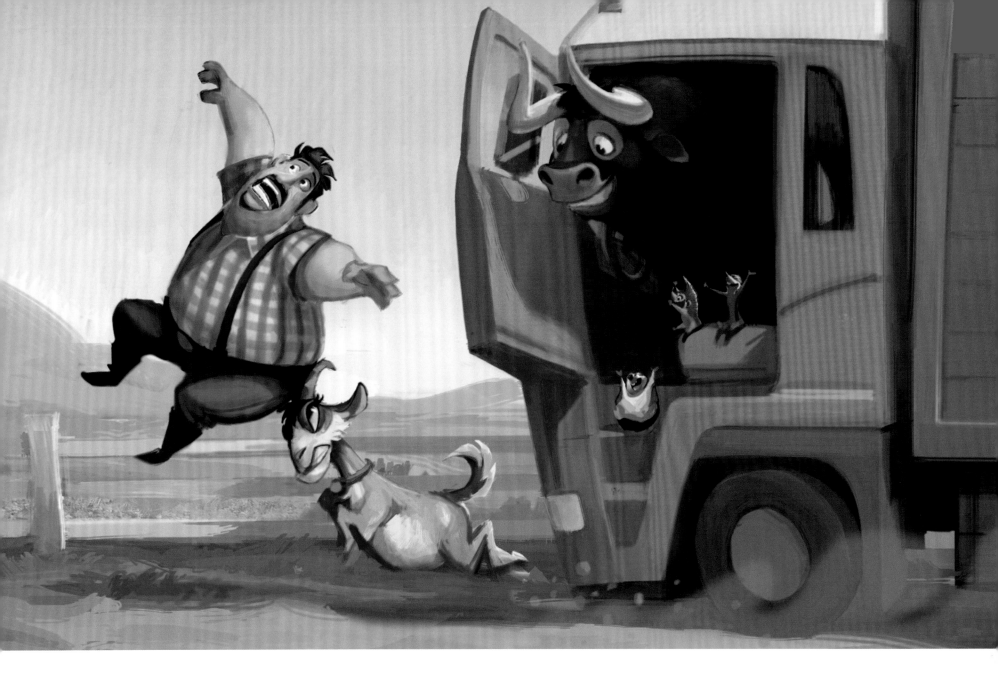

ABOVE:
Early concept art of Lupe leading the escape: Digital Painting by Sang Jun Lee

LEFT:
Lupe expressions: Drawings by Sang Jun Lee

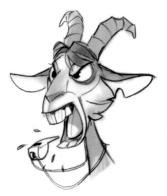
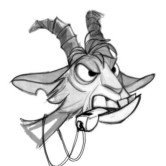
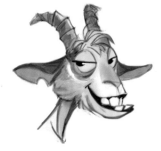

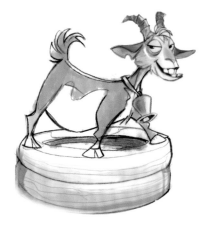

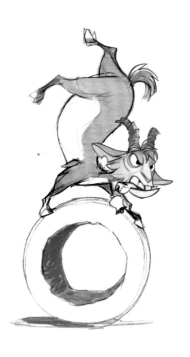

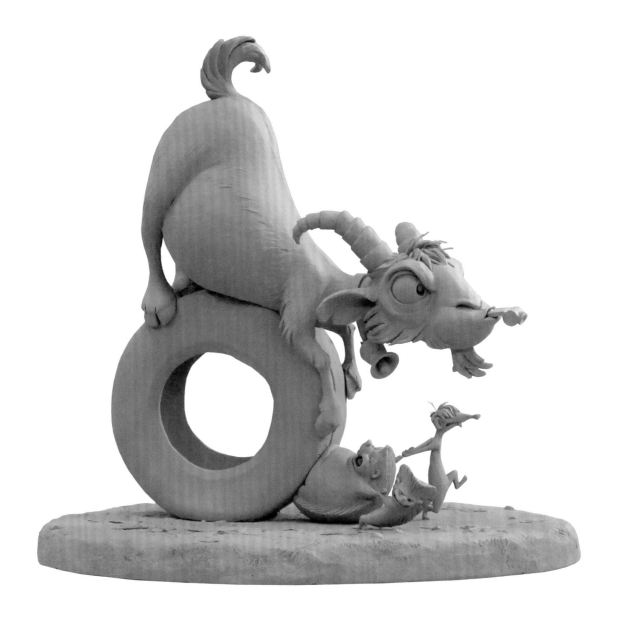

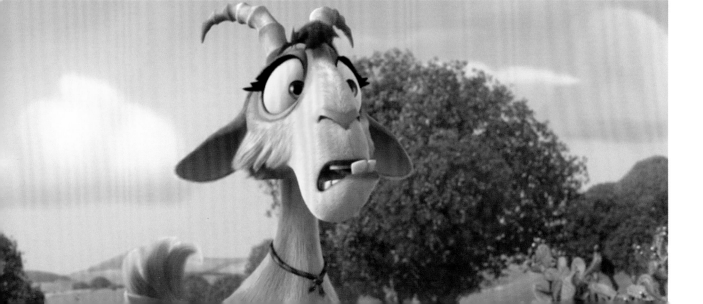

ABOVE LEFT:
Lupe: Physical sculpt by Vicki Saulls

ABOVE:
Lupe concepts: Drawings by Sang Jun Lee

LEFT:
Lupe: Final digital art

UNA, DOS, CUATRO

Serving as Casa del Toro's barnyard scroungers, the hedgehogs become valuable friends and allies to Ferdinand.

"The hedgehogs are cute and very savvy," production designer Cardone explains. "They have wild personalities and that, combined with their small scale and natural physical traits, brings an opportunity for a broad range of comedy."

RIGHT:
Hedgehogs: Color callout by Mike Lee

BELOW:
The hedgehogs take the wheel: Drawing by Dan Seddon, Painting by David Dibble

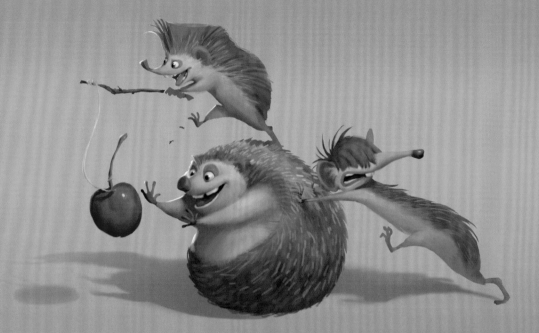

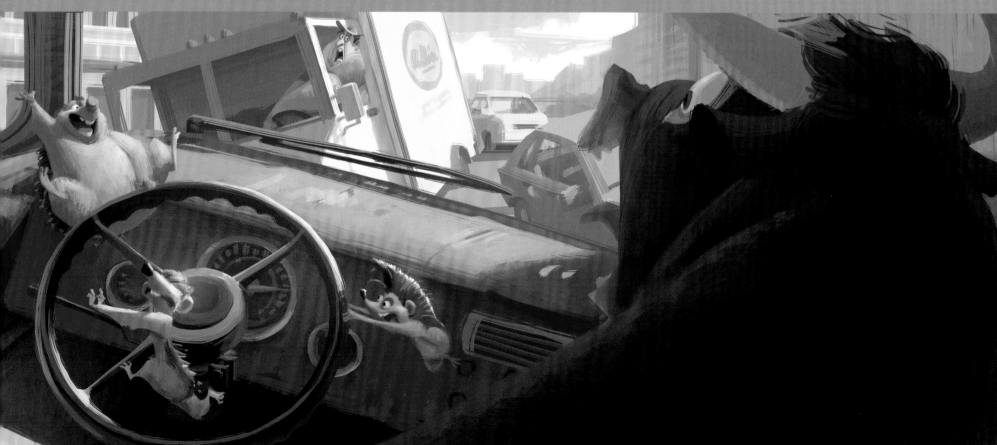

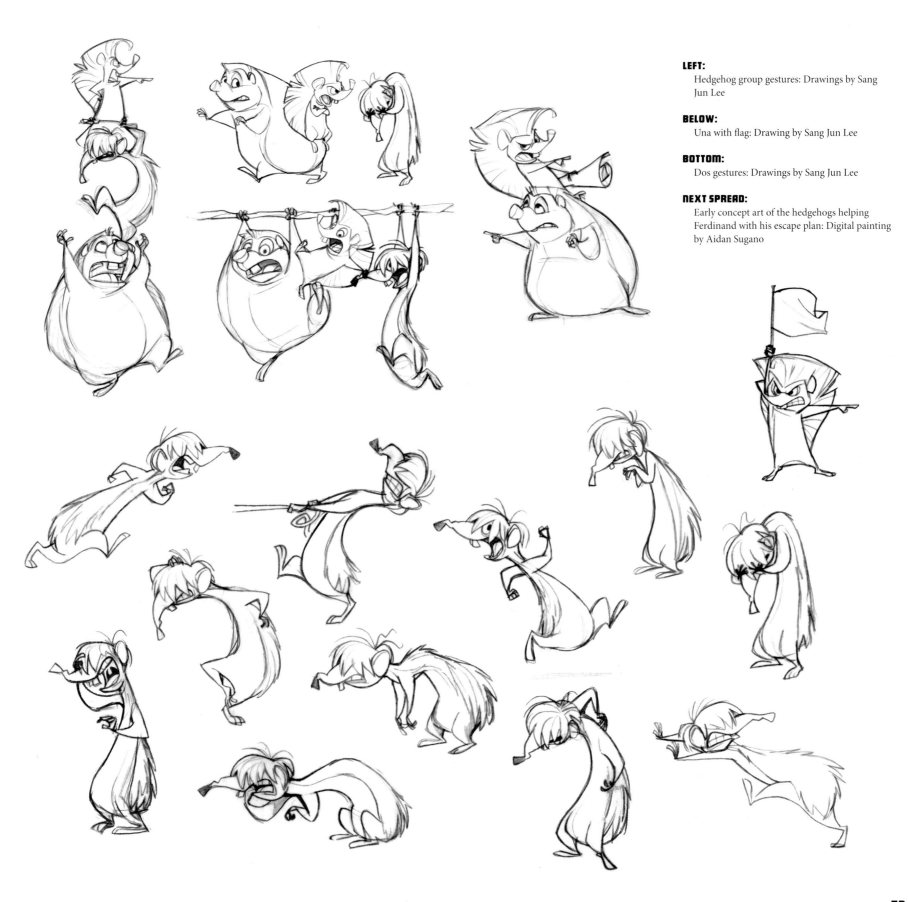

LEFT:
Hedgehog group gestures: Drawings by Sang Jun Lee

BELOW:
Una with flag: Drawing by Sang Jun Lee

BOTTOM:
Dos gestures: Drawings by Sang Jun Lee

NEXT SPREAD:
Early concept art of the hedgehogs helping Ferdinand with his escape plan: Digital painting by Aidan Sugano

"Una is the leader of the trio. Dos and Cuatro are more the comic relief characters. They aren't as clever, so they often get themselves into trouble, which Una has to get them out of. That dynamic was key for me in creating a triangle shape for Una, who is always pointing; she's proactive and moves forward. She's got more sharpness to her features and her hair is more pointy. The round shape is for Cuatro, who loves to eat food – instead of doing anything else! Dos is more rectangular. When I pitched to Carlos that Una is the leader, I pitched Dos as a character whose emotions are directly expressed in his face and gestures. He's easily excited. A hedgehog's natural inclination is to ball up when it is in danger, so when Una orders him to do something, Dos's reaction to roll up and go is explosive."

Sang Jun Lee, Lead Character Designer

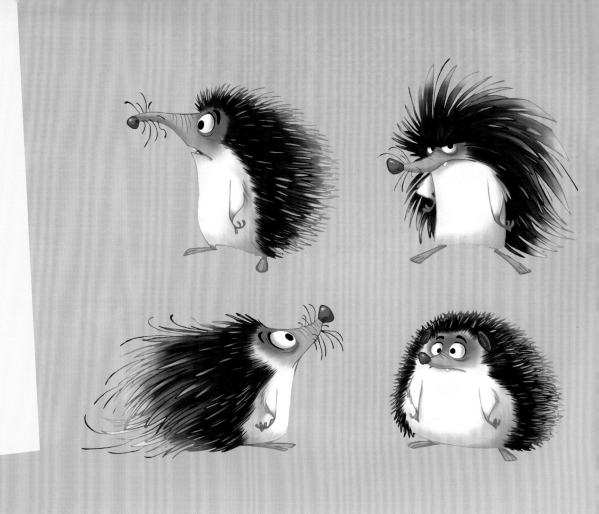

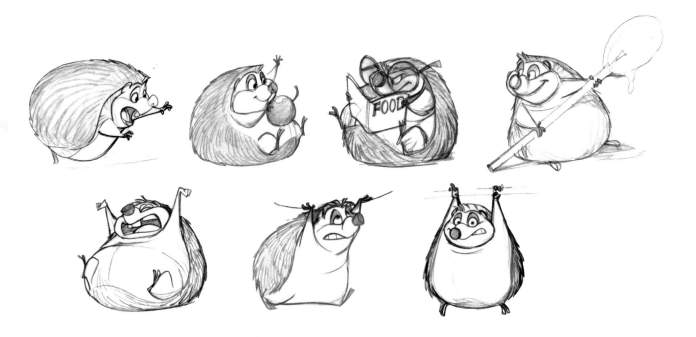

ABOVE:
Hedgehog early concepts: Digital paintings by Sergio Pablos

LEFT:
Cuatro gestures: Drawings by Sang Jun Lee

OPPOSITE TOP:
Hedgehog group gestures: Drawings by Sang Jun Lee

FAR RIGHT:
Una gestures: Drawings by Sang Jun Lee

RIGHT:
Una, Dos and Cuatro: Physical sculpt by Alena Tottle

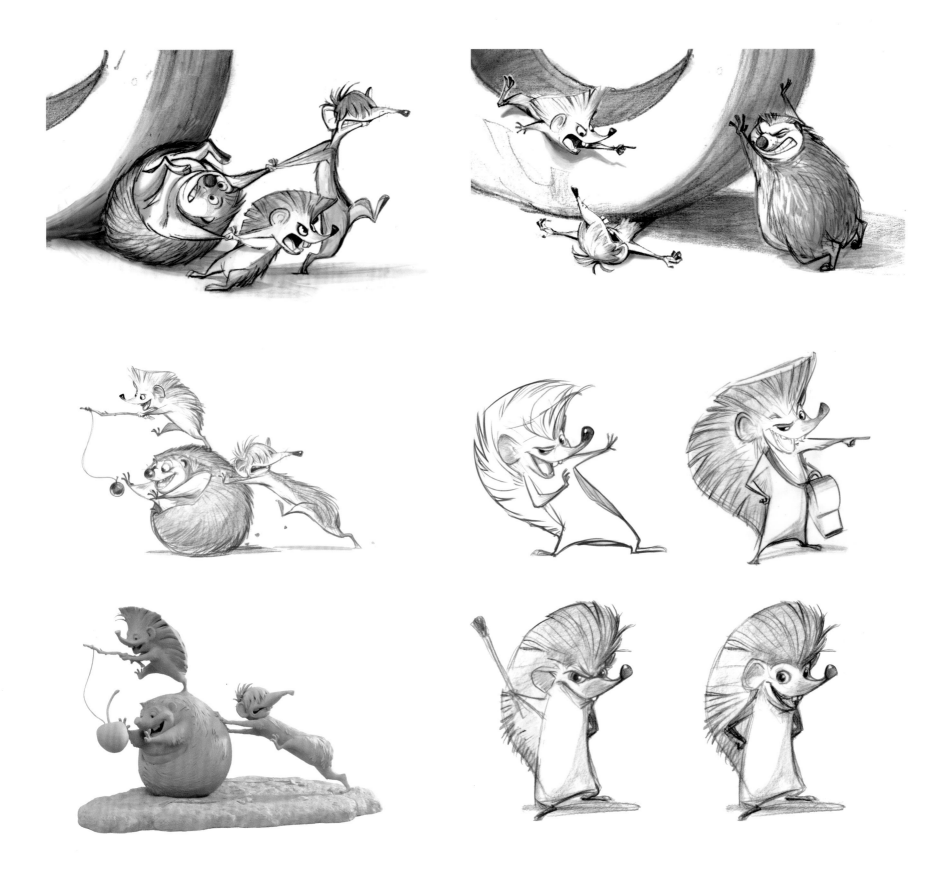

PACO

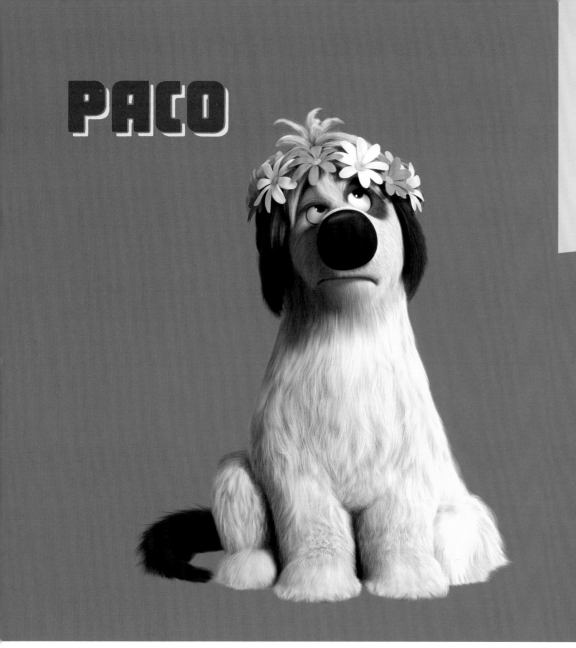

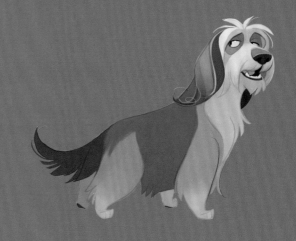

"Paco, a Catalan sheepdog, is Ferdinand's friend and his reality check, in a way. He's supposed to be 'herding' him, or trying to keep him in line, but ends up getting pulled into Ferdinand's adventures."

Thomas Cardone, Production Designer

LEFT:
Paco: Final digital art

BELOW:
Paco early concept: Digital painting by José Manuel Fernández Oli

BOTTOM:
Paco concepts: Drawings by Sang Jun Lee

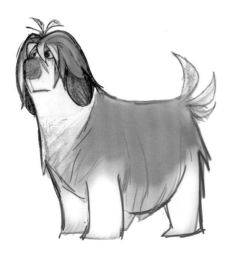

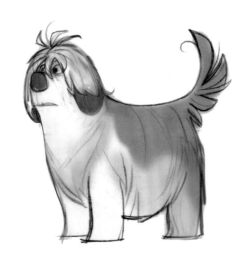

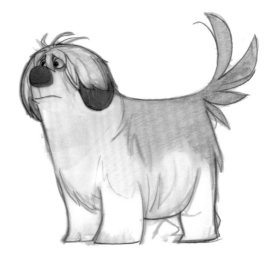

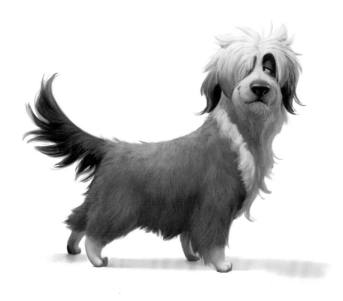

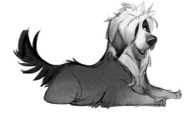

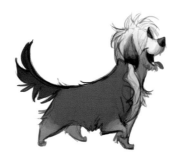

"Carlos wanted to have a lazy sheepdog who knows everything about the farm. We had several early designs, but settled on a more simplified idea. We used this thick coat to create a whole body silhouette formed with one line, like Ferdinand."

Sang Jun Lee, Lead Character Designer

LEFT:
Paco early concept: Digital paintings by José Manuel Fernández Oli

BELOW LEFT:
Paco turnaround and gestures: Drawings by Sang Jun Lee

BELOW:
Paco: Color callout by Mike Lee over digital model

HANS, KLAUS, GRETA

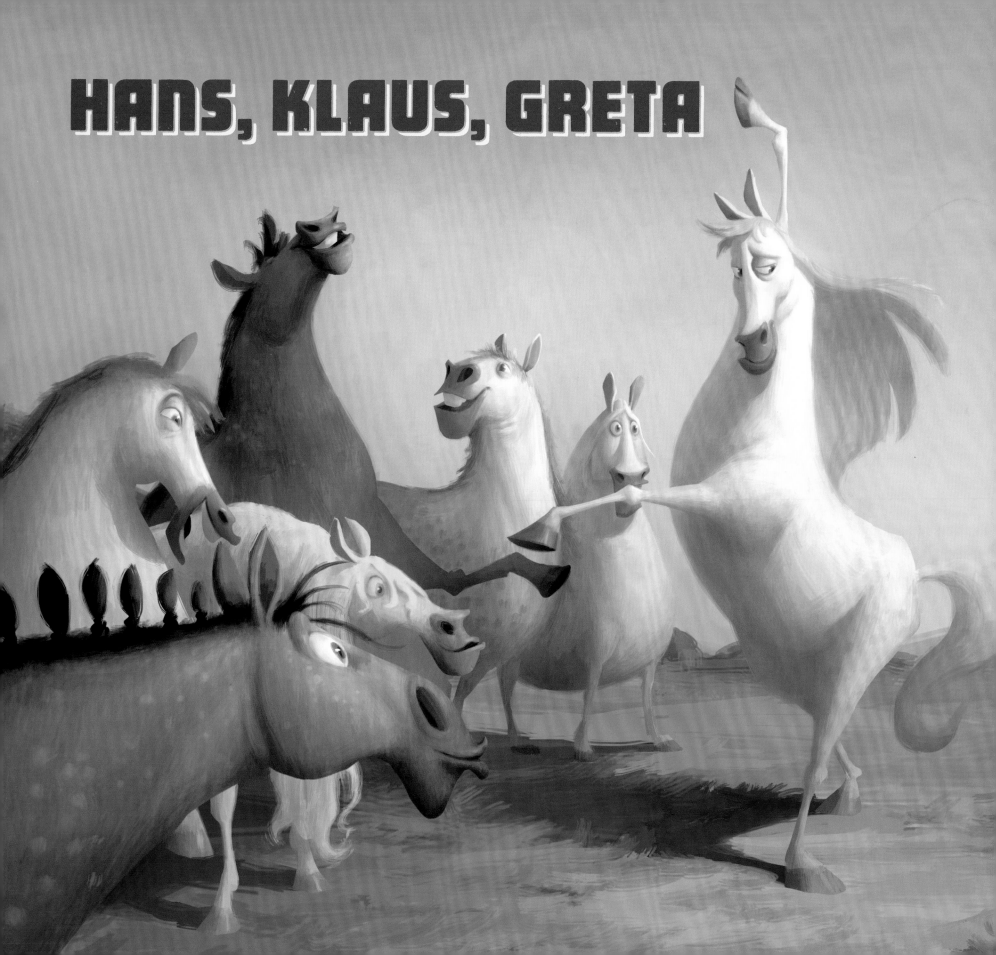

As well as the bulls being trained at the ranch, the grounds are also home to a trio of haughty Lipizzaner horses who are used during the majestic opening ceremony filled with pomp and circumstance at the arena in Madrid.

"You see the horses come in and the pageantry is very intense," says Saldanha. "I wanted some of the characters to embody a little bit of that pompous presence, which is how they came about in the film.

They are also good comedic adversaries for the bulls. They are bred to be beautiful, talented, and graceful, as opposed to the bulls, who are bred to be brutes. So we have the 'beauties' and we have the 'beasts.'"

THIS SPREAD:
The horses and the bulls have a danceoff: Drawing by Dan Seddon, Painting by Mike Lee

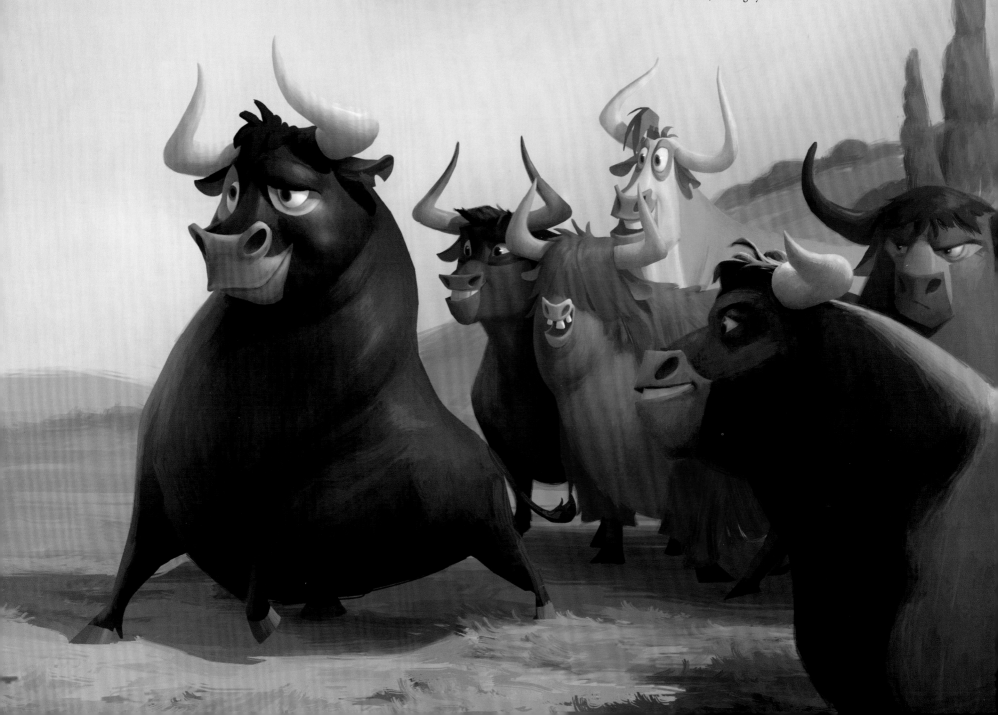

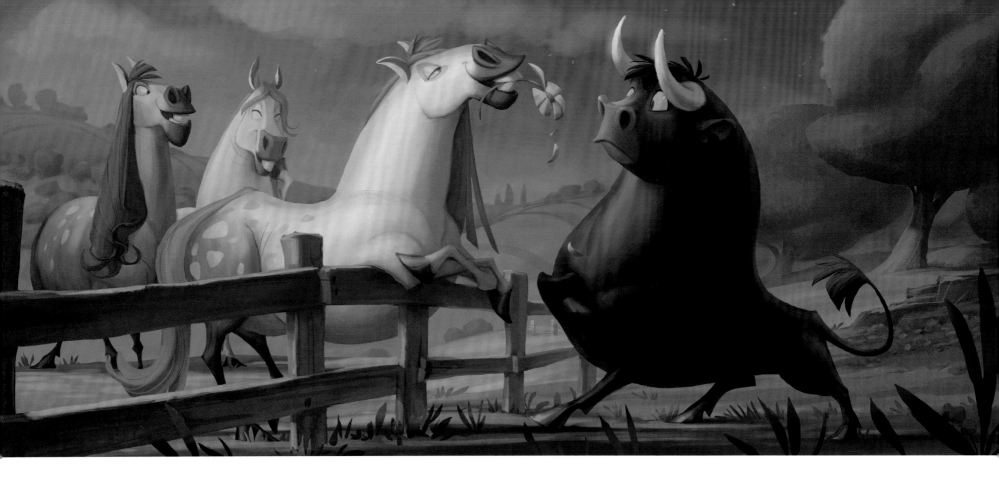

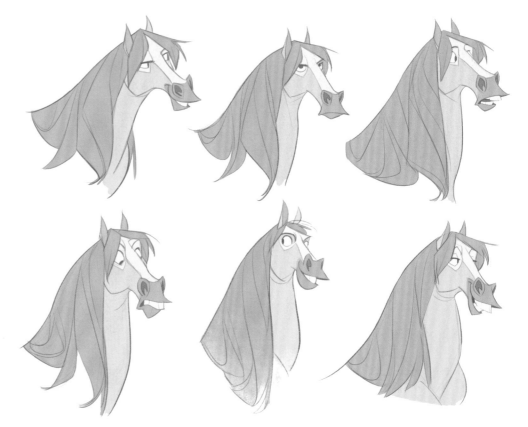

TOP:
 Ferdinand meets the horses: Drawing by José Manuel Fernández Oli,
 Painting by Ron DeFelice

ABOVE & RIGHT:
 Horse gesture and expressions: Drawings by José Manuel Fernández
 Oli

OPPOSITE:
 Horse early concepts: Digital paintings by Sergio Pablos

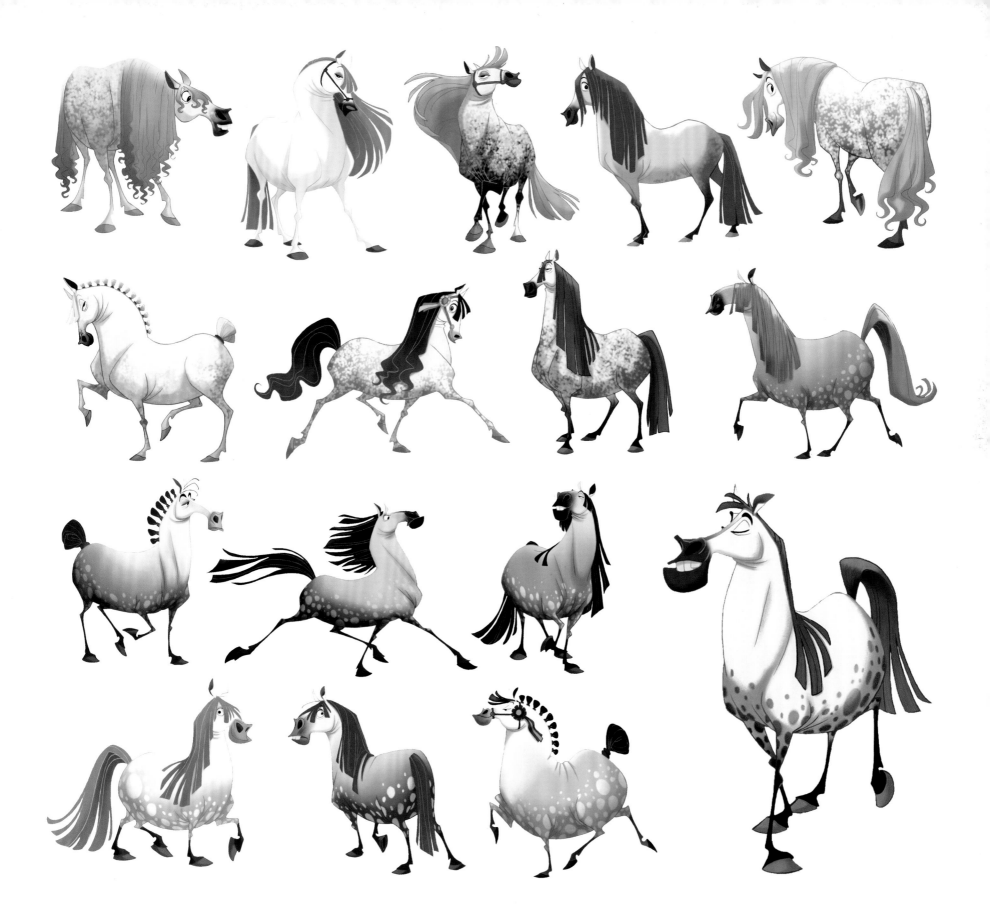

EL PRIMERO

LEFT:
El Primero final concept: Digital painting by Sang Jun Lee

BELOW:
El Primero head turnaround: Drawings by Sang Jun Lee

BOTTOM:
El Primero concepts: Digital paintings by Sergio Pablos

"Sergio Pablos did initial design work on El Primero and set the tone for the look of the characters. Sang Jun Lee then carried that treatment forward and further developed it. He made a deliberate decision to call attention to and emphasize the harsh intersections between the basic shapes in heads and bodies, rather than smoothing them over."

Jason Sadler, Character Designer

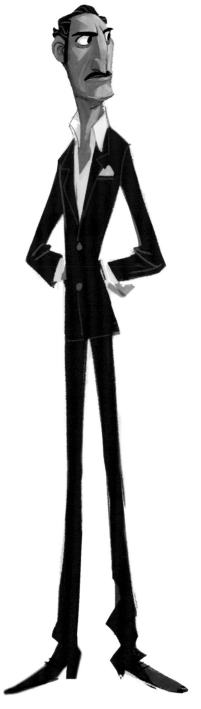

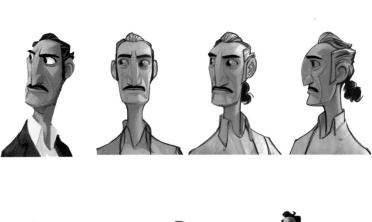

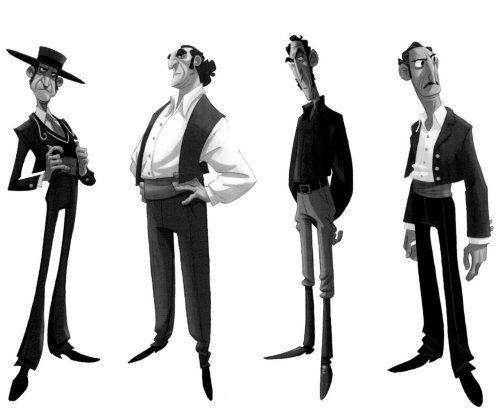

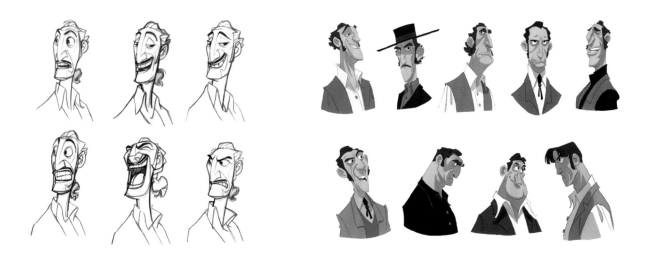

FAR LEFT:

El Primero expressions: Drawings by Sang Jun Lee

LEFT:

El Primero early concepts: Drawings by Sergio Pablos

BELOW:

El Primero makes his entrance: Final digital art

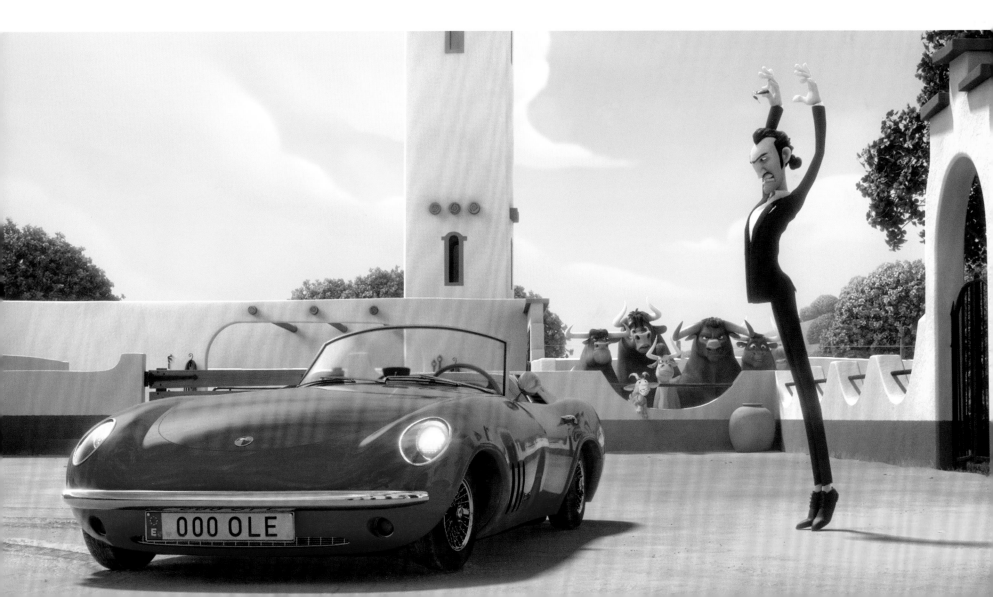

"We looked at a lot of matador reference and took stock of the traits that interested us the most. We also analyzed the way matadors move and how the cape is an extension of the arm. We wanted that flow in our character."

Carlos Saldanha, Director

RIGHT:
El Primero movement studies: Drawings by Sang Jun Lee

BELOW:
El Primero poses: Poses by Patrick Puhala, Drawn over by Sang Jun Lee

OPPOSITE TOP LEFT:
El Primero: Drawings by Sang Jun Lee

OPPOSITE BOTTOM LEFT:
El Primero early concepts: Digital paintings by Sergio Pablos

OPPOSITE RIGHT:
El Primero: Drawing by Sang Jun Lee, Painting by Mike Lee

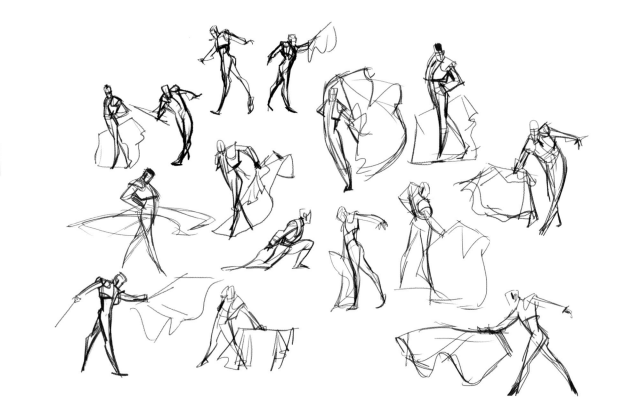

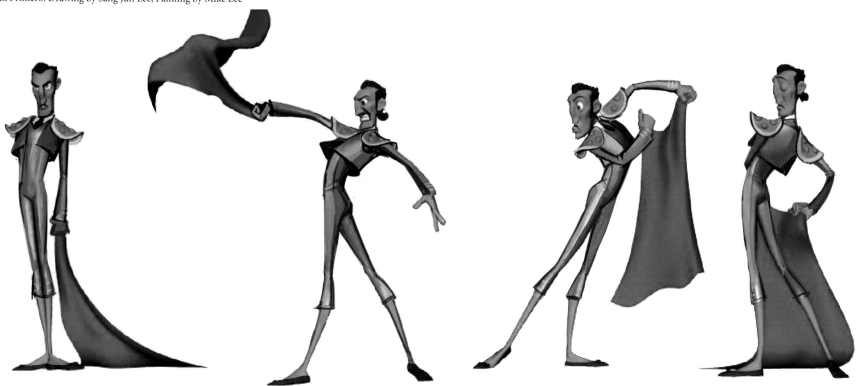

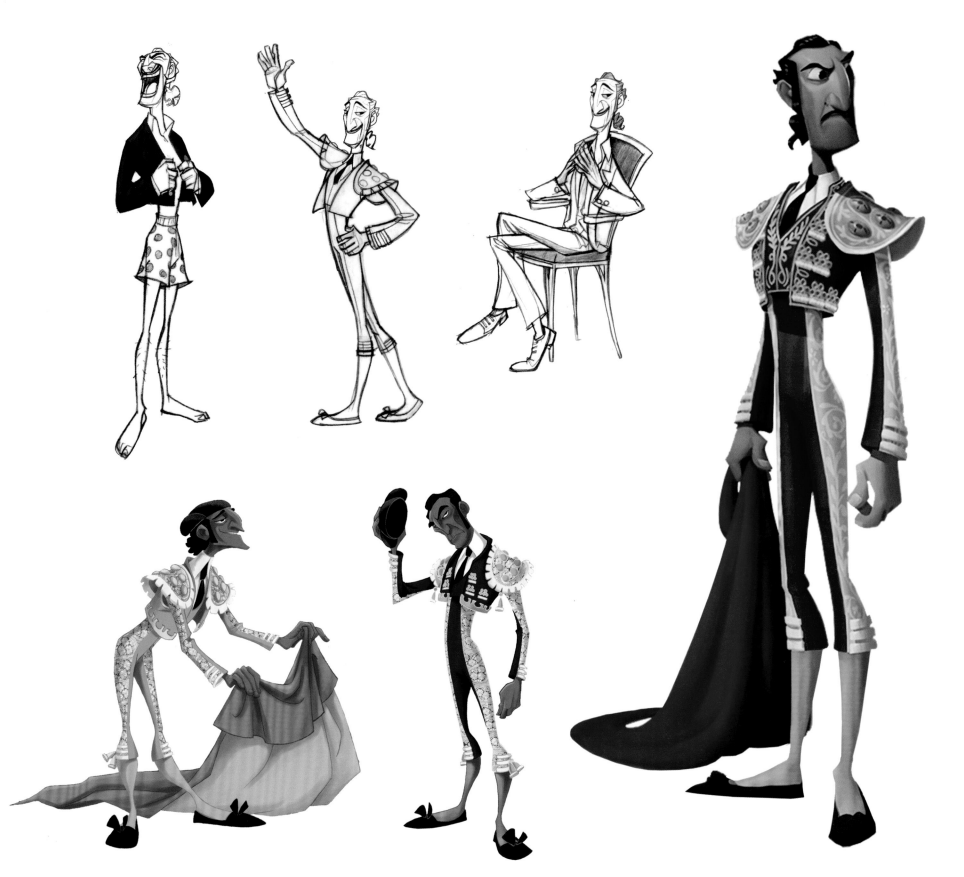

EL PRIMERO & FERDINAND

INTERACTION & MOVEMENT

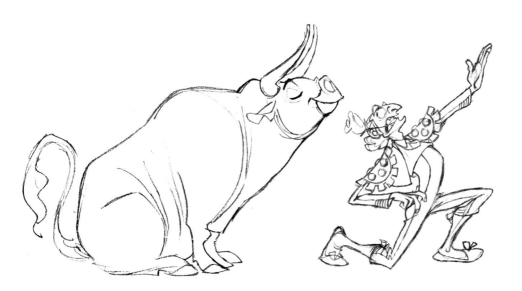

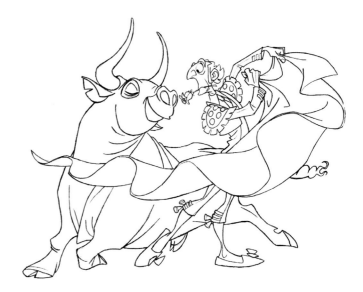

"El Primero and Ferdinand set the building blocks for our style. While the inspiration for Ferdinand came from the rolling hills of the countryside, El Primero was to represent the opposite of that. He is like a wall. Studying the physique of matadors, they are often thin and strike theatrical or exaggerated and dramatic poses. Drawing on all these things, we decided to make El Primero extremely tall and thin in contrast to Ferdinand's large, rounded mass. Stretching El Primero's height then dictated the height of all our humans, which in turn affected the architecture and surroundings."

Thomas Cardone, Production Designer

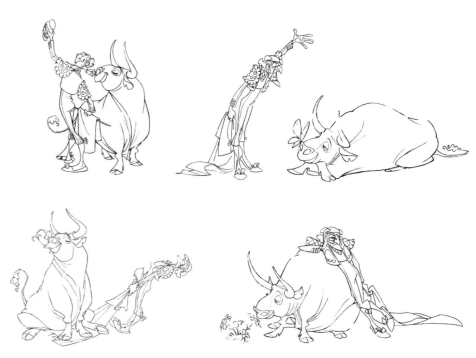

THIS SPREAD:
Ferdinand and El Primero movement studies: Drawings by
Jorge A. Capote

BOTTOM:
Ferdinand and El Primero face each other in the arena:
Drawing by Sang Jun Lee, Painting by Mike Lee

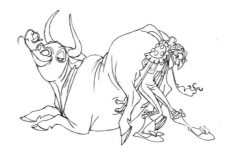

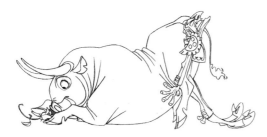

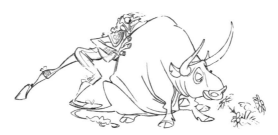

"Our lead character designer, Sang Jun Lee, studied the movement between a matador and a bull. Obviously, the movement of one affects the other. Jun discovered a rhythm between the two, and identified it over and over again in his reference. This inspired the animation."

Thomas Cardone, Production Designer

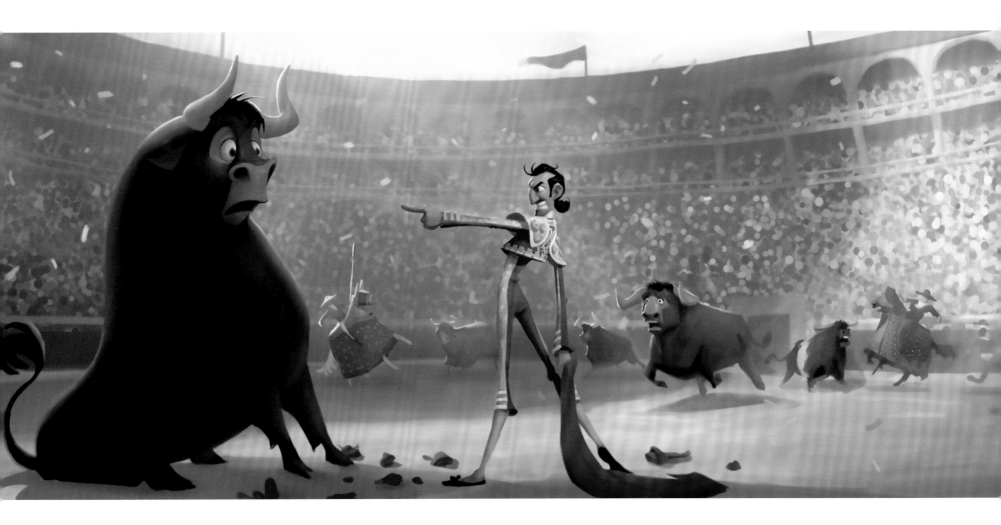

SHAPE LANGUAGE

Early in the development phase of the film, Tom Cardone, Jason Sadler, Arden Chan, Sang Jun Lee, David Dibble, and Andrew Hickson created a production style guide based on what they discovered in the initial design development process. "On a production the size of *Ferdinand*, with so many individual artists eventually working on the film, establishing guidelines for everyone to follow is critical to achieving a uniform aesthetic," Cardone explains. "We locked down Ferdinand's design first, he's the main character. He's a large black shape who dominates the composition when he's on screen. For that reason he had to have a really beautiful silhouette at all times. We were looking to exploit different contrasts in this film to enhance the storytelling through design. So, with Ferdinand, Sang Jun decided that he was going to echo the rhythmic, flowing hills of his natural environment with his silhouette.

"In contrast to that, the matador El Primero

BELOW & RIGHT:
Production style guide pages: by Jason Sadler

BOTTOM RIGHT:
Casa del Toro concept: Drawing by Jason Sadler

NEXT SPREAD:
Juan and Paco at the farm house: Final digital art

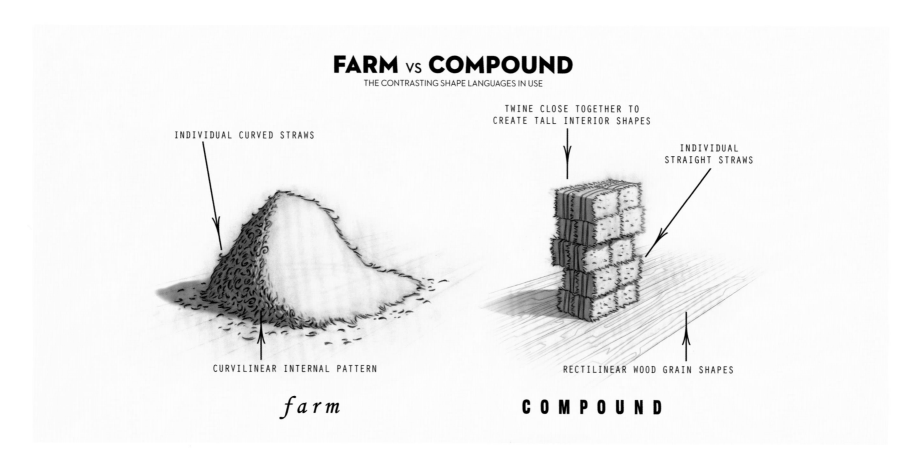

FARM vs COMPOUND
THE CONTRASTING SHAPE LANGUAGES IN USE

TWINE CLOSE TOGETHER TO
CREATE TALL INTERIOR SHAPES

INDIVIDUAL CURVED STRAWS

INDIVIDUAL
STRAIGHT STRAWS

CURVILINEAR INTERNAL PATTERN

RECTILINEAR WOOD GRAIN SHAPES

farm

COMPOUND

DESIGN THEME
OF THE OVERALL STORY

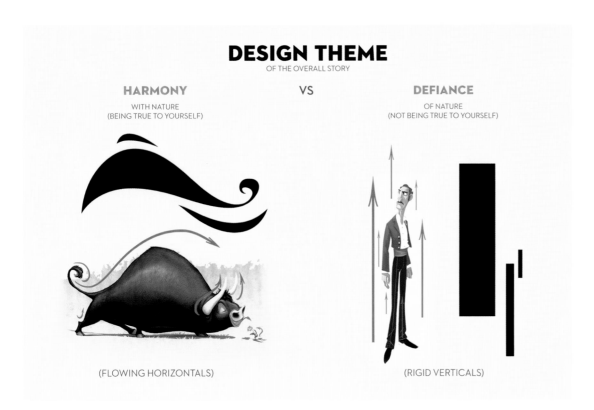

HARMONY
WITH NATURE
(BEING TRUE TO YOURSELF)

VS

DEFIANCE
OF NATURE
(NOT BEING TRUE TO YOURSELF)

(FLOWING HORIZONTALS)

(RIGID VERTICALS)

> "If Ferdinand's flowing silhouette represents harmony with nature, then El Primero's tall vertical stance is like a wall for that to come up against. Harmony personified by Ferdinand versus defiance personified by El Primero creates a shape language that serves as the creative spine to the film's design."
>
> *Jason Sadler, Character Designer*

is vertical and straight. Jason Sadler defined it beautifully in the style guide as Harmony vs. Defiance. This was the starting point for everything else," Cardone recalls. "If your humans have long skinny legs like El Primero, then chairs have to be taller and the windows have to be higher on the walls, so the buildings get a little taller and skinnier, too. If you put one of those characters in a car, then the roof has to be higher, but you don't want the car to be too big, so you make the wheels tiny. Eventually everything takes on this caricature that you begin to identify and you push it further. The style is born out of a philosophy dictated by the needs of the story."

With that proportional language set in stone, Cardone says their rules expanded. "We tried to add cubist elements to the set designs. There are no parallel planes, which gives a handmade, graphic look to things. That in turn pushes it away from reality and makes everything more interesting."

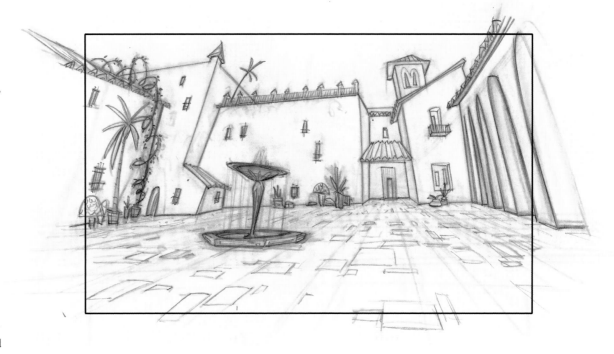

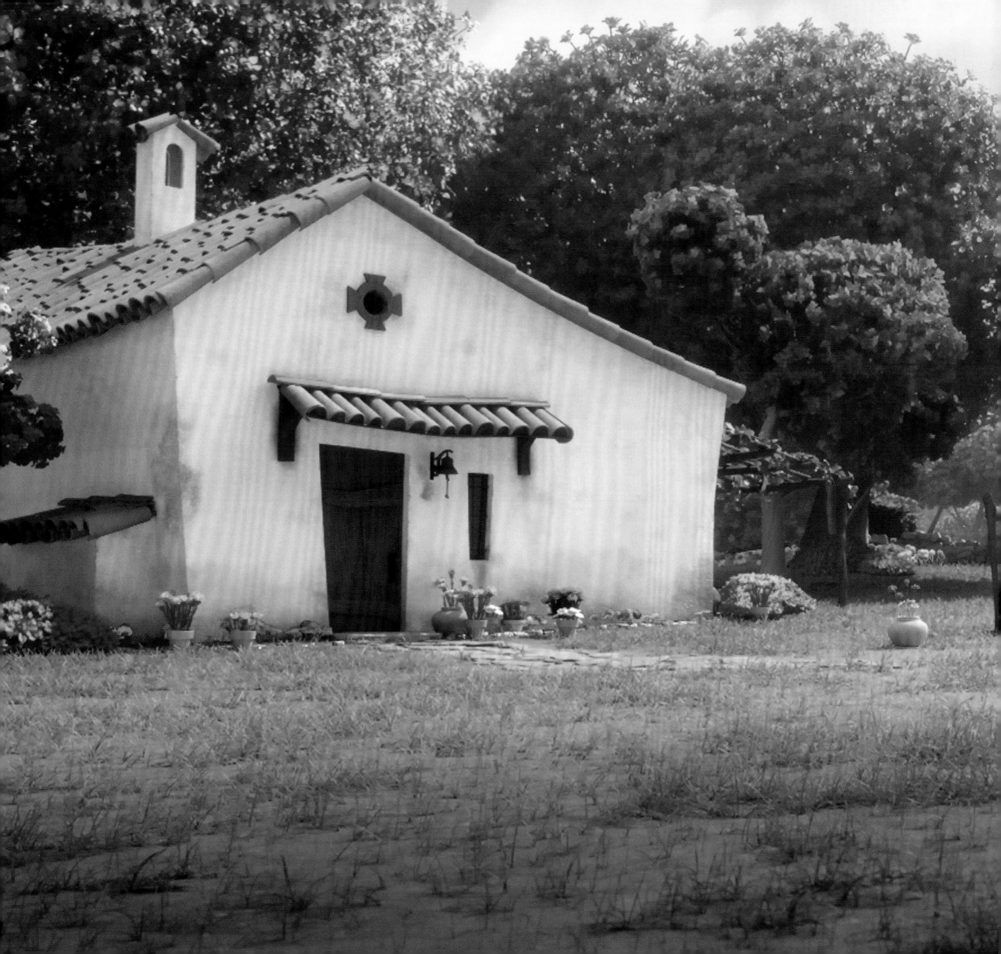

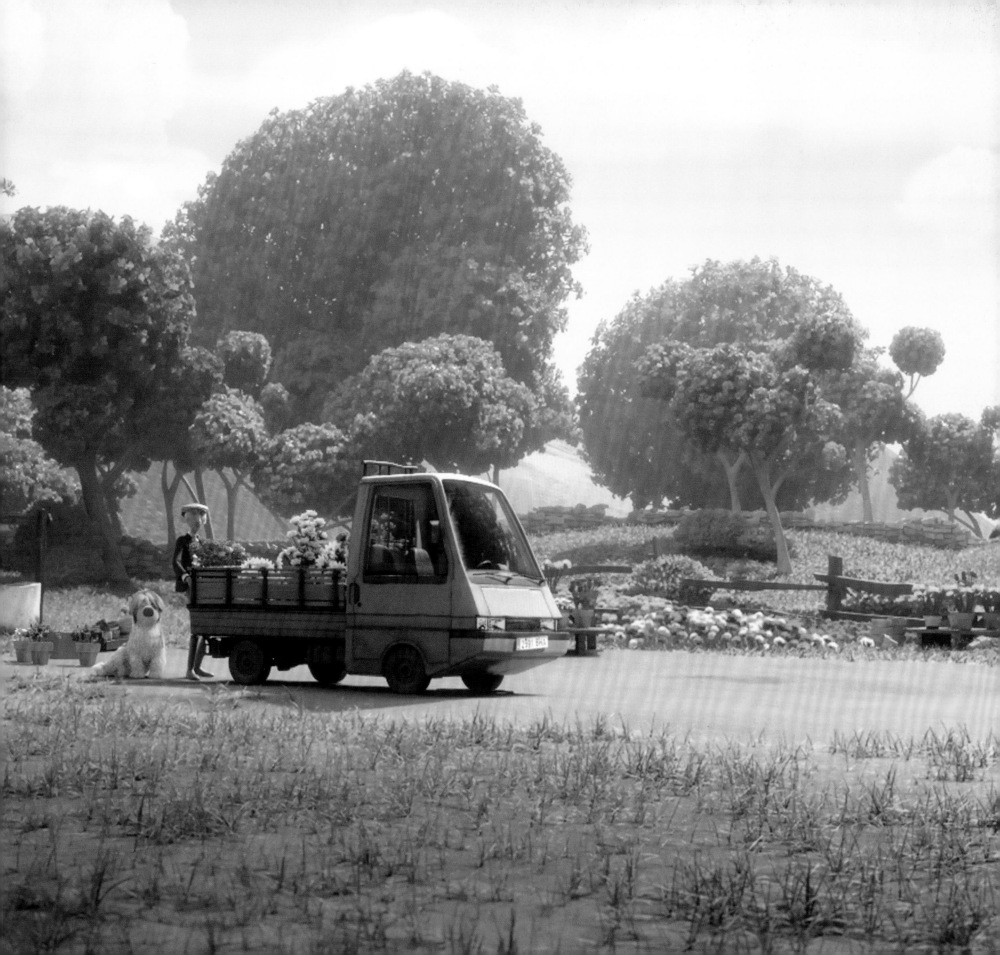

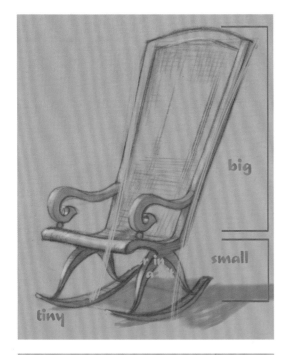

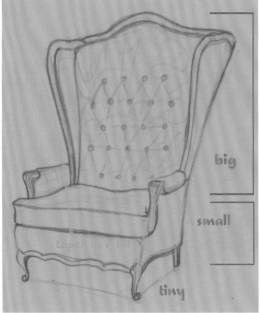

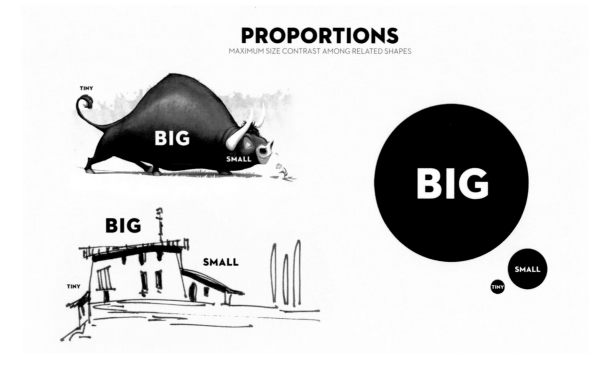

PROPORTIONS

MAXIMUM SIZE CONTRAST AMONG RELATED SHAPES

TINY

BIG

SMALL

BIG

SMALL

BIG

TINY

BIG

SMALL

TINY

TOP RIGHT & OPPOSITE TOP:
Production style guide pages: by Jason Sadler

ABOVE & RIGHT:
Showing how the "proportions" concept applies to production design: Drawings by Arden Chan

OPPOSITE BOTTOM:
Showing how the "detail : void" concept applies to costume design: Costume design by Sang Jun Lee, Pattern design by Robert MacKenzie, Material design by Diana Diriwaechter

DETAIL : VOID
THE RATIO OF POSITIVE TO NEGATIVE SPACE

- SMALL AREAS OF INTENSE DETAILSURROUNDED BY LARGE AREAS OF VOID

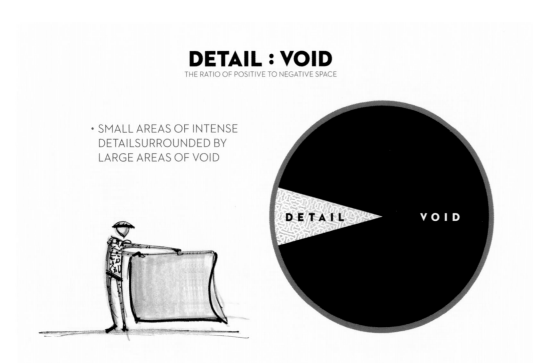

DETAIL > VOID

"While doing visual research on Andalusia we noticed many subjects with areas of incredibly intense detail surrounded by an immense amount of void. We saw this in the embroidery, the ironwork and the Moorish architecture, for example. My eyes loved swimming around those beautifully ornate areas, but they also needed that negative space to rest and breathe. It really felt like this particular proportion of detail to void permeated the region and Tom [Cardone] was intent on carrying that throughout the visual language of the film. It was another visual element that could be consciously and deliberately controlled."

Jason Sadler, Character Designer

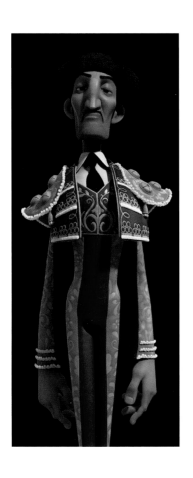

BACKGROUND CHARACTERS

"We created the look of our core humans using photo reference to identify certain attributes, like distinctive facial features, shapes, and skin tones. We played around with the caricature of these elements while also trying to represent the people of that region of southern Spain."

Carlos Saldanha, Director

RIGHT:
Ranch hands color callout: Designs by Jason Sadler and Annlyn Huang, Painting by Mike Lee

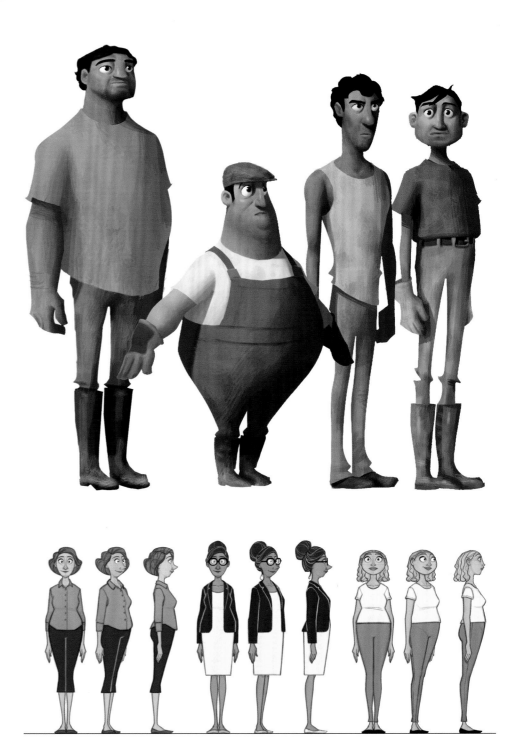

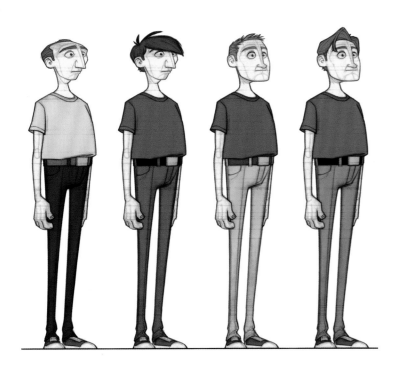

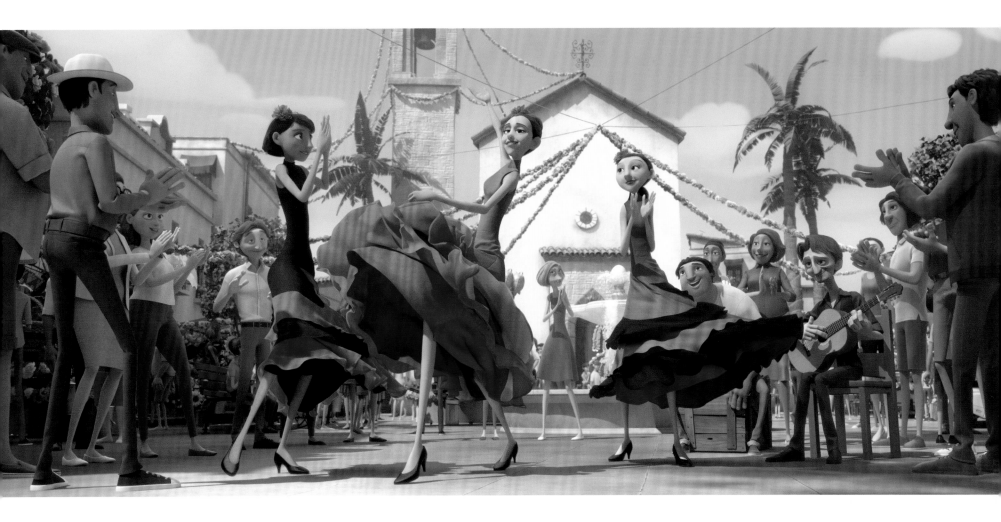

"I love working on background characters, because it's a true design dilemma. You're constantly balancing two opposing attributes. Each character needs to be distinct enough to warrant the resources devoted to creating it, but it also shouldn't call so much attention to itself so as to distract from the main characters."

Jason Sadler, Character Designer

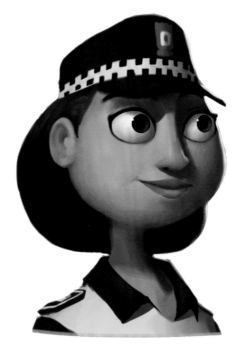

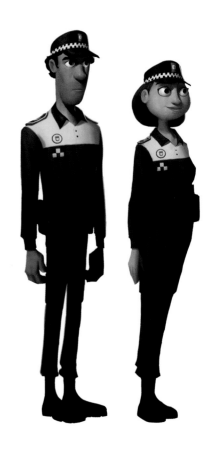

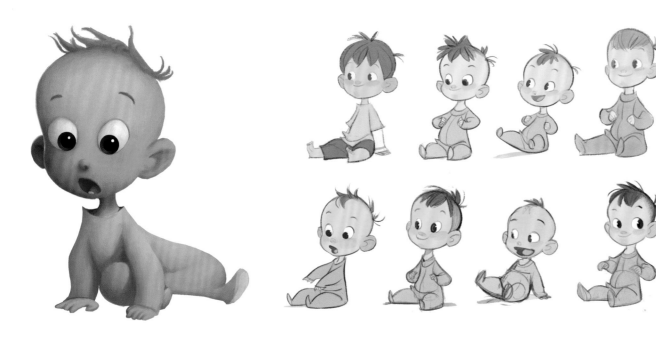

OPPOSITE TOP:
Police: Color callouts by Mike Lee over digital model

OPPOSITE BOTTOM:
Shopkeeper concepts: Drawings by Annlyn Huang

FAR LEFT:
Baby: Color callout by Mike Lee

LEFT:
Baby early concepts: Drawings by José Manuel Fernández Oli

BOTTOM LEFT:
Baby turnaround: by José Manuel Fernández Oli

BELOW:
Children concepts: Drawings by Jason Sadler

"We always look for variety and contrast in our human lineup. We start with the most basic shapes – a circle, a square, a triangle – as a theme for each body type, and work out from there. We have tall thin people, short round people and a few in between. More variation is gained from color and clothing. There's a delicate balance between making the background characters different enough from each other to make it interesting, and making them similar enough that they look like related elements of a group."

Thomas Cardone, Production Designer

THIS PAGE:
Background women concepts: Drawings by Annlyn Huang

OPPOSITE TOP:
Bee concepts: Drawings by José Manuel Fernández Oli

OPPOSITE BOTTOM:
Ferdinand and the bee: Digital painting by José Manuel Fernández Oli

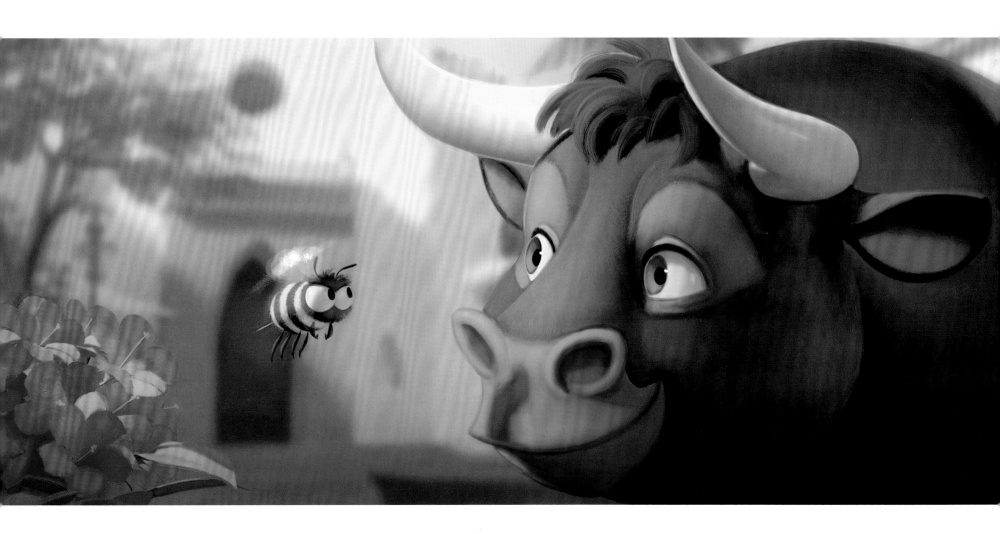

RIGHT:
 Budgerigar concepts: Drawings by José Manuel Fernández Oli

BELOW:
 Chick: Color callout by Mike Lee

BELOW RIGHT:
 Chick concepts: Drawings by José Manuel Fernández Oli

OPPOSITE TOP LEFT:
 Caterpillar concepts: Drawings by José Manuel Fernández Oli

OPPOSITE TOP RIGHT:
 Caterpillar concept: Drawing by José Manuel Fernández Oli, Painting by Ron DeFelice

OPPOSITE MIDDLE LEFT:
 Fish concepts: Drawings by Annlyn Huang

OPPOSITE MIDDLE RIGHT:
 Fish: Color callout by Mike Lee

OPPOSITE BOTTOM LEFT:
 Cockerel turnaround: by Jason Sadler

OPPOSITE BOTTOM RIGHT:
 Cockerel: Painting by Ron DeFelice

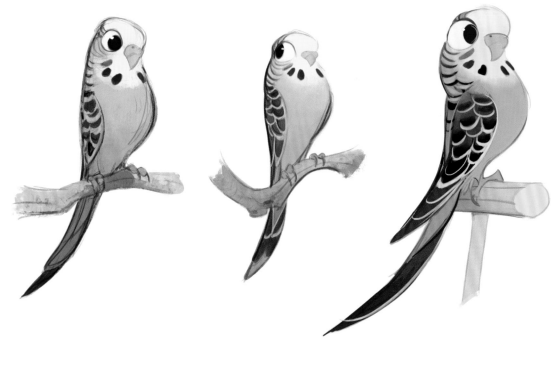

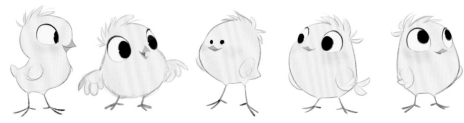

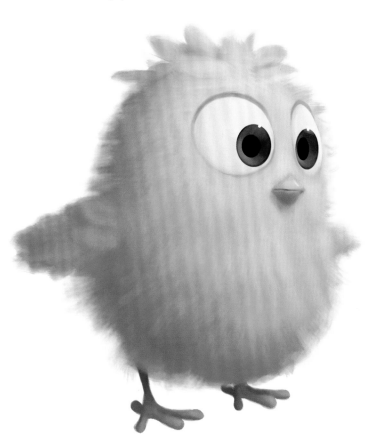

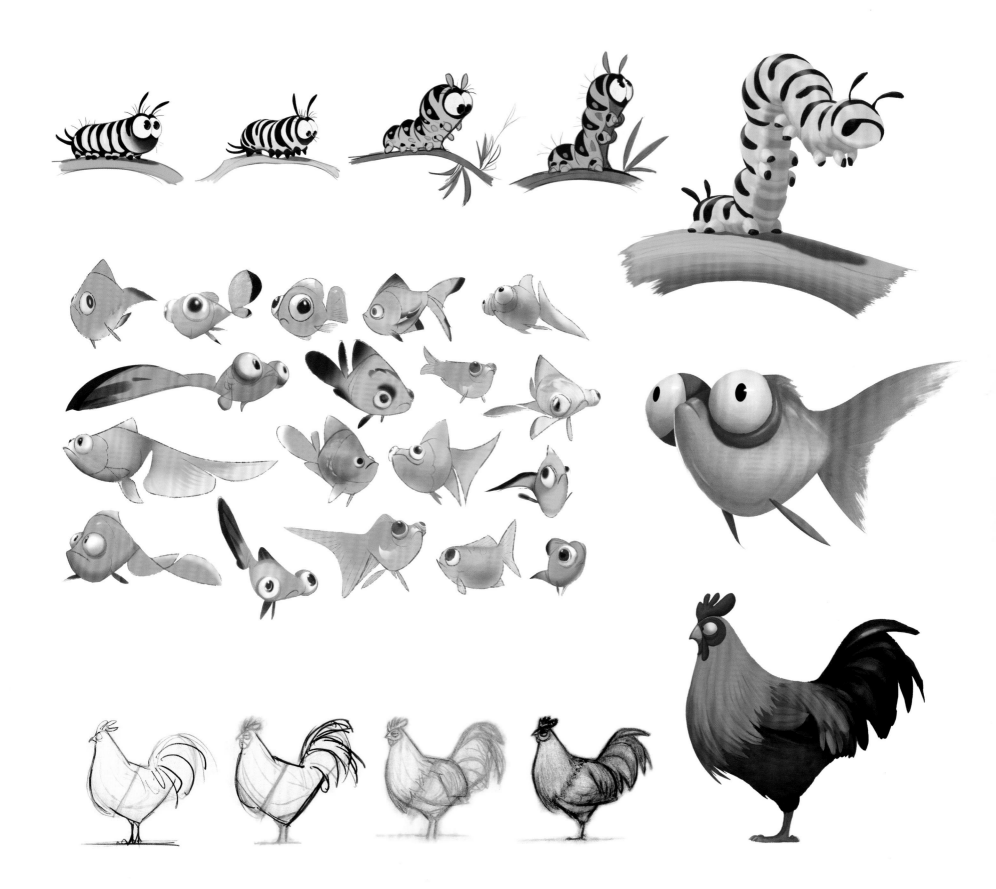

RIGHT & BELOW:

Rabbit movement and expressions studies:
Drawings by Annlyn Huang

BOTTOM LEFT:

Cat concepts: Drawings by Annlyn Huang

BOTTOM RIGHT:

Cat: Color callout by Mike Lee

OPPOSITE TOP:

Young bull head turnaround: by José Manuel
Fernández Oli

OPPOSITE BOTTOM:

Young bulls early concepts: Drawings by José
Manuel Fernández Oli

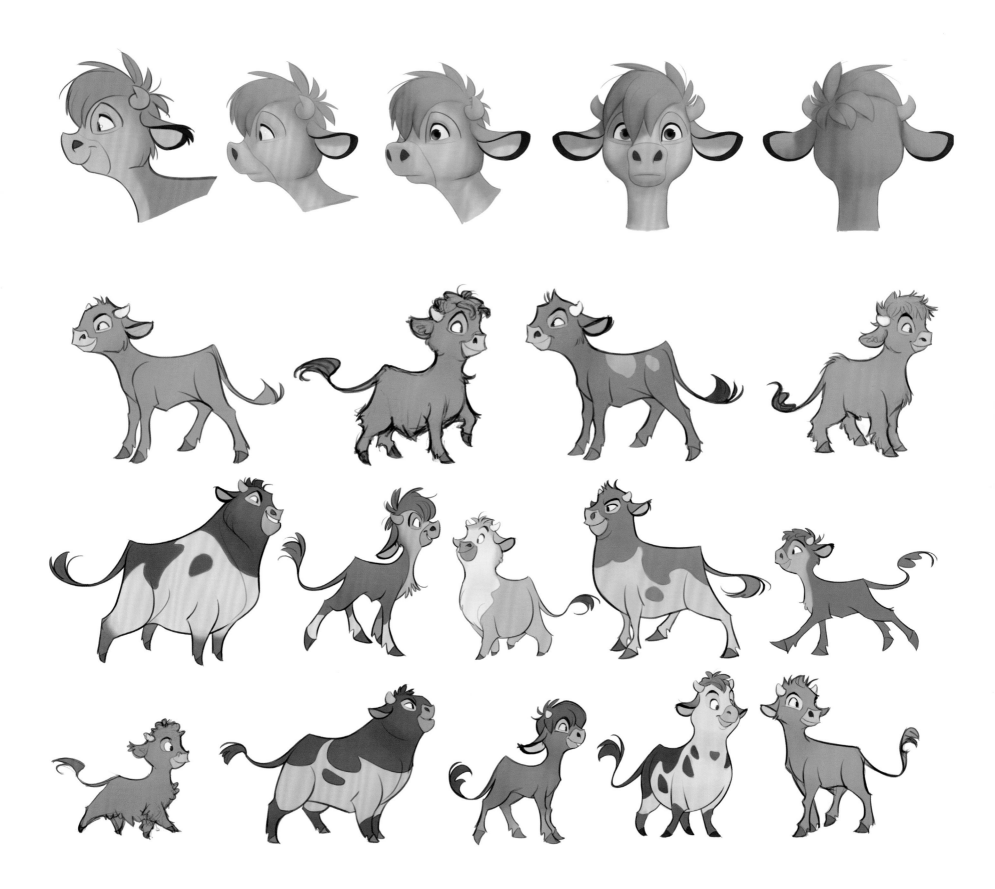

PAINTINGS

Snr. Diego

El Vecchio

DOMINGO

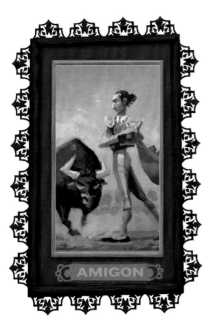

AMIGON

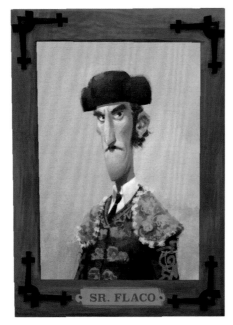

SR. FLACO

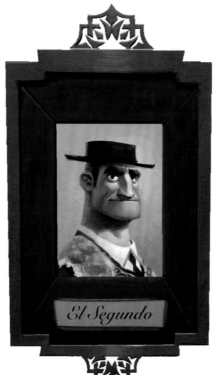

El Segundo

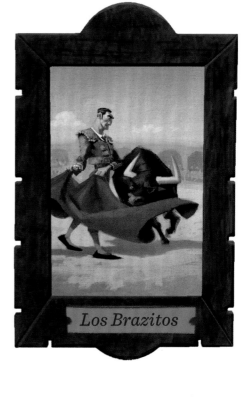

Los Brazitos

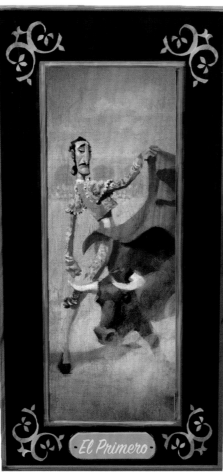

M. Cervantes

El Primero

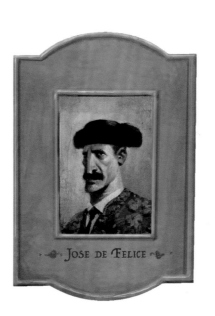

JOSE DE FELICE

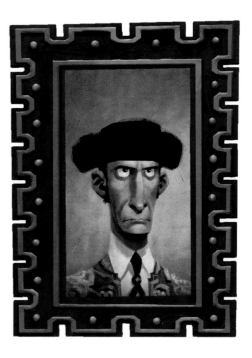

THIS SPREAD:
Matador portraits frames gallery: Digital paintings by Peter Nguyen and Mike Lee, some over Drawings by Sergio Pablos, Frame design by Andrew Hickson

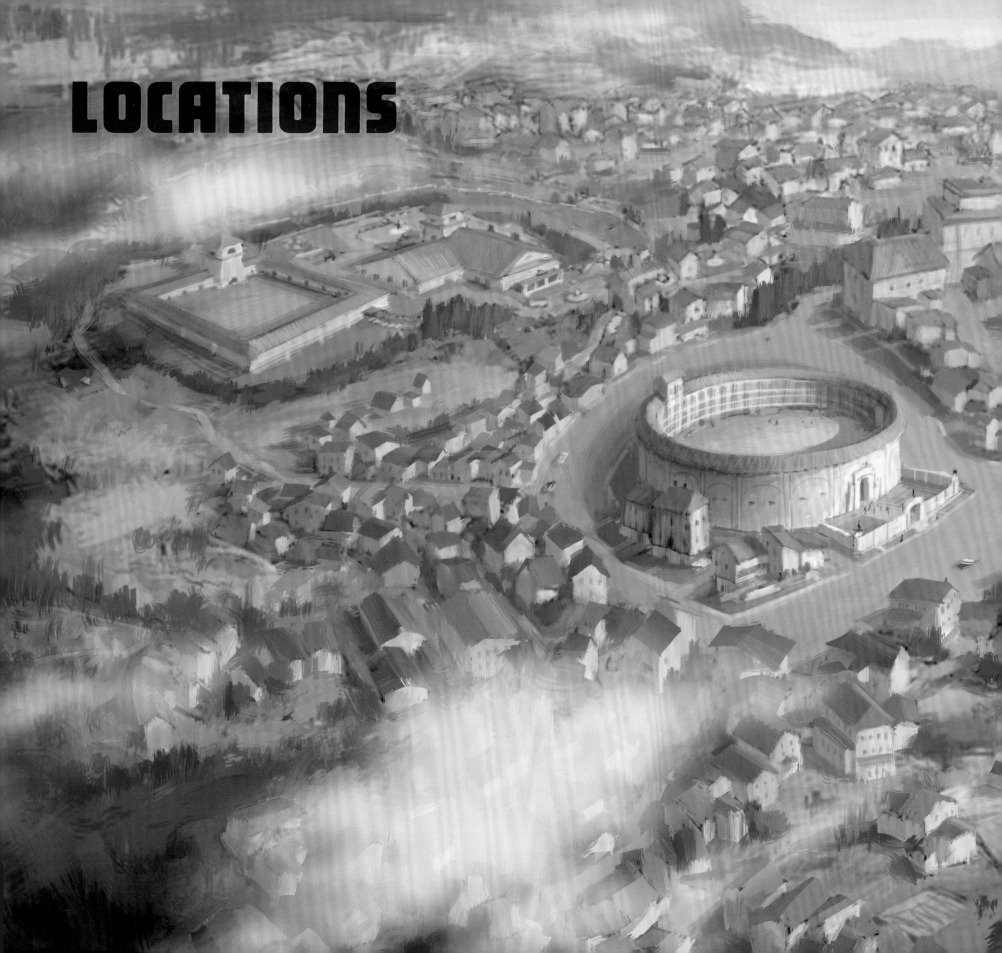

LOCATIONS

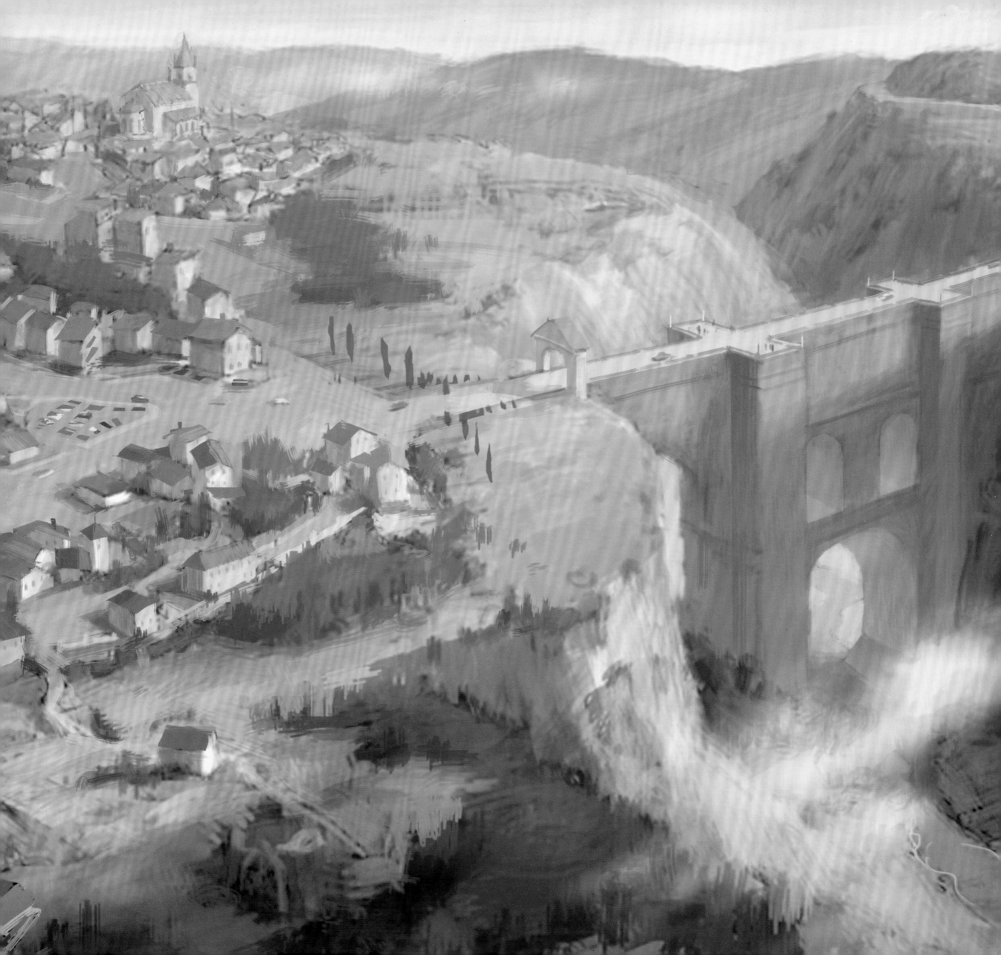

REALIZING SPAIN

With story in place and an overall design aesthetic in the early stages of development, director Carlos Saldanha and production designer Tom Cardone visited Spain. "It's so important to have an immersive experience when you're making a film about a real place, because whatever your impression may be before the visit, it's just not the same thing," Cardone explains. "There's so much to absorb. We were trying to be authentic. You have to go there to experience it and see, because it's always surprising. The people, textures, architecture, color, light, landscape, textiles, all these things added up to an impression that we tried to capture in our stylized way for this film. We started our trip in Madrid and drove down south to Andalusia, stopping at different villages as we went. On that drive we saw olive groves combing the landscape as far as we could see."

While the team carried Munro Leaf's book with them, they looked at contemporary Spain to inspire their modern take on the original story. "The book was written in the mid 1930s, so the design of Spain and the elements of the book are very 'retro' now," Saldanha says. "We wanted to keep the tradition and the feel of Spain, where you see the houses that have been there for two or three hundred years and the history that still coexists with the modern country."

Based on their visit, Saldanha and Cardone determined which specific areas of their travels they would use as inspiration for key locales in the film. "There are a few main locations in the film," Cardone lists. "We start with Juan's farm, where Ferdinand grows up. It's a modest old farm with white stucco buildings and red tile roofs nestled in the hills looking out across a rolling green valley and olive groves. As in the book, we set the farm near the village of Ronda with its iconic bridge. The village itself is quaint and whitewashed with stone streets. We treated Ronda's surrounding landscape as a lush green place with wild flowers. This is in contrast to the Casa del Toro compound, which is a working ranch near Madrid; a 'finca': a sprawling estate, with multiple barns. The surrounding landscape there is more arid, with yellow grass and exposed dirt as far as the eye can see. It's set in a part of the countryside with olive oil refineries and other industrial buildings. Establishing this visual contrast between these two key locations in the film drives home the story point that Ferdinand has been out of his comfort zone and has happily returned."

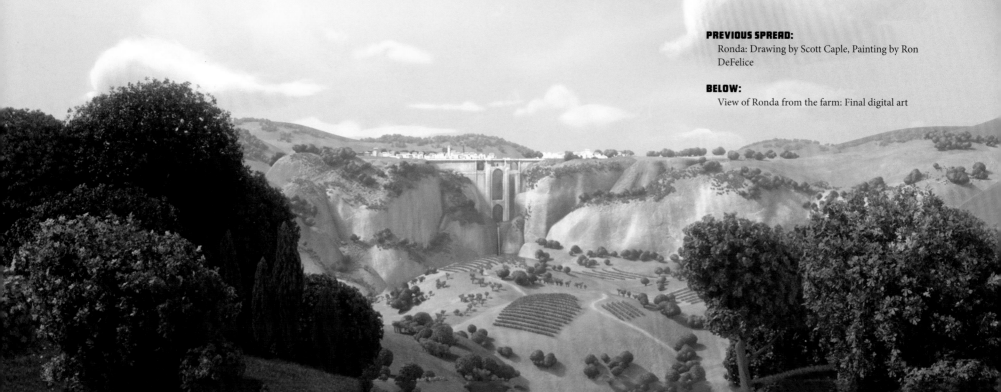

PREVIOUS SPREAD:
Ronda: Drawing by Scott Caple, Painting by Ron DeFelice

BELOW:
View of Ronda from the farm: Final digital art

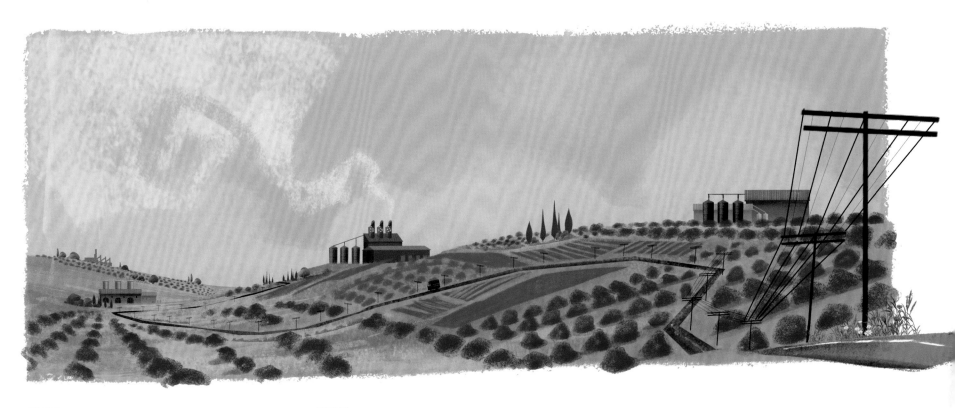

Landscape around Casa del Toro: Digital painting by Andrew Hickson

Ronda and the surrounding landscape: Digital painting by Thomas Cardone

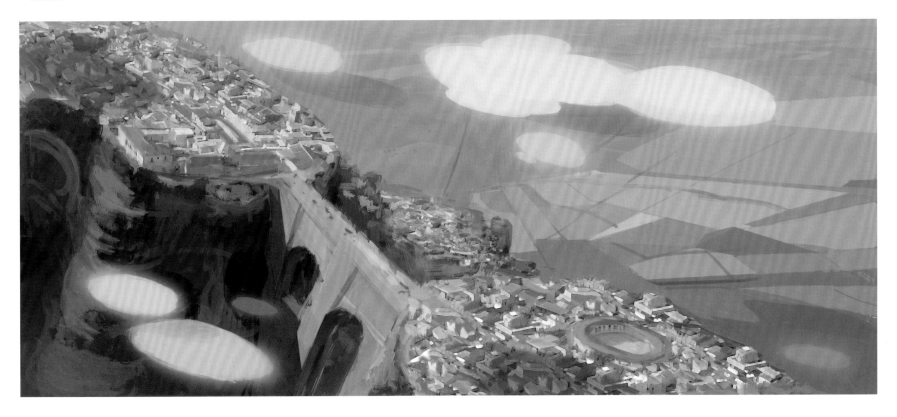

FARM

For the halcyon farm where Ferdinand grows up with Juan, Nina and Paco, Saldanha was initially hesitant about using the natural palette of the Spanish countryside as inspiration for the film's color palette. "The Spanish countryside is beautiful," he enthuses, "but it is very pastel. The search for natural color was something we had to readjust our perception to appreciate. In Brazil [the setting for the *Rio* movies], it is all about intense greens and blues and the vibrant flowers. In Spain, the landscape has a different intensity. It is colorful in a different way – earthier, dustier.

BELOW:
The farmhouse: Drawing by Scott Caple, Painting by Ron DeFelice

RIGHT:
The farmhouse: Drawings by Scott Caple

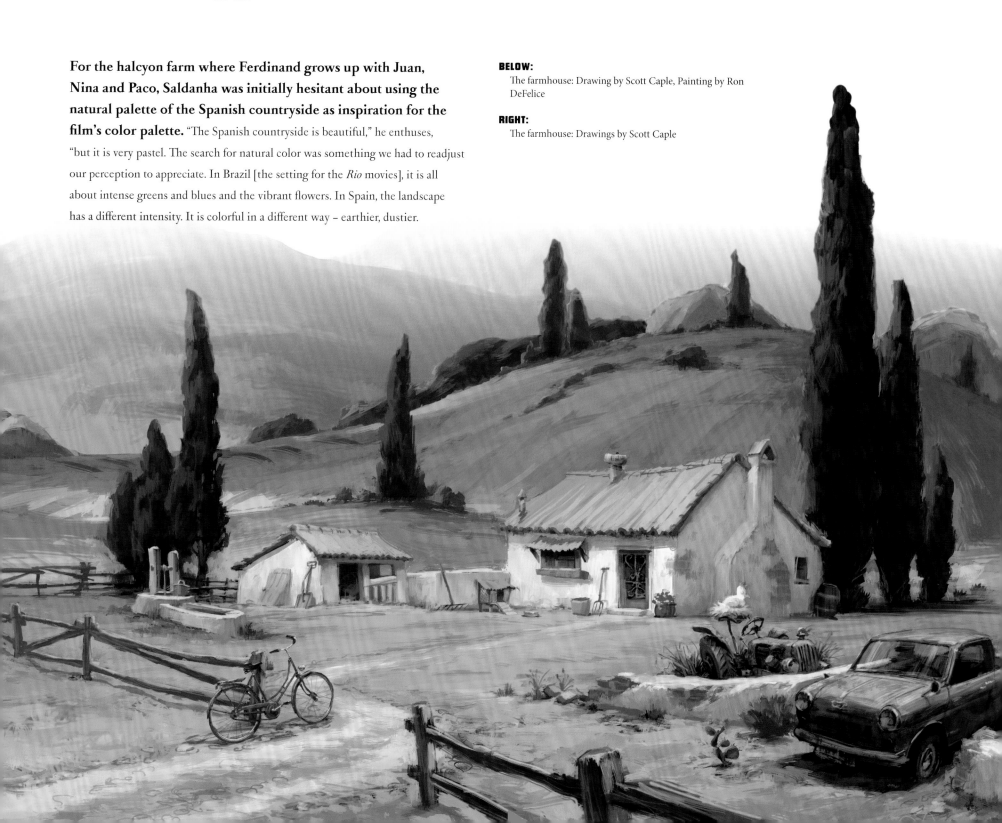

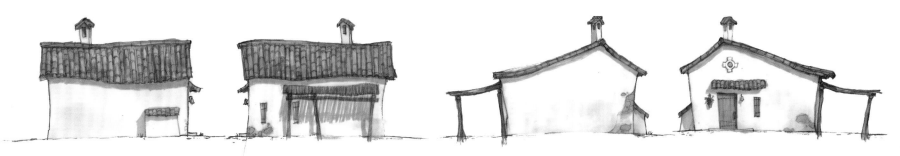

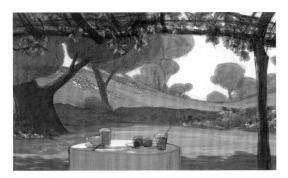

ABOVE MIDDLE:
Farmhouse turnaround: by Arden Chan

ABOVE:
Farmhouse garden: Drawing by Arden Chan

RIGHT:
Farmhouse: Drawing by Arden Chan

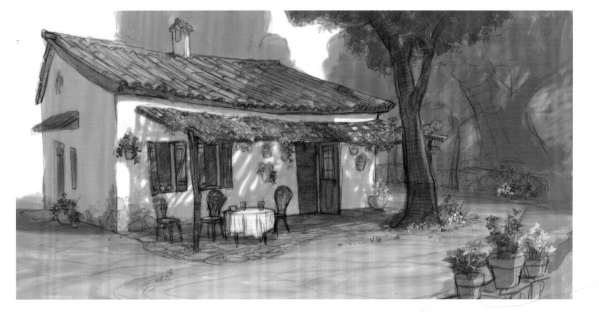

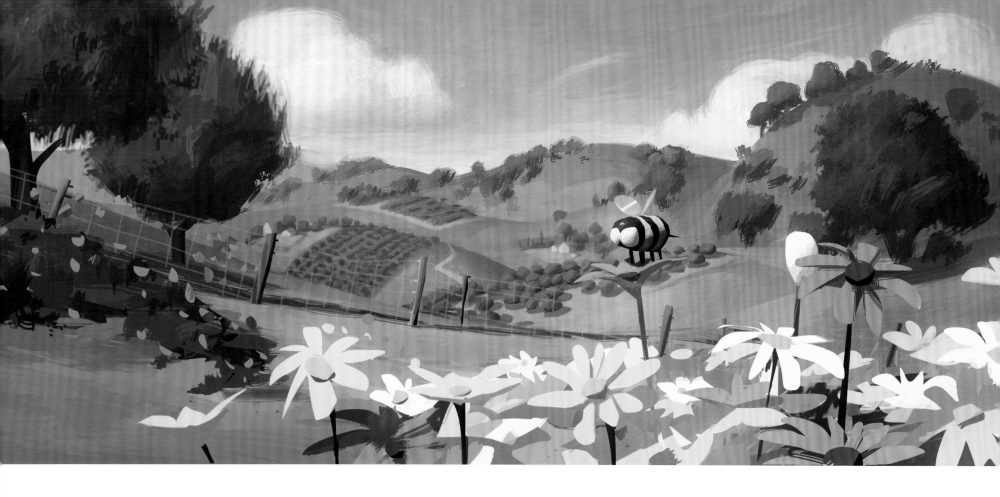

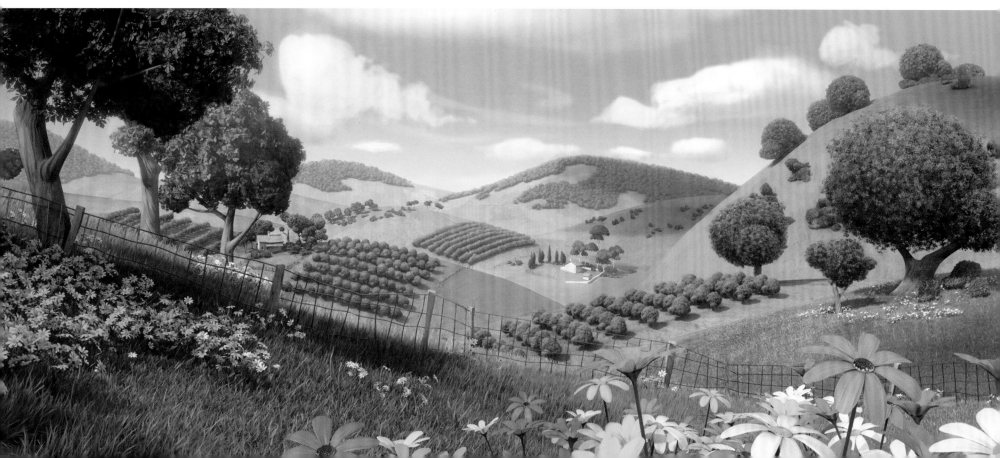

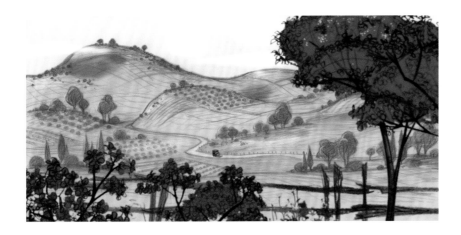

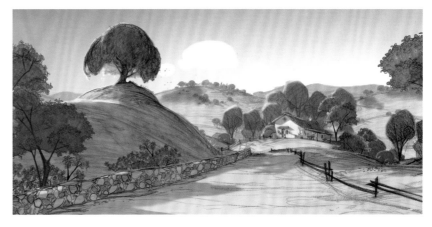

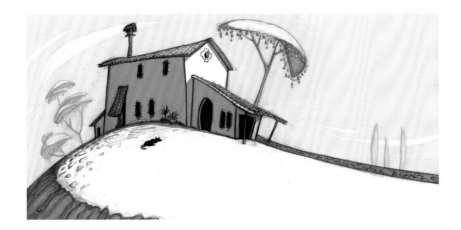

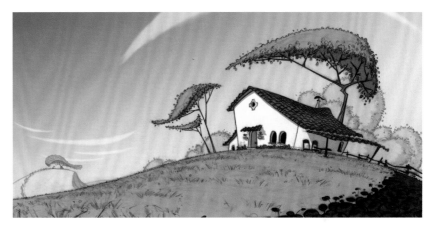

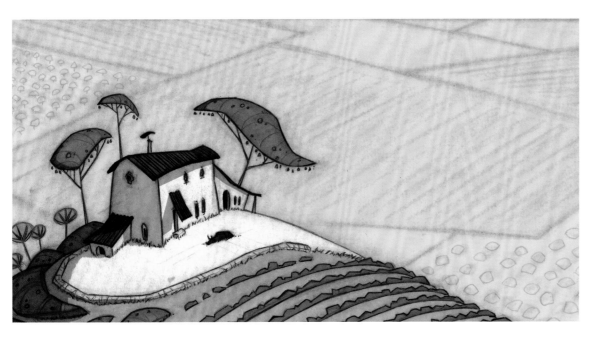

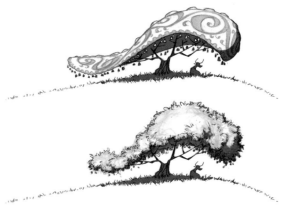

OPPOSITE:
Farmhouse landscape: (top) Color key by Mike Lee; (bottom) Digital painting by Thomas Cardone over early lighting frame

TOP:
Farmhouse location designs: Drawings by Arden Chan

ABOVE & LEFT:
Farmhouse early concepts: Drawings by Jason Sadler

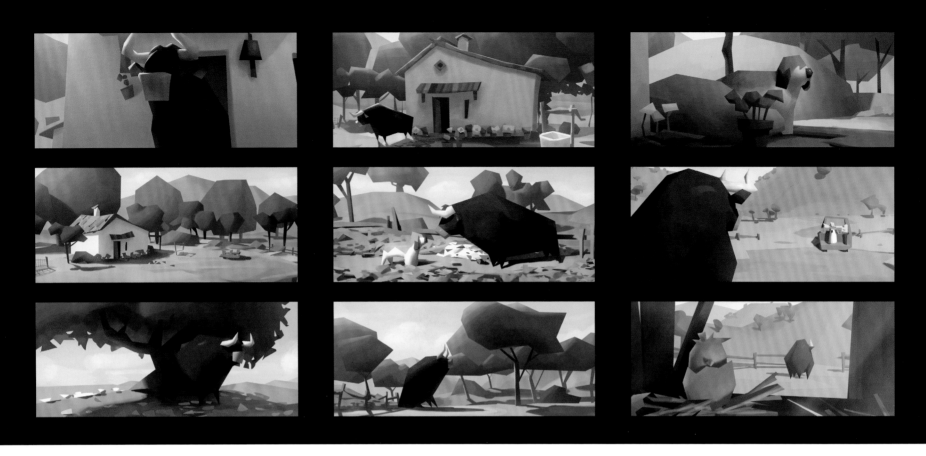

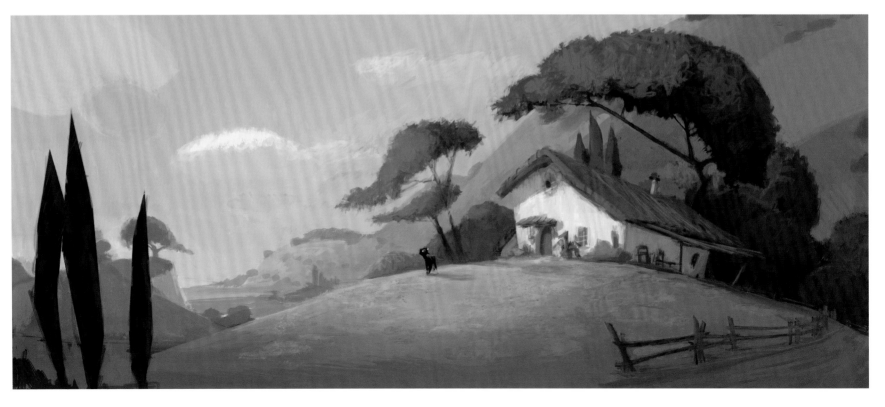

THE ART OF FERDINAND

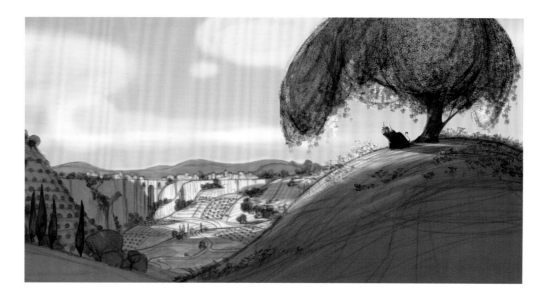

"The very first [sculpture] I did for *Ferdinand* was the iconic scene of him sitting under the cork tree, before the film was even greenlit. It was really fun to do and got everybody excited about the project and reminiscing about having read the book when they were kids."

Vicki Saulls, Lead Sculptor

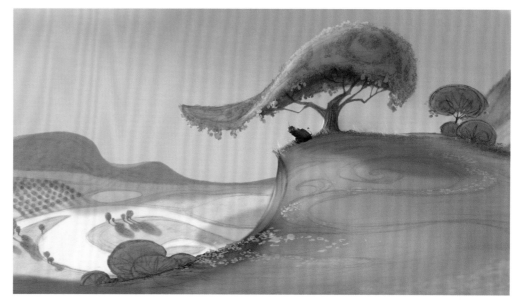

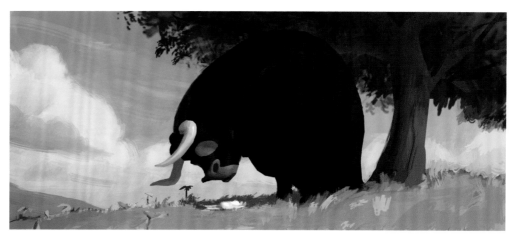

TOP LEFT:
Ferdinand on the farm: Color keys by Mike Lee

LEFT:
Early concept art of young Ferdinand at the farm: Digital painting by Thomas Cardone and Arden Chan

ABOVE:
Ferdinand sitting under the cork tree: Physical sculpt by Vicki Saulls

ABOVE RIGHT & MIDDLE RIGHT:
Early concept art of Ferdinand sitting under the cork tree: Drawings by Arden Chan

RIGHT:
Ferdinand sitting under the cork tree: Color key by Mike Lee

We had to adapt that palette, so that as earthy as the palette is for Spain, the movie still plays very colorful. The reds and the yellows are very strong and we used a lot of the greens. We peppered in color where you don't expect it to be, and that way things started to become more playful and fun."

Ferdinand's beloved farm is particularly verdant. "What you notice first about that farm is its lush green hills covered in colorful wildflowers," Cardone shares. "When Ferdinand dreams of it later in the film, we want the audience to miss it too, and to feel great when he returns at the end. As appealing as the other locations need to be in terms of the look of the film, his home must be the most idyllic."

The farm's land is also the location of the iconic place where Ferdinand sniffs his flowers in peace under the limbs of a cork tree. Saldanha says he and his team looked to Robert Lawson's original book illustrations to inspire their own take on that beautiful space. "The image that was always in my head was the solitary bull under the cork tree. I wanted the tree on the hill to be iconic and I wanted the tableau to feel the same," he shares. "We ended up conceiving the tree in a different way [to the book], but at the end I wanted to capture that moment. For me, that was the signature moment of the book and I wanted it to be the signature moment of the film as well, both with young and adult Ferdinand."

BELOW:
Ferdinand sitting under the cork tree: Color key by Mike Lee

RIGHT:
Ferdinand sitting under the cork tree: Drawing by Arden Chan, Painting by Mike Lee

BOTTOM RIGHT:
Ferdinand sitting under the cork tree: Drawing by Arden Chan, Painting by Thomas Cardone

NEXT SPREAD:
Ferdinand sitting under the cork tree: Digital painting by Vincent Nguyen over early lighting frame

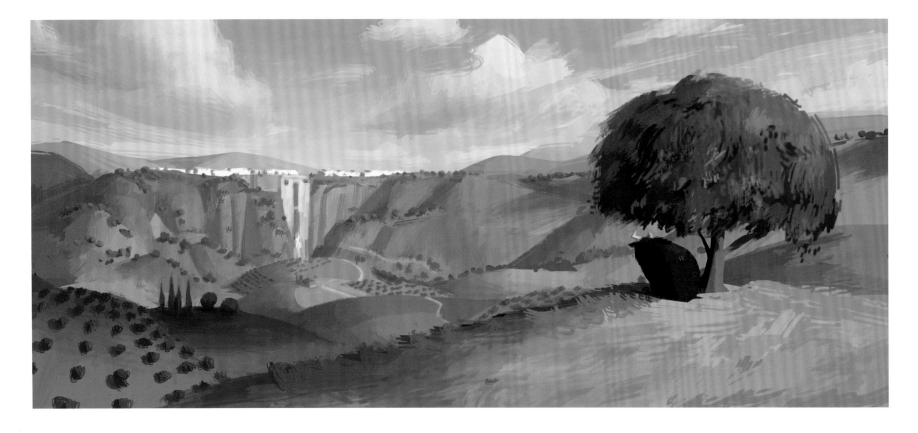

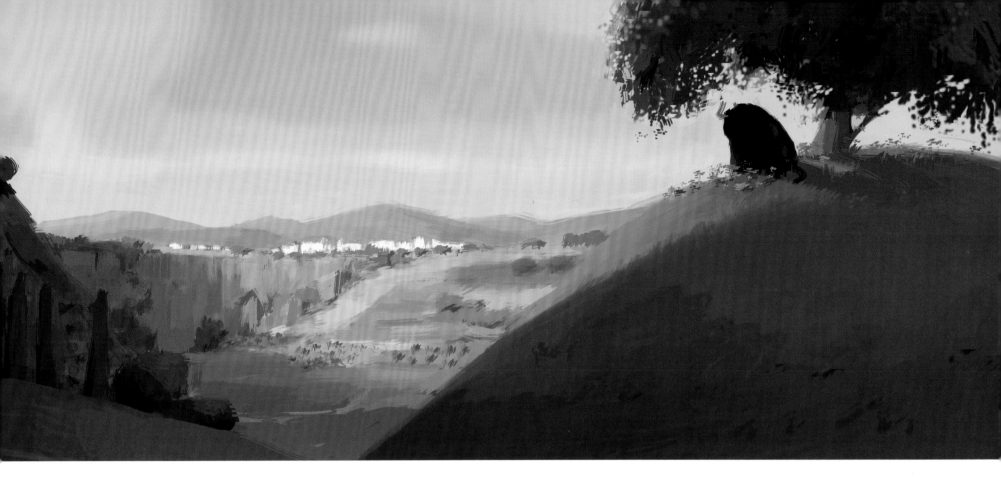

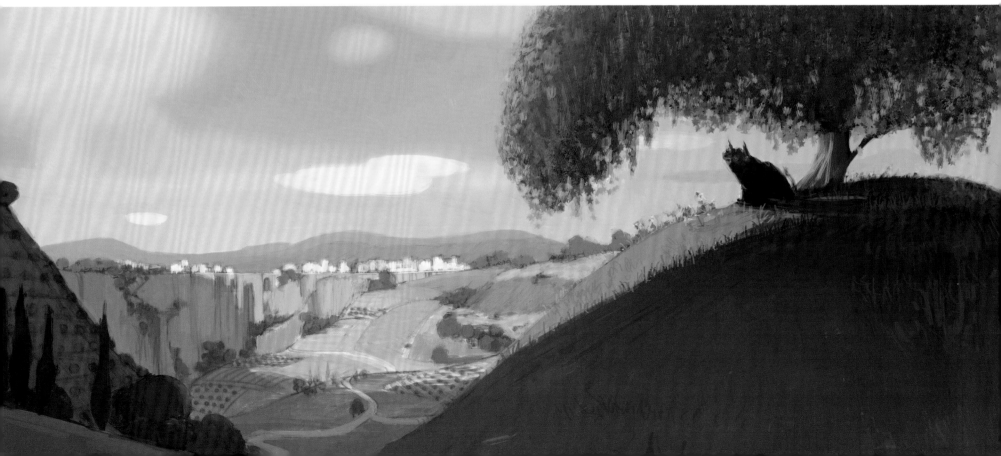

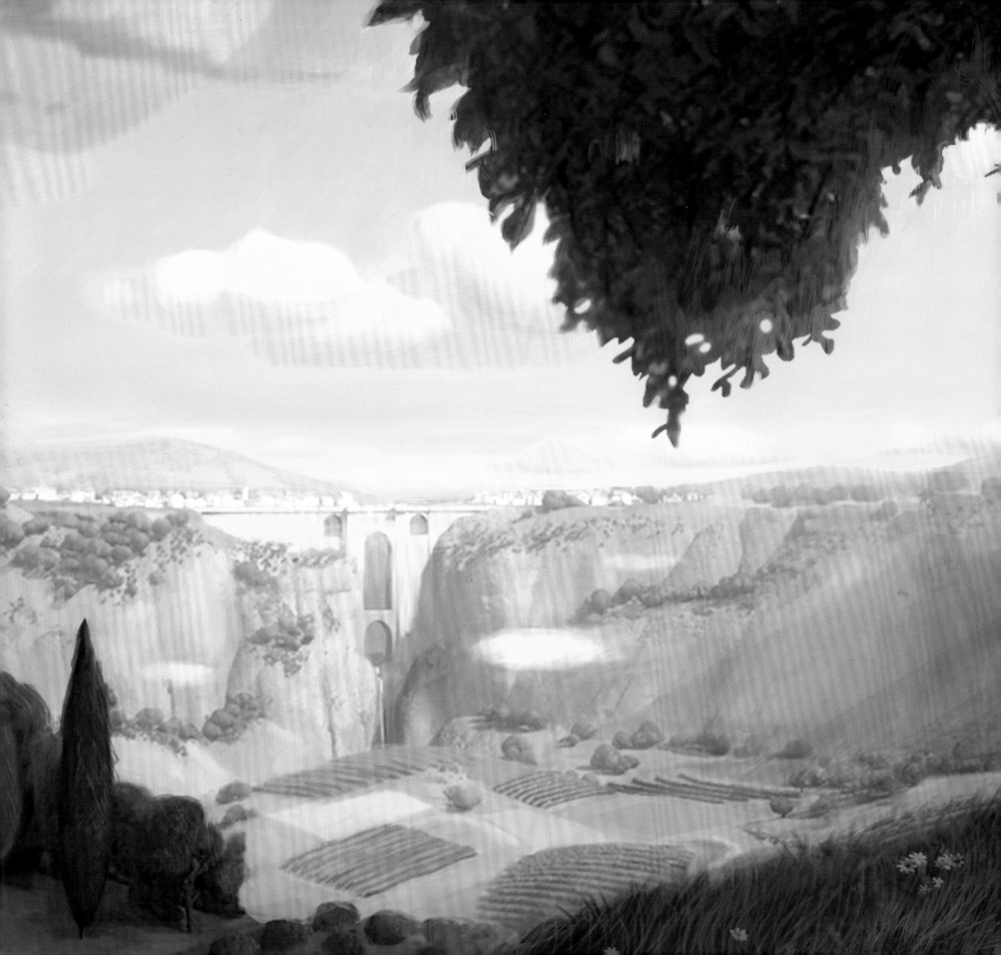

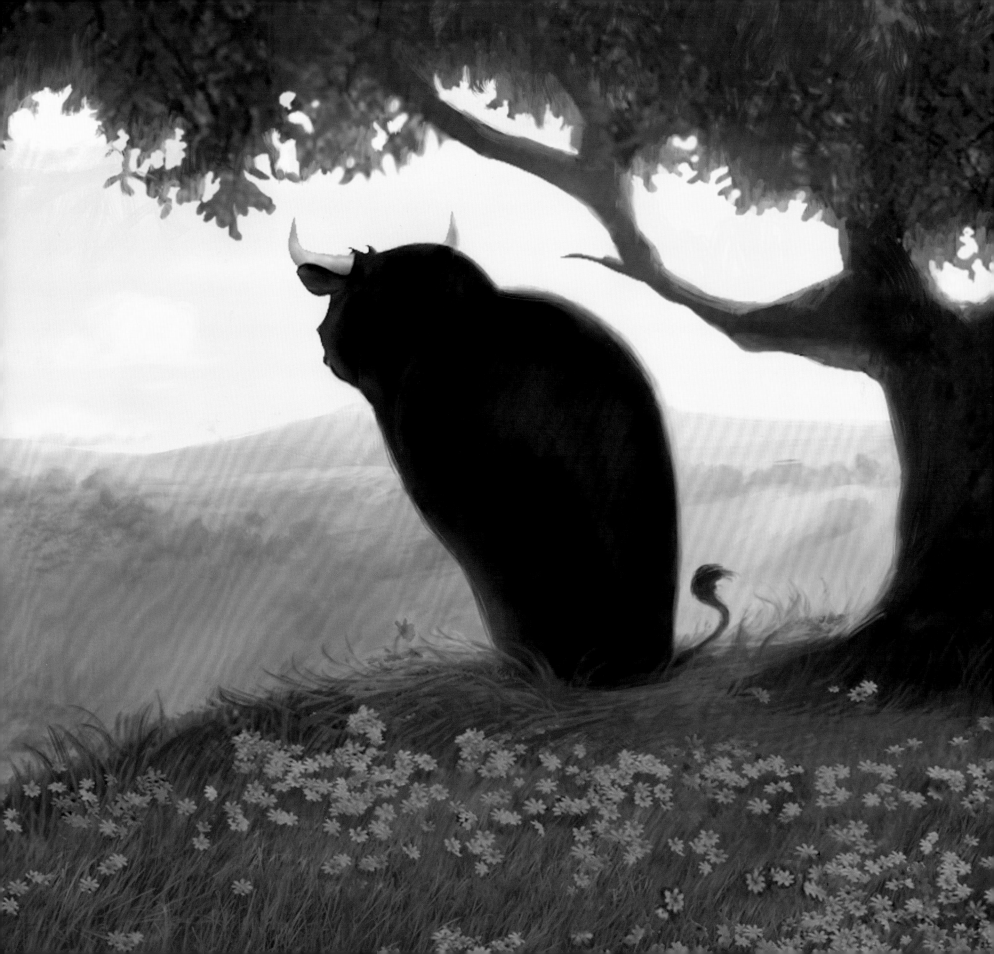

RONDA

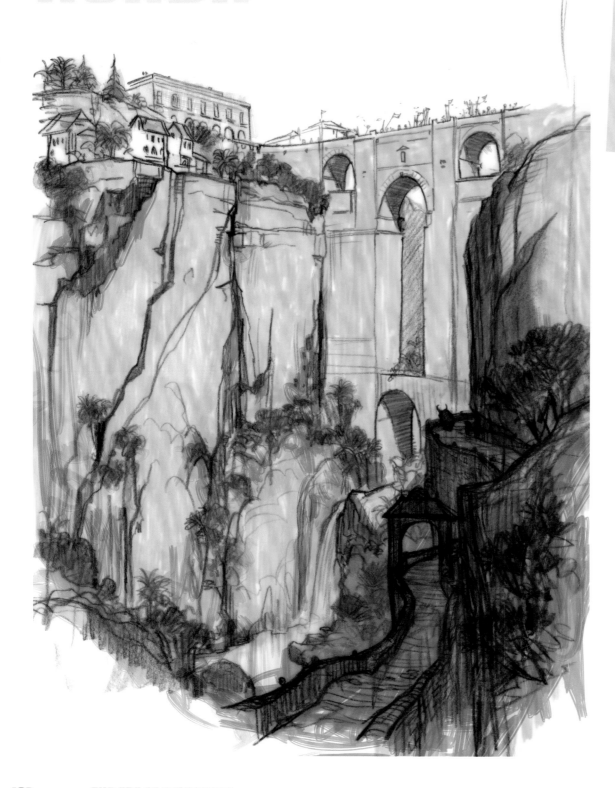

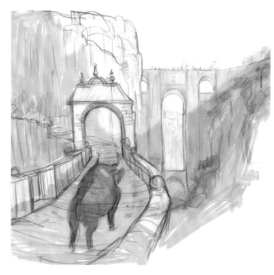

LEFT & ABOVE & OPPOSITE TOP:
Ronda's bridge: Drawings by Arden Chan

RIGHT:
Ronda's bridge: Digital painting by Thomas Cardone

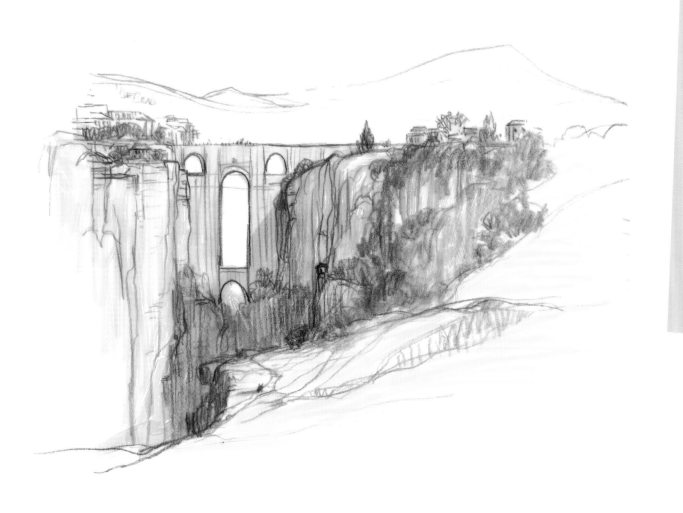

"Our goal for the village of Ronda was to capture the awe and beauty of the architecture, with its iconic bridge and stone cliffs rising up from the rolling green valley of patchwork olive groves and farms. The streets of the village are lined with white buildings capped with terra cotta roofs. When we first see the village in the film, it is decorated for a flower festival, literally covered in flowers."

Thomas Cardone, Production Designer

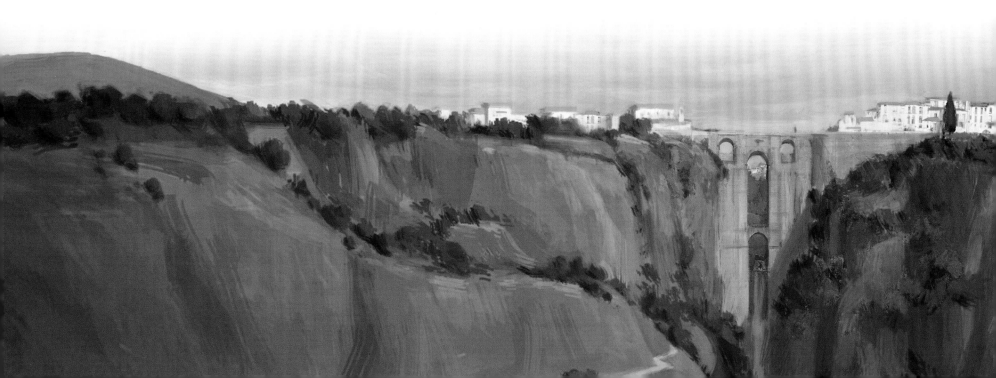

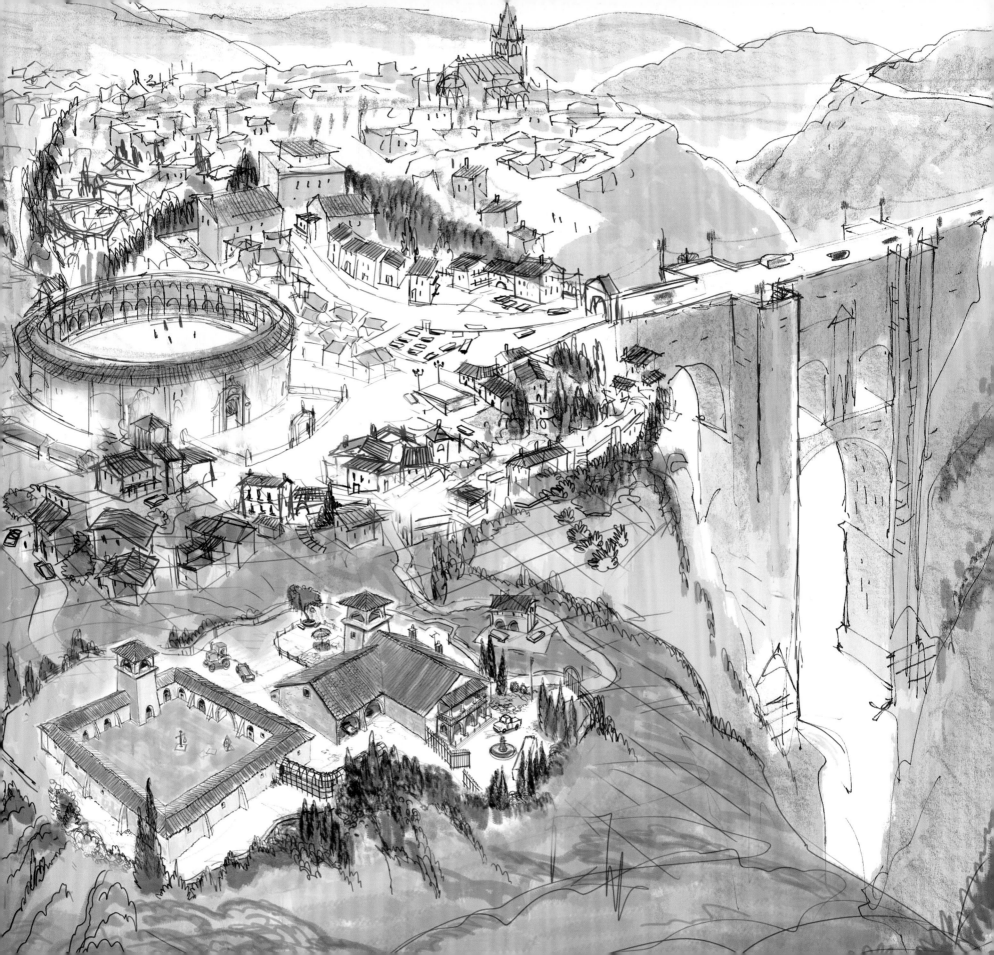

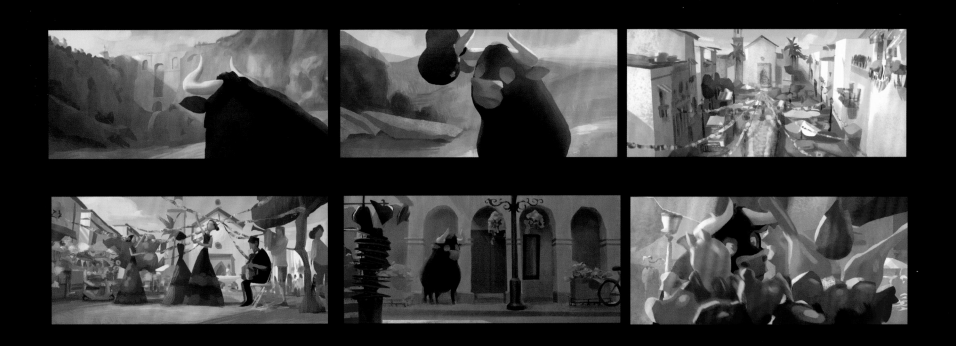

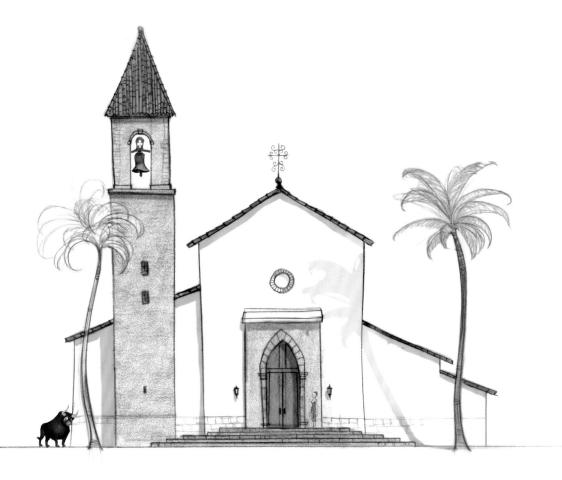

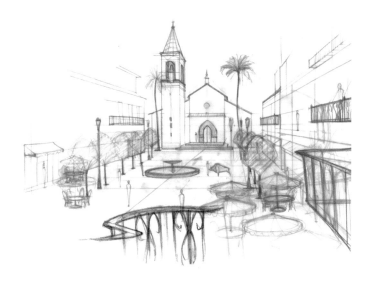

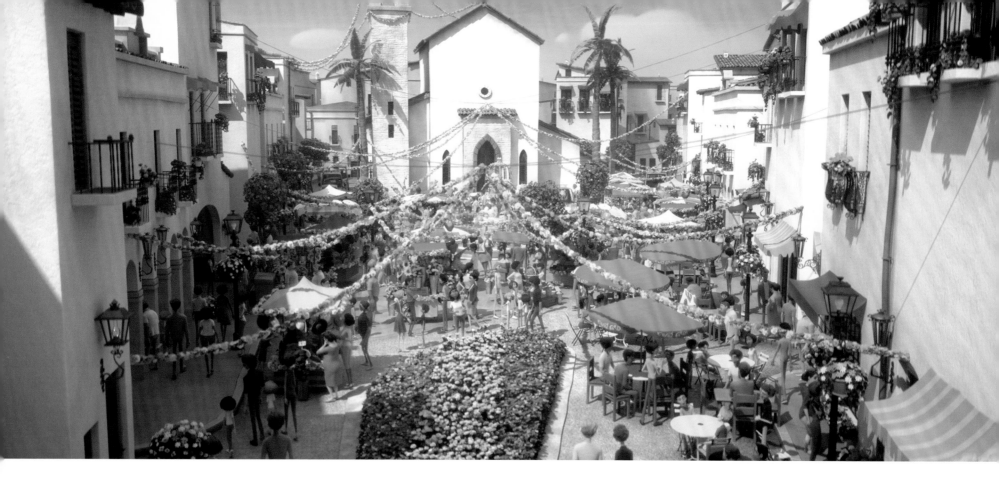

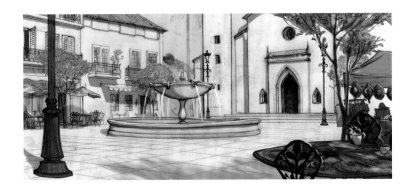

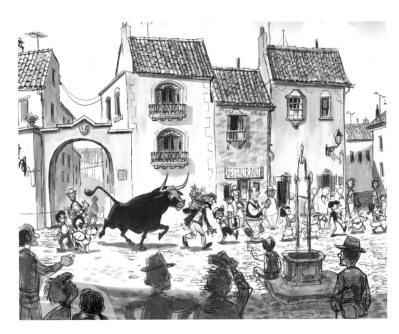

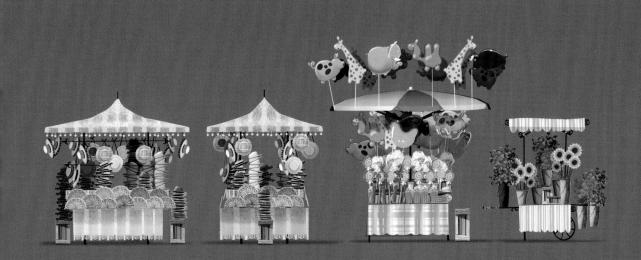

OPPOSITE:
The flower festival and Ferdinand: Final digital art

TOP LEFT:
The town square: Drawing by Arden Chan

MIDDLE LEFT:
Early concept art of Ferdinand in Ronda: Drawing by Scott Caple

ABOVE & LEFT:
Stalls at the flower festival: Concepts by Andrew Hickson

107

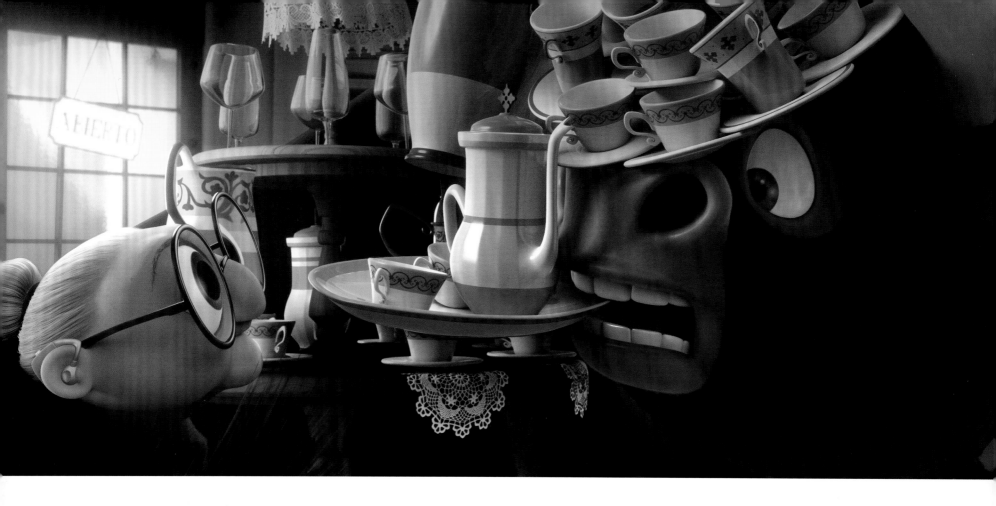

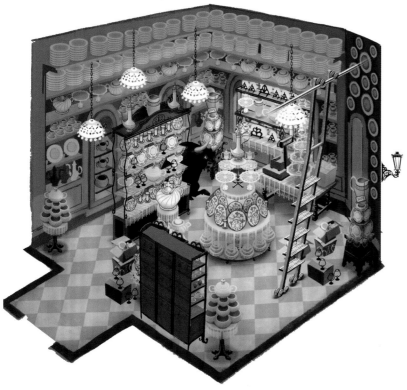

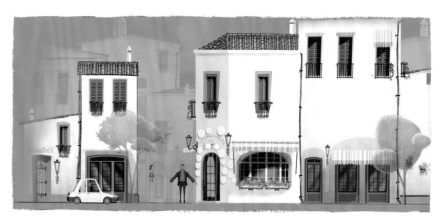

TOP:
Ferdinand in the china shop: Final digital art

LEFT & RIGHT:
China shop interior: Set designs by Andrew Hickson

ABOVE:
China shop exterior: Set design by Andrew Hickson

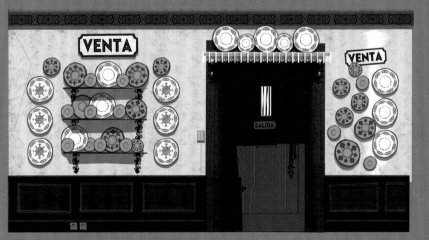

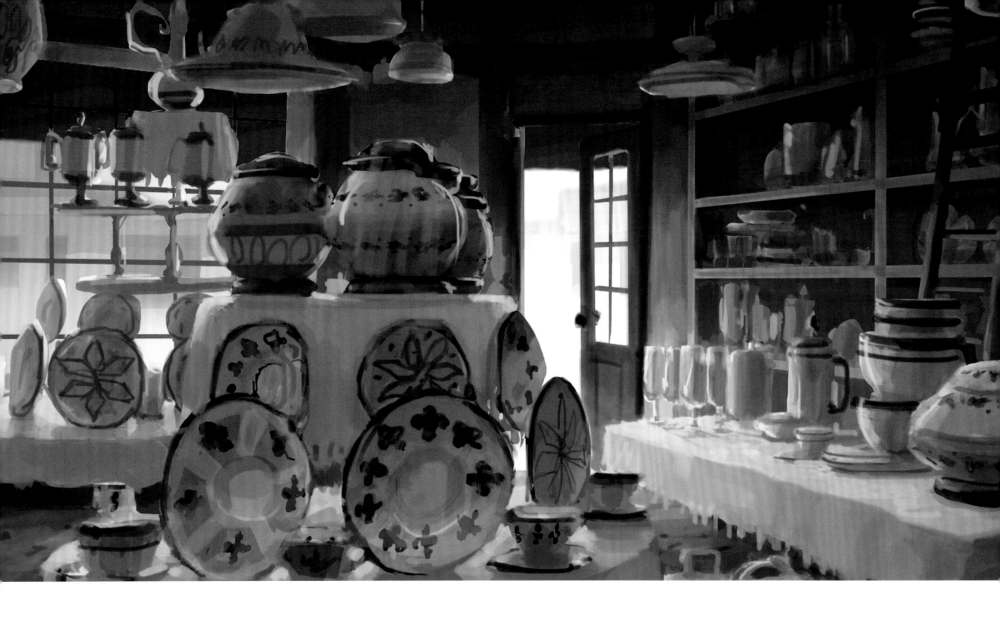

"I wanted the village's spaces to be a challenge for Ferdinand. I wanted everything to feel smaller than it should feel, for spaces to feel tighter than they should feel. I wanted things to be in his way. It is almost a metaphor for his life; he needs to have physical obstacles to overcome. I mean, come on... a bull in a china shop! We had to do it. That is the representation of how he can go around that [obstacle]. So, if you put the bull in the china shop, what do you do with it? It opened up creative ideas that were fun to play with, and it created these nice little contrasts with size and space."

Carlos Saldanha, Director

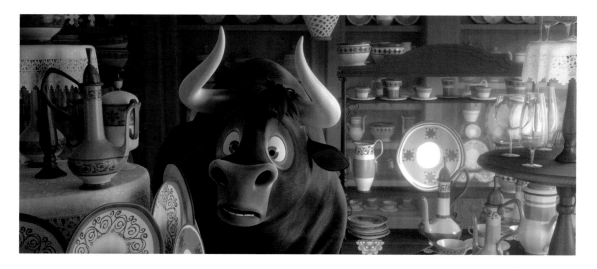

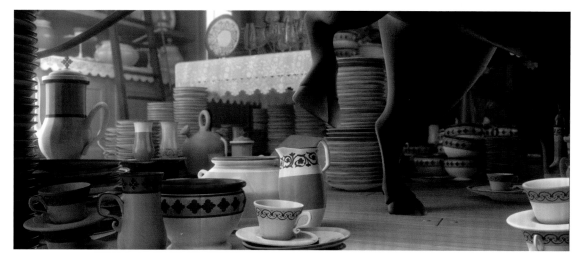

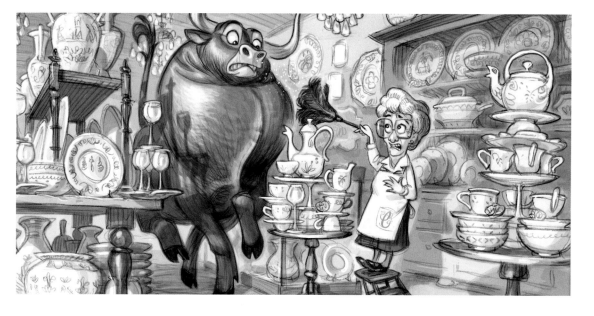

ABOVE:
China shop interior: Color key by Ron DeFelice

LEFT:
China shop contents: Prop designs by Andrew Hickson, Color callout by Ron DeFelice

TOP RIGHT:
Ferdinand in the china shop: Final digital art

RIGHT:
Early concept art of Ferdinand in the china shop: Drawing by Peter Chan

COUNTRYSIDE

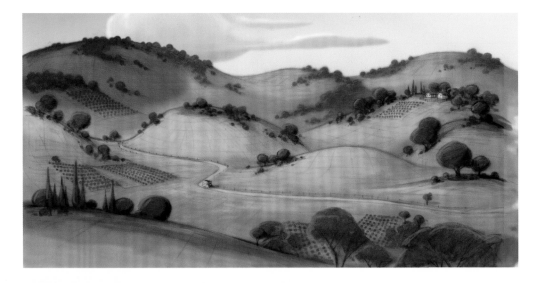

"During our visit to Spain I was struck by the graphic patterns in the landscape created by stands of trees winding around hilltops, rows of round olive trees striping the plains, and the color contrast of the yellow grassy areas against the rich red soil. It was all there, so we embraced it and looked for opportunities to bring it into our film."

Thomas Cardone, Production Designer

LEFT:
The landscape around the farm: Drawing by Arden Chan

BELOW LEFT & OPPOSITE:
Creating pattern in the landscape: Drawings by Arden Chan

BELOW:
The Andalusian countryside: Drawing by Arden Chan

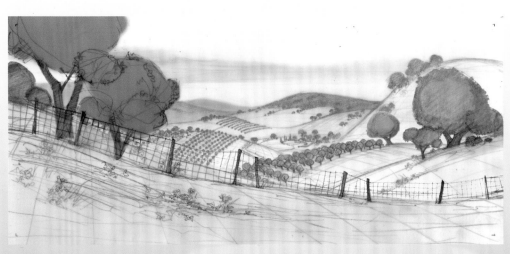

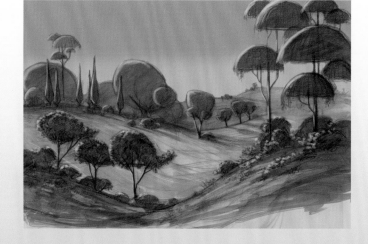

BELOW:
Tree shape variation: Lineup by Arden Chan

NEXT SPREAD:
Ferdinand is driven from Ronda to Casa del Toro: Drawing by Scott Caple, Painting by Ron DeFelice

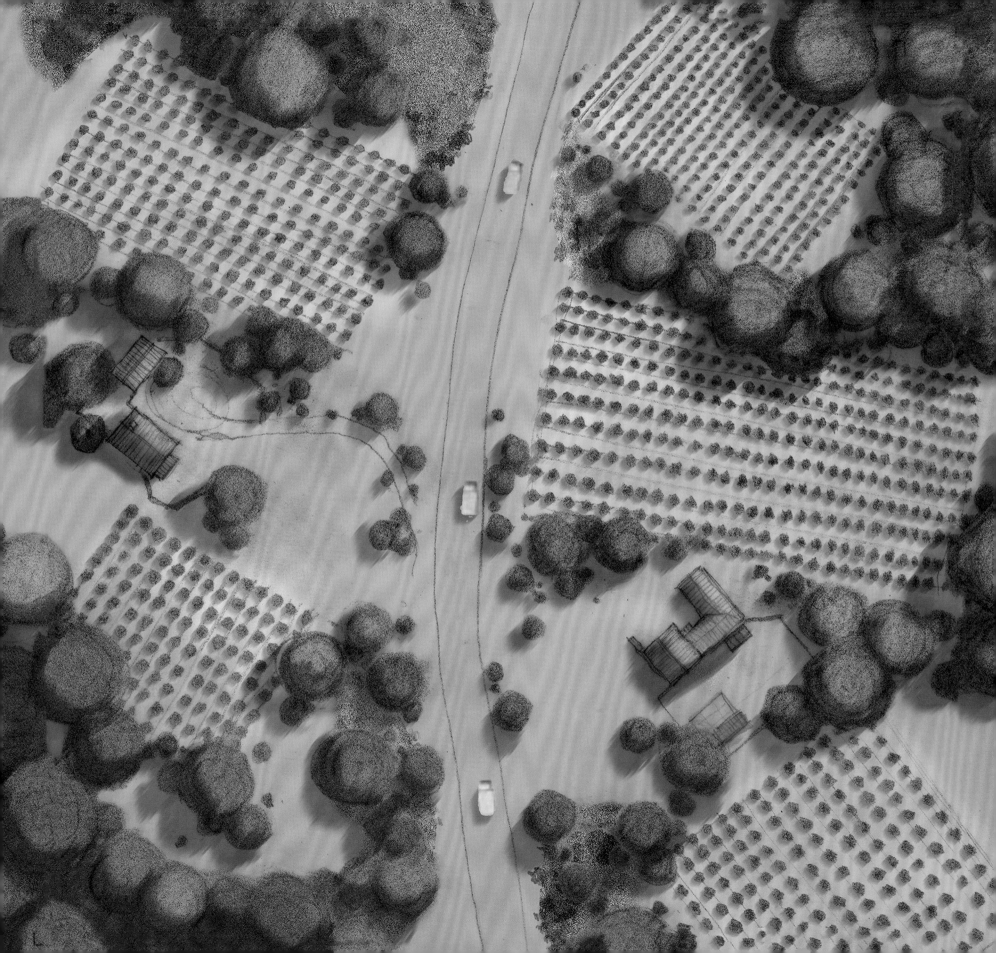

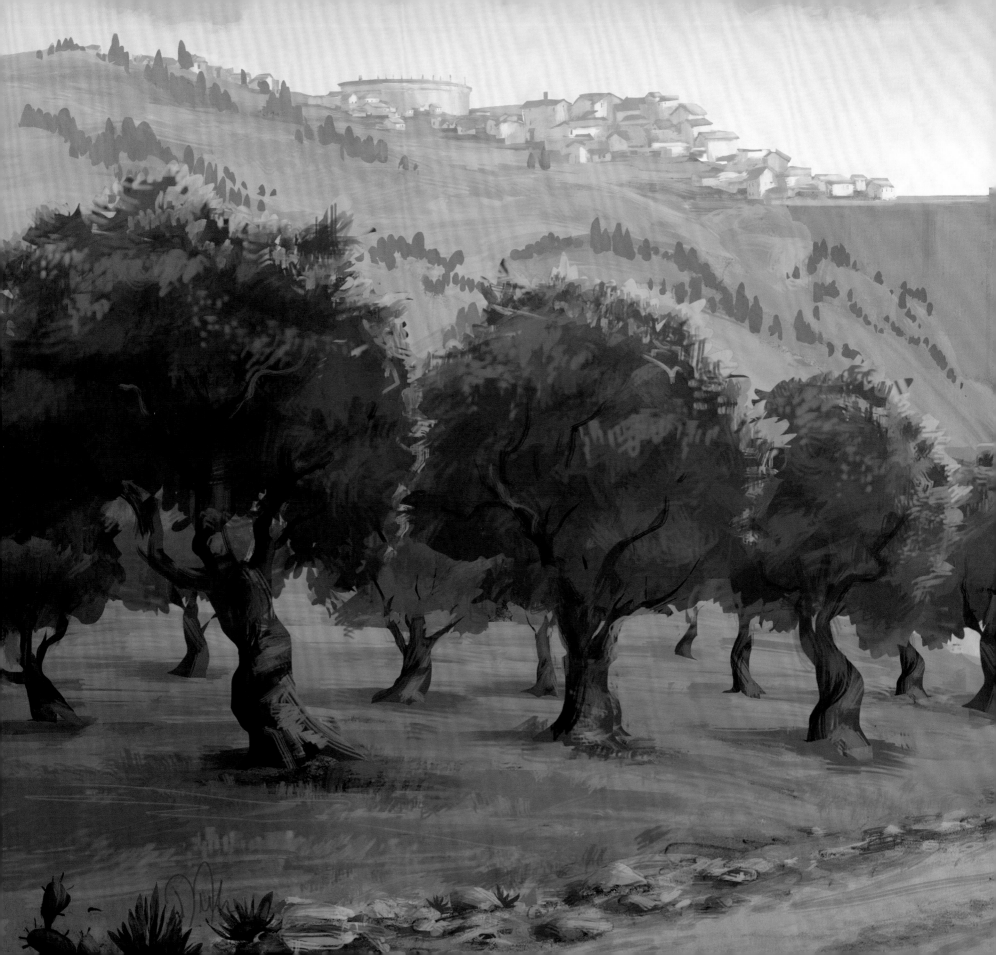

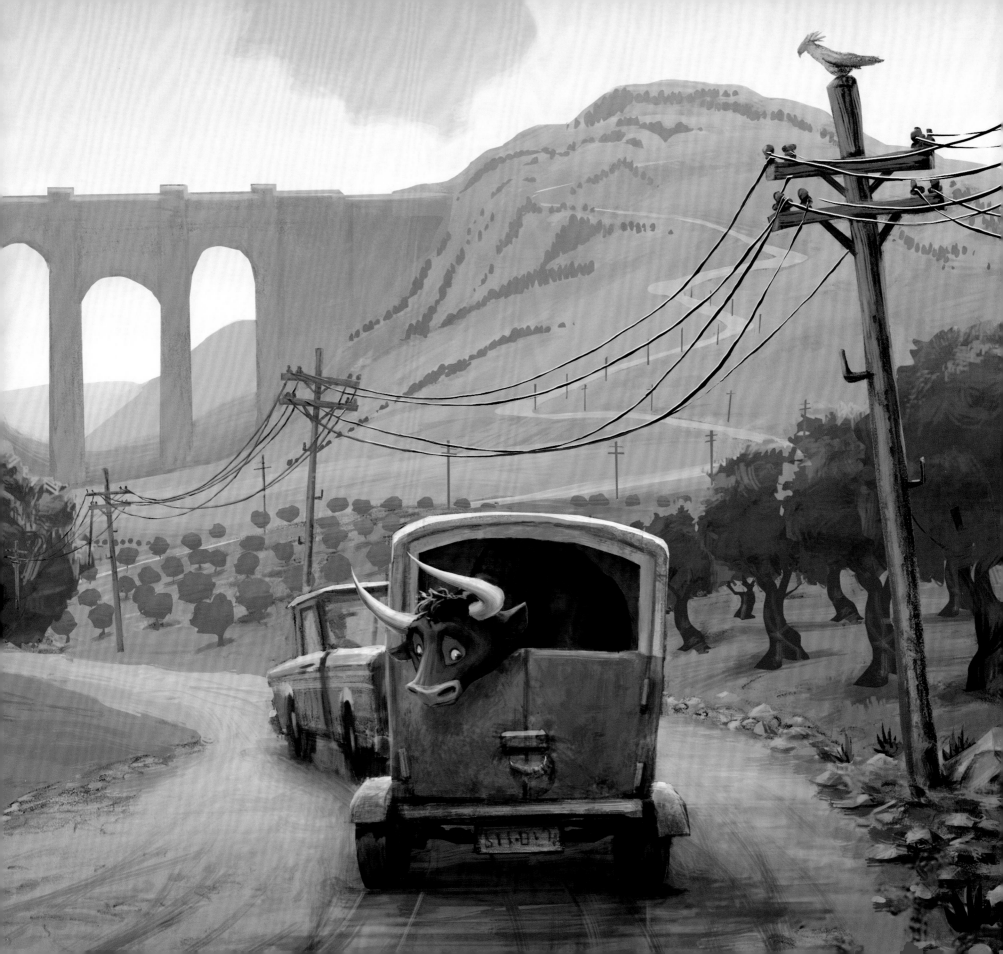

CASA DEL TORO

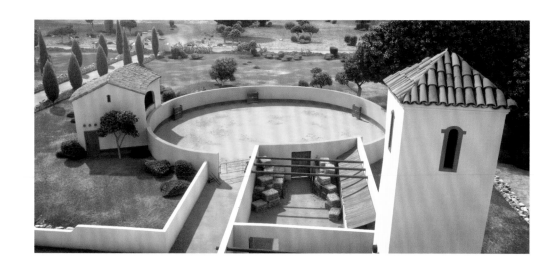

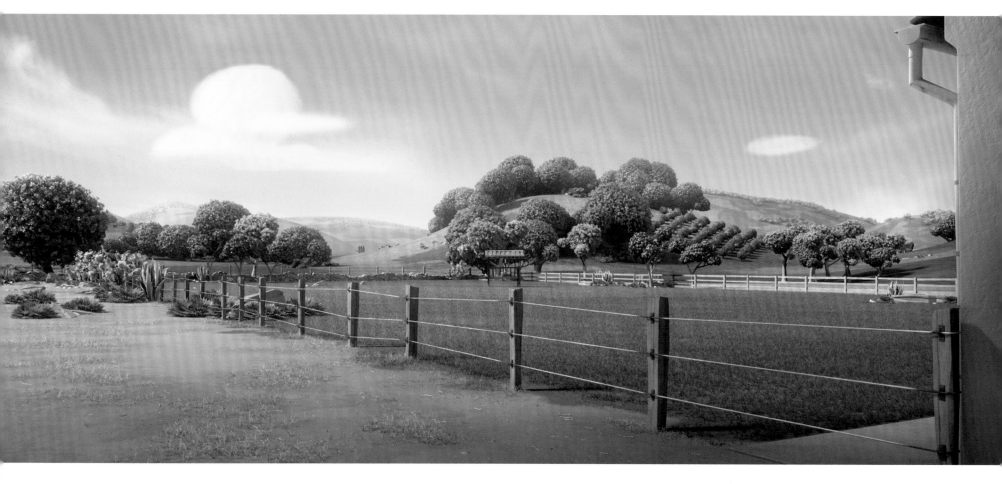

FAR LEFT & BOTTOM LEFT & BOTTOM:
Casa del Toro's training area; The exercise yard; Ferdinand, Bones and Valiente in the exercise yard: Final digital art

LEFT:
Casa del Toro's ceramic sign: Set design by David Dibble

BELOW:
The exercise yard: Final digital art

"With the textures on the film in general, we wanted to achieve a richness to everything, while making sure there was a hierarchy to what grabbed the attention of the audience. We established a clean, graphic silhouette for our characters, which then dictated a cleaner look to the textures. Instead of going for complex photo-real texture, we tried to simplify and stylize the look. I wanted the audience to see the characters first and then notice the beauty of the environment. For example, when you look at the training field at the compound, the grass and dirt are close-contrast and similar in color. The dirt itself has just enough texture to read as dirt, but not so much that it competes for attention with the characters. This, in conjunction with the limited but bold palette, created a pleasing aesthetic that is reminiscent of hand-painted films of the 1950s."

Thomas Cardone, Production Designer

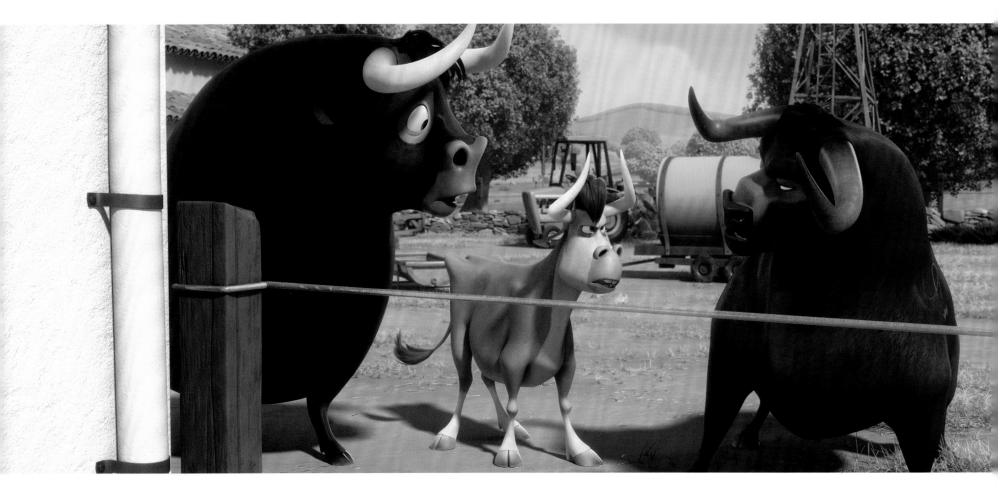

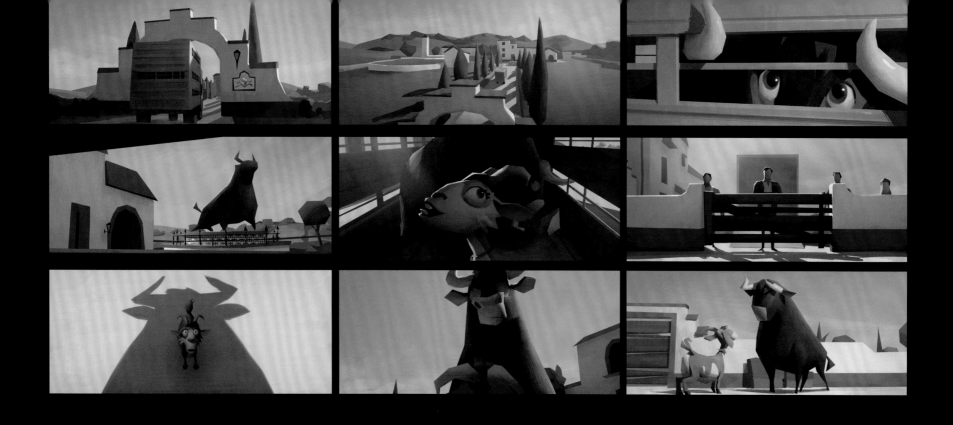

ABOVE:
Ferdinand returns to Casa del Toro: Color keys by Mike Lee

BELOW:
Barn interior set: Drawing by Arden Chan, Painting by Thomas Cardone

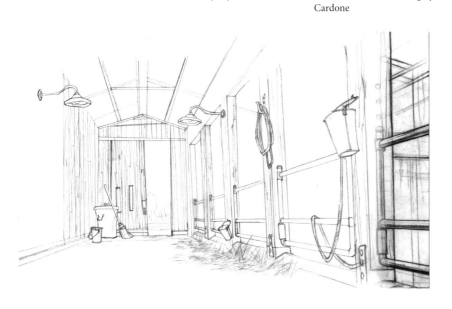

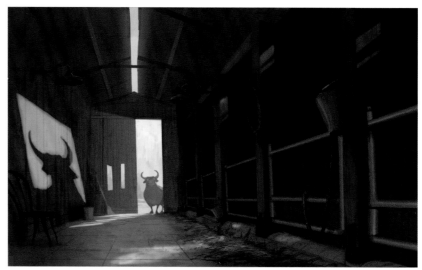

BELOW & RIGHT:
Barn interior: Set design by Andrew Hickson

BOTTOM:
Barn interior: Set concept design by Andrew Hickson

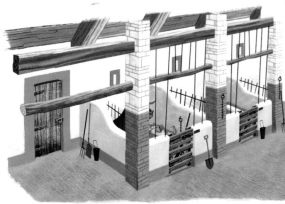

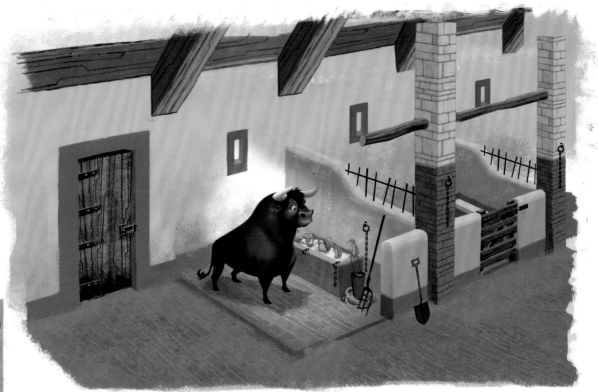

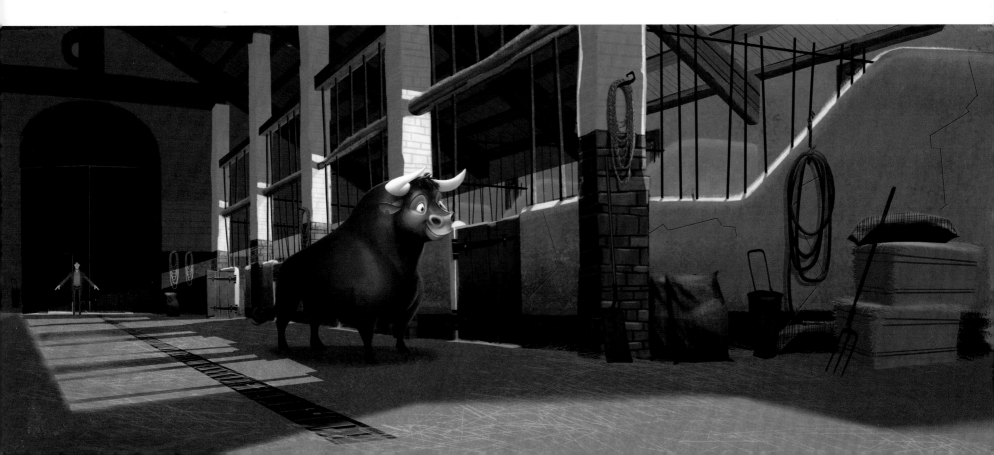

"A big thing stylistically was taking the palette and the textures in the film out of reality. For instance, if there's a wooden door, instead of having it look like photo-real wood grain, we gave it a more stylized pattern, which is more in keeping with what you might have done on a 2D film in the past."

Carlos Saldanha, Director

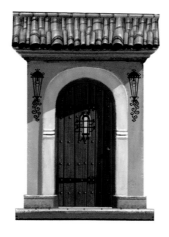

ABOVE:
Casa del Toro front door; Door detail; Gate: Set design elements by Andrew Hickson

BELOW:
Barn interior: Set design by Andrew Hickson

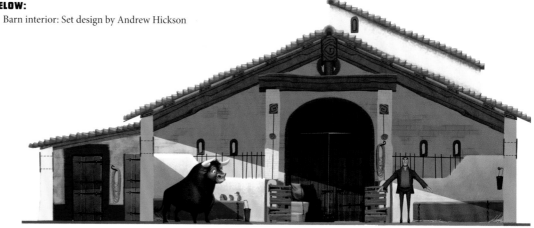

BELOW:
Water trailer turnaround: by Andrew Hickson

OPPOSITE TOP:
Barn props: by Andrew Hickson

OPPOSITE BOTTOM:
Implements; Gate; Buckets: Digital painting by Mike Lee, Prop designs by Jason Sadler and Andrew Hickson

OPPOSITE BOTTOM RIGHT:
Wheelbarrow turnaround: by Andrew Hickson

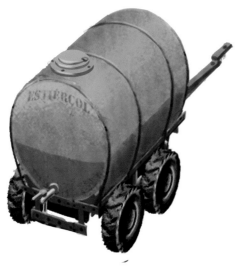
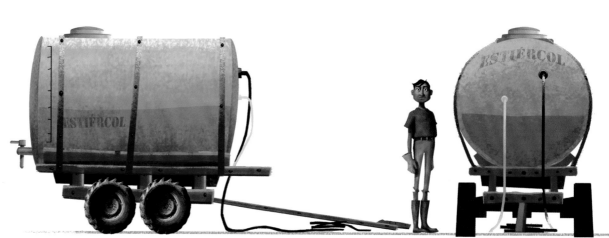

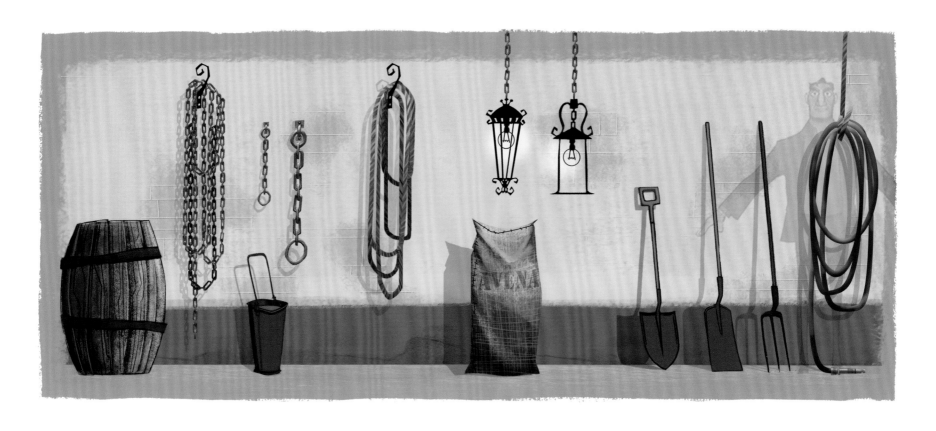

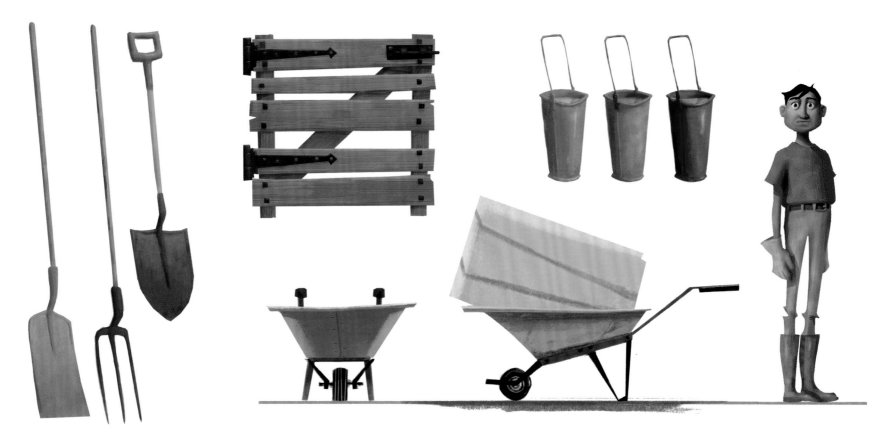

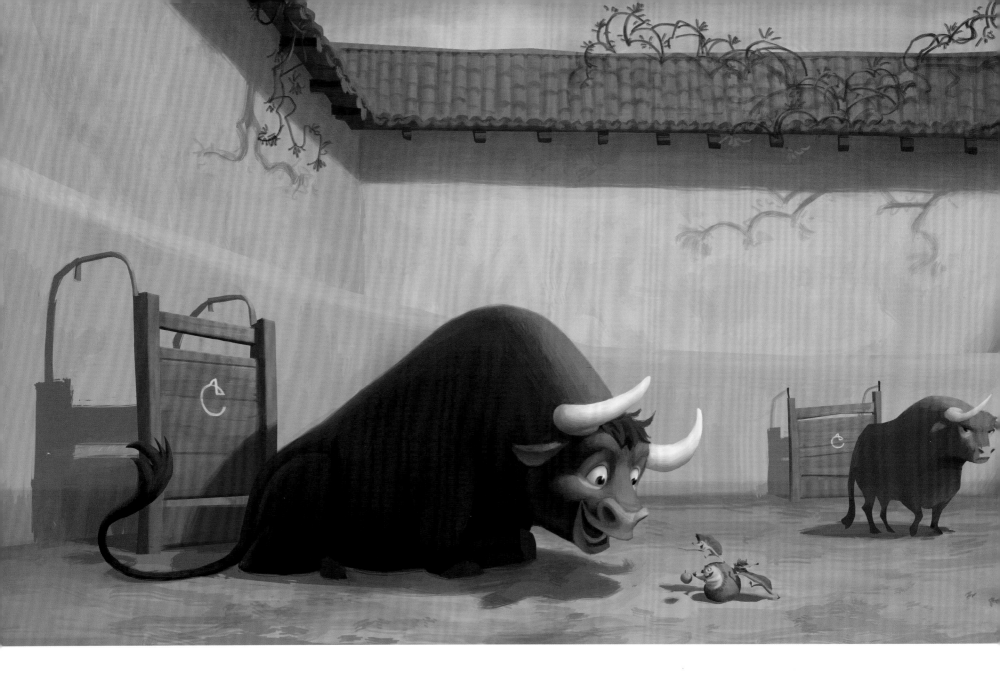

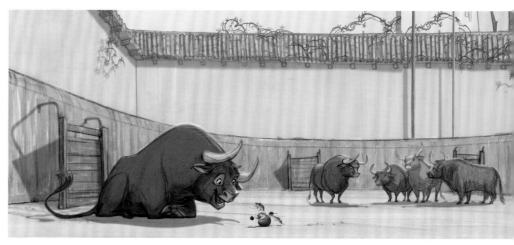

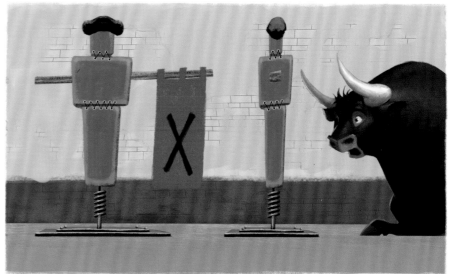

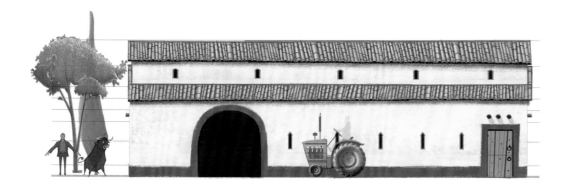

TOP LEFT:
Ferdinand and the hedgehogs in the training area: Drawing by Arden Chan, Painting by Mike Lee

TOP:
Ferdinand and the hedgehogs in the training area: Drawing by Arden Chan

ABOVE:
Training props: by Andrew Hickson

LEFT:
Barn exterior turnaround: by Andrew Hickson

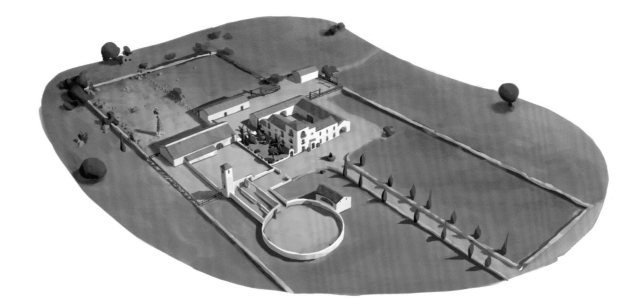

"In contrast to the humble farm where Ferdinand grew up, Moreno's farm is meant to be large and intimidating. Almost prison-like."

Thomas Cardone, Production Designer

TOP:
The Casa del Toro compound: Drawing by Andrew Hickson, Painting by Mike Lee

RIGHT:
The Casa del Toro house exterior: Design by Andrew Hickson

BELOW:
The Casa del Toro landscape: Drawing by Andrew Hickson

OPPOSITE TOP:
Map of Casa del Toro: Design by Andrew Hickson

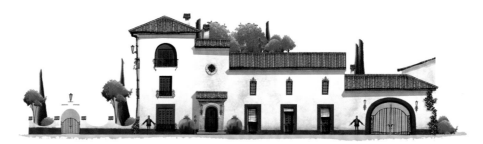

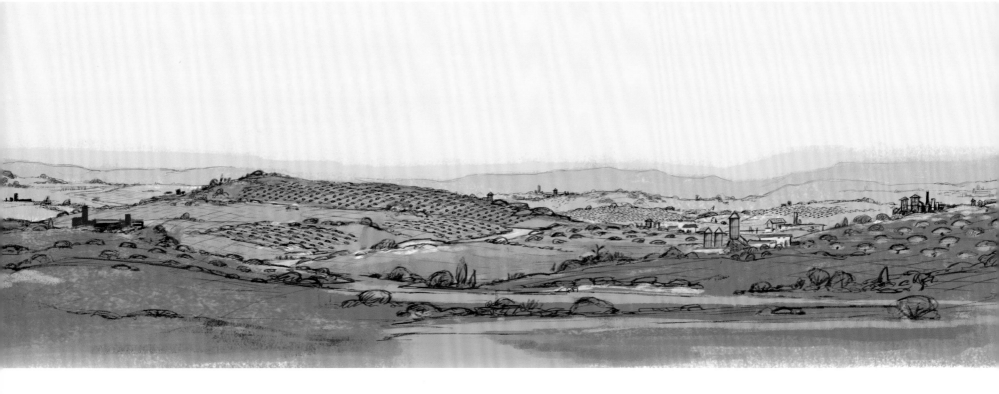

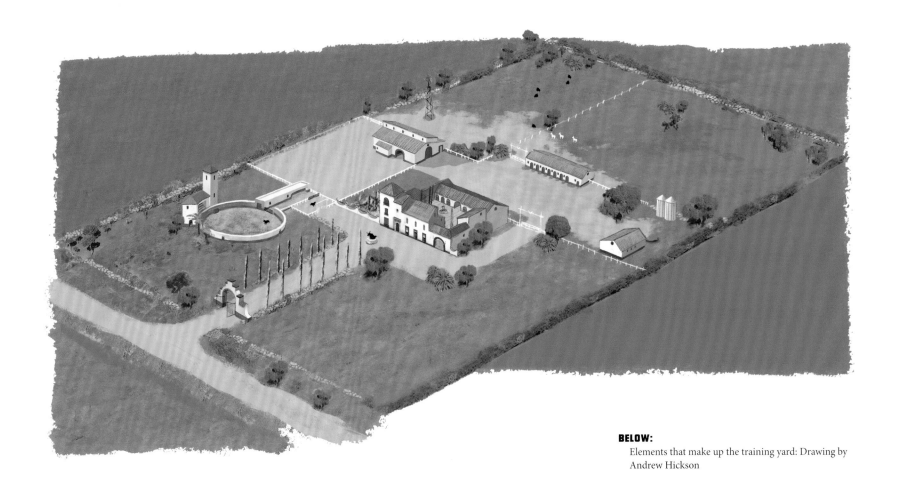

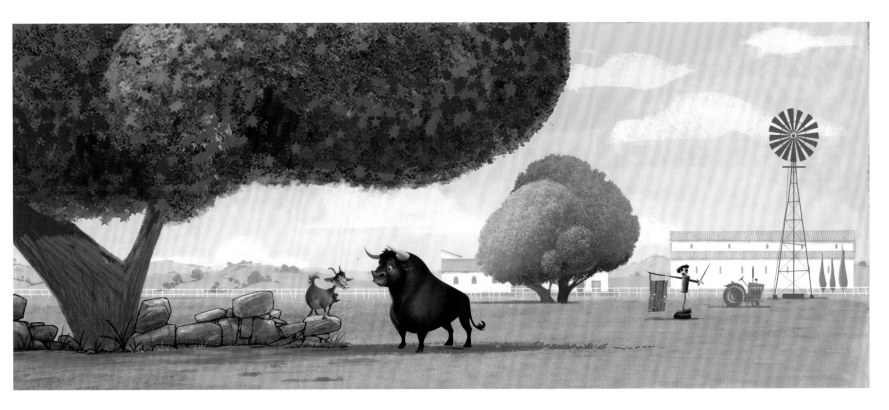

"Moreno's ranch is a classic white stucco Spanish *finca*. In keeping with what we had seen when we visited a ranch like this in Andalusia, the roofs were all terracotta tile. The walls inside and out are white stucco. The ground is mostly dirt, with patches of golden grass dotted with olive trees, eucalyptus and oaks. This gave us a great neutral base for our characters to read against, and an opportunity to bring in some bold hits of saturated color to balance with our characters. As a philosophy for the film, we looked for a limited number of key elements in each set to paint a beautiful energetic color, like a cobalt-blue tractor, venetian-red trim on the buildings, a yellow-ochre fence, a teal water tank, etc. It added an energy and an element of fun in a carefully designed way, while still being faithful to the places that inspired the film in the first place."

Thomas Cardone, Production Designer

BELOW:
Ferdinand, Lupe and a rabbit in the exercise yard: Final digital art

BOTTOM:
Casa del Toro's main house courtyard early concept: Drawing by Arden Chan

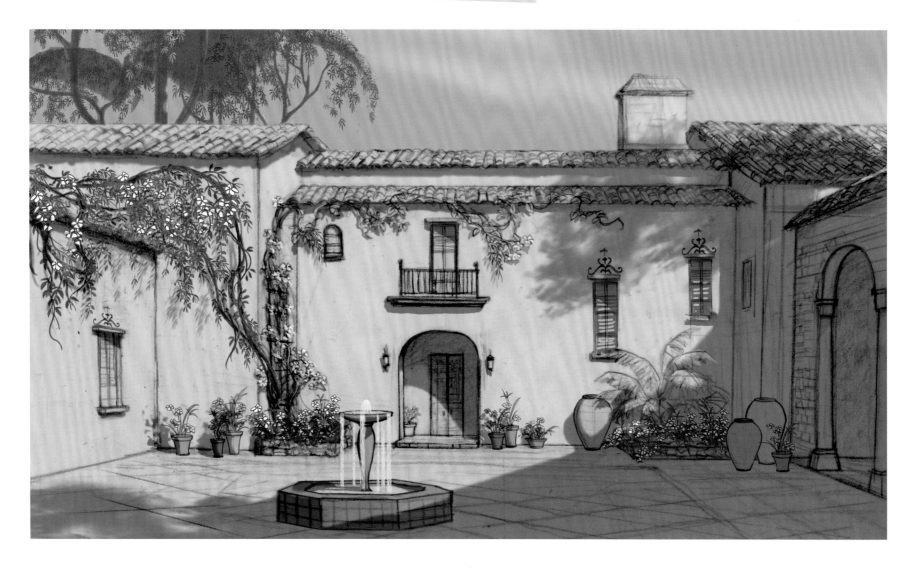

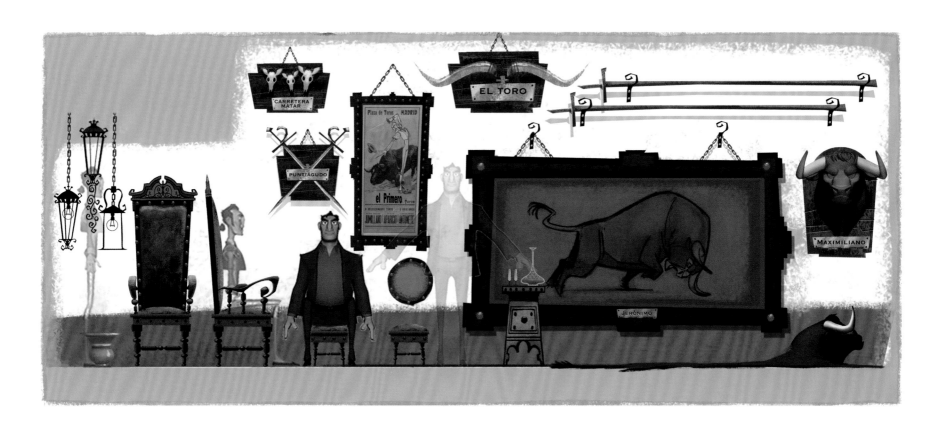

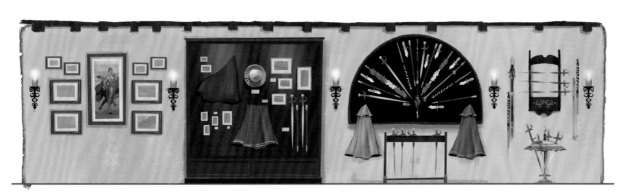

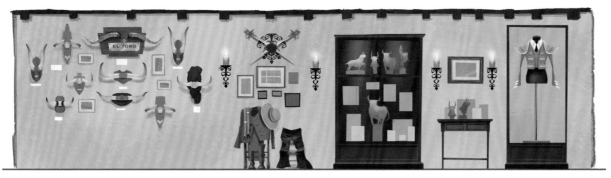

TOP & ABOVE:
Main house set dressing and interior: Set design by
Andrew Hickson

LEFT:
Main house trophy room: Set designs by Sandeep Menon

VEHICLES

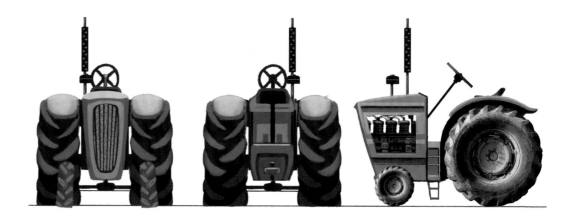

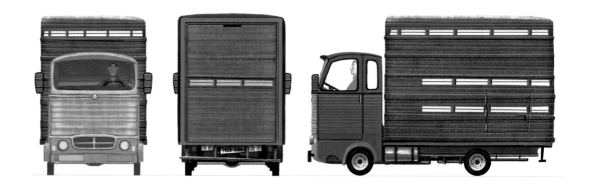

TOP LEFT:
Tractor turnaround: by Andrew Hickson

LEFT:
Generic cattle truck turnaround: by Andrew Hickson

BELOW:
Ferdinand and friends escape in the Casa del Toro cattle truck: Final digital art

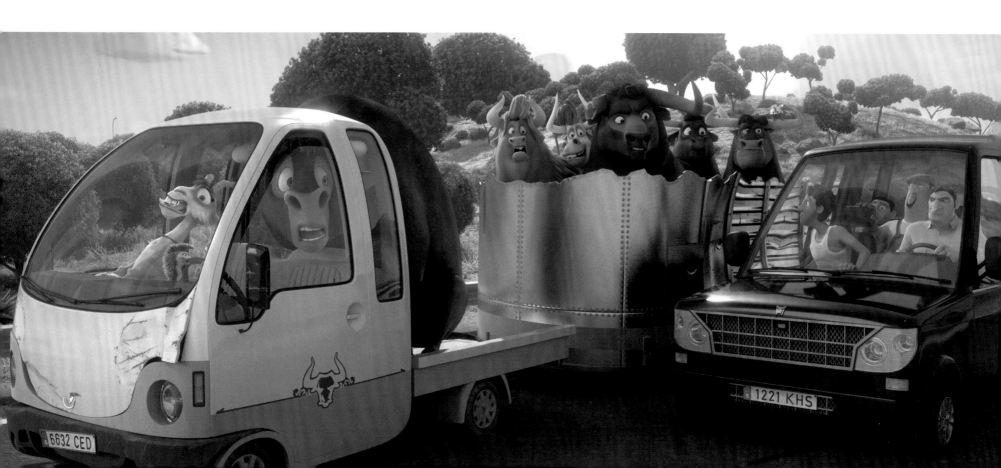

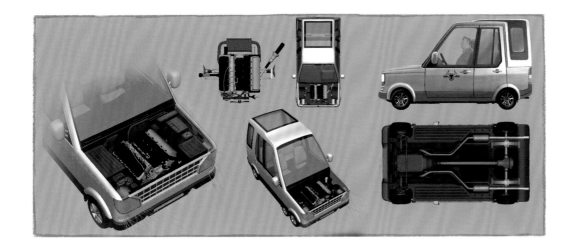

"The vehicles in the film were caricatured to match the proportions we established with the characters. As part of our design language, we pushed the contrast of shape within elements to be large, medium and tiny. So our cars have tiny wheels and tall roof heights to accommodate our humans. This extreme caricature adds to the appeal. The vehicles can make you smile even when they are standing still."

Thomas Cardone, Production Designer

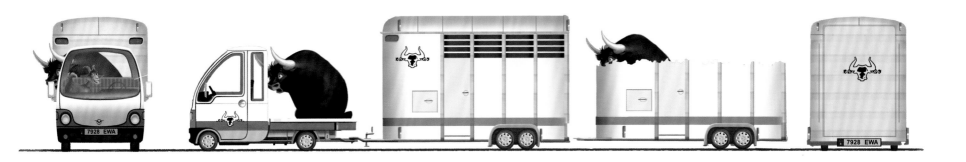

TOP:
Moreno's SUV: Design by Andrew Hickson

ABOVE:
Cattle truck turnaround: by Andrew Hickson

LEFT & BELOW:
El Primero's car turnaround: by Andrew Hickson

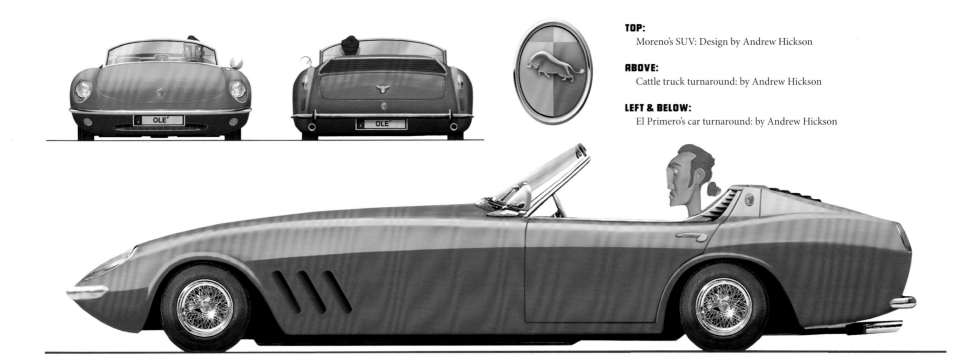

MADRID

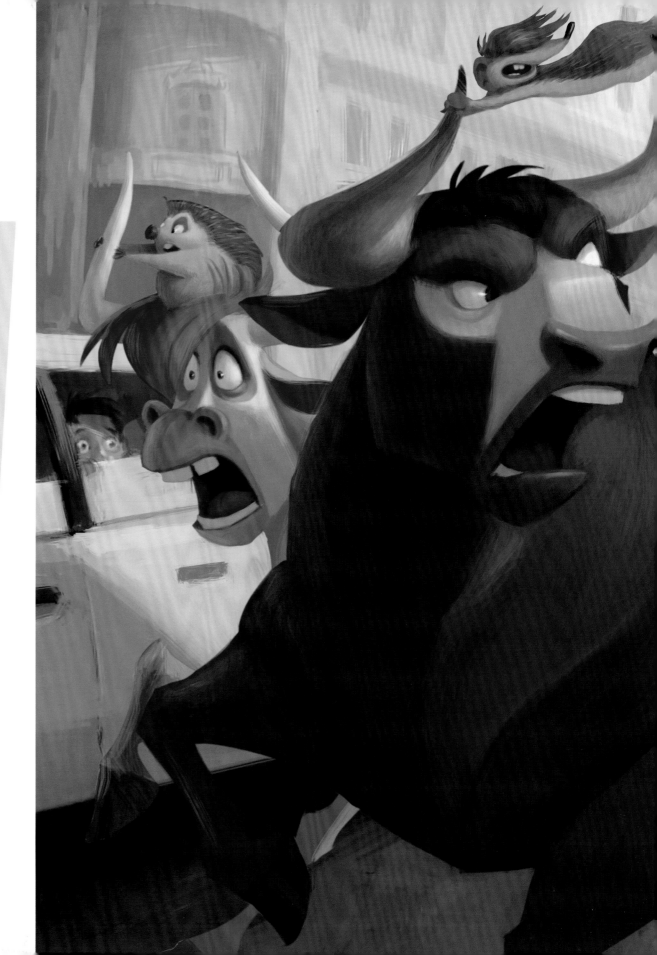

"In contrast to the village of Ronda with its two- and three-story buildings, the city of Madrid has much taller buildings. In the film, we have an epic chase that begins on the highway and continues through the city streets. The streets are packed with cars, buses, scooters, and pedestrians. We were looking for a stark contrast between what Ferdinand is used to and the situation he has been put in."

Thomas Cardone, Production Designer

THIS SPREAD:
The bulls run through Madrid's streets: Digital painting by Robert MacKenzie and Vincent Nguyen

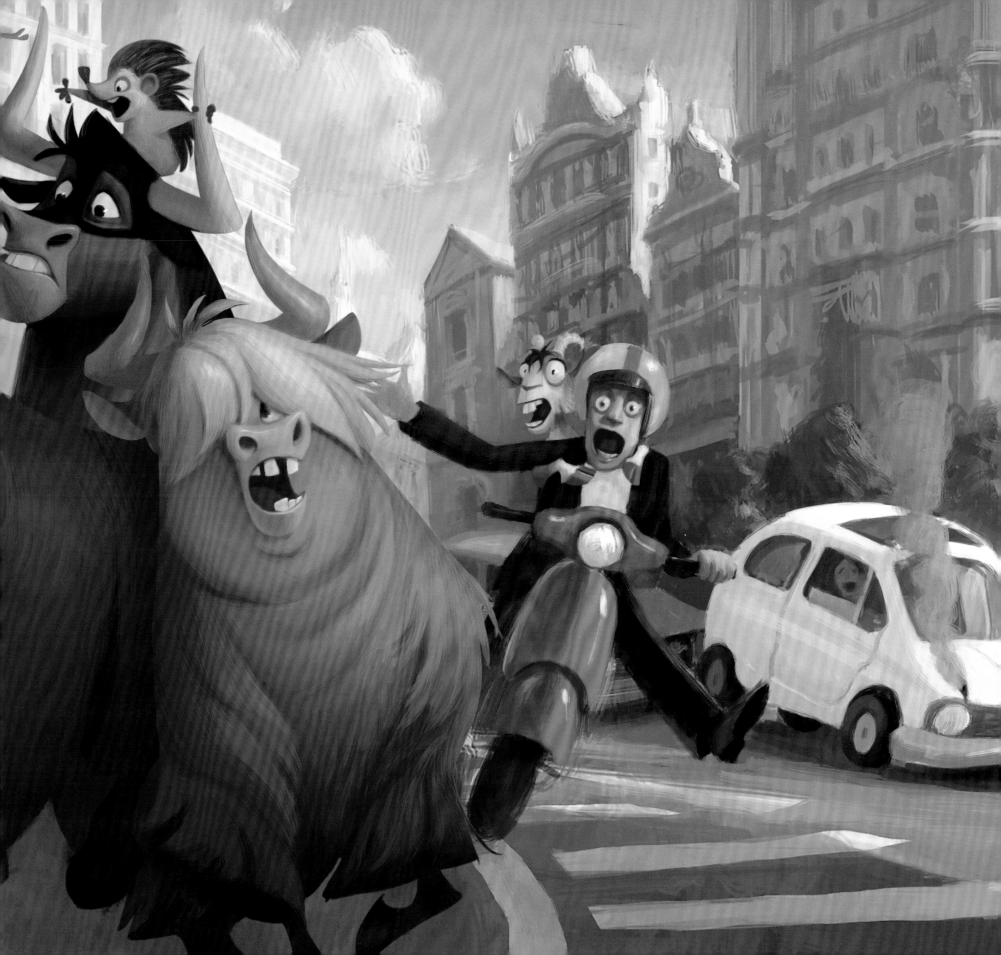

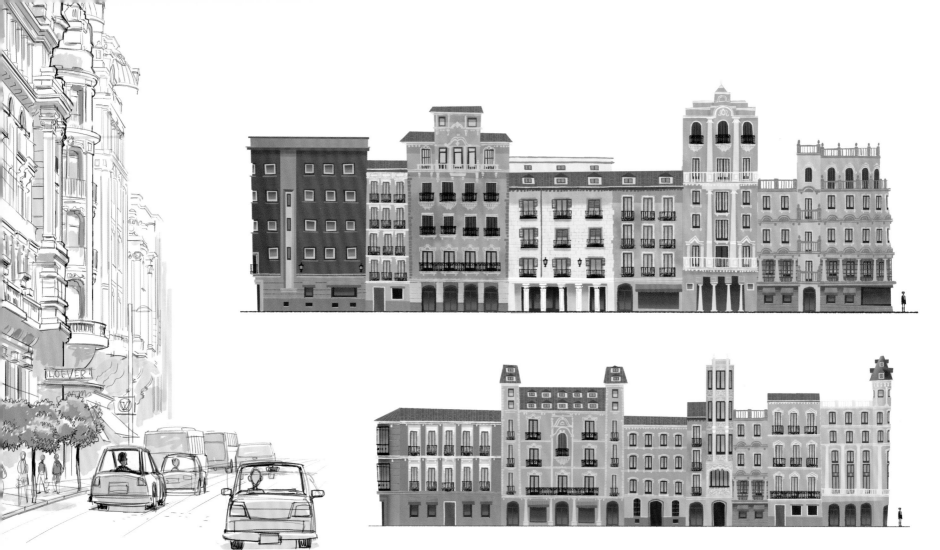

ABOVE:
A Madrid street: Drawing by Scott Caple

ABOVE RIGHT:
Madrid buildings: Designs by Sandeep Menon, Painting by Mike Lee

BELOW:
The bulls by Madrid's Victory Arch: Final digital art

RIGHT:
Madrid's Victory Arch: Set design by Sandeep Menon

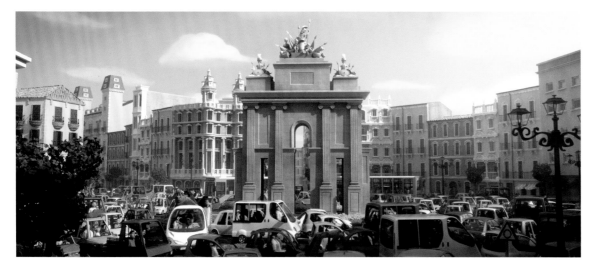

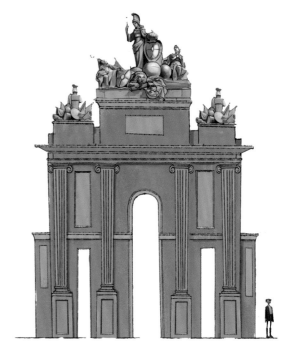

ABOVE:
The bulls run through Madrid's streets: Final digital art

BELOW:
The bulls travel through Madrid to reach Atocha Railway Station: Color keys by Mike Lee

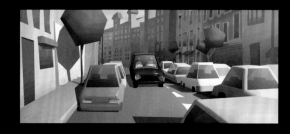

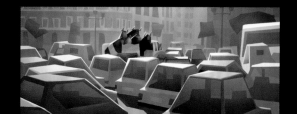

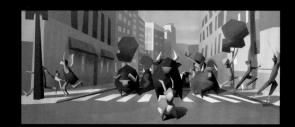

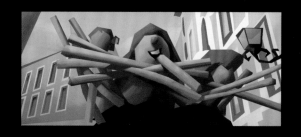

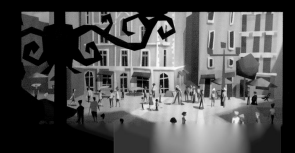

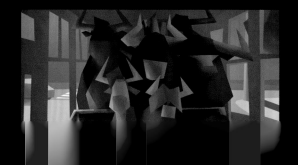

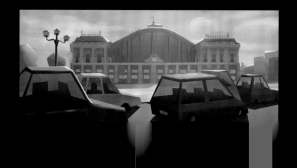

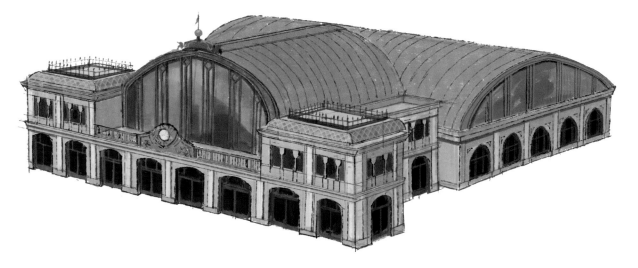

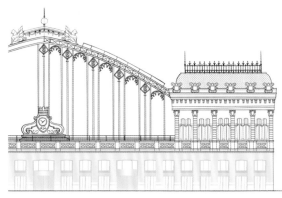

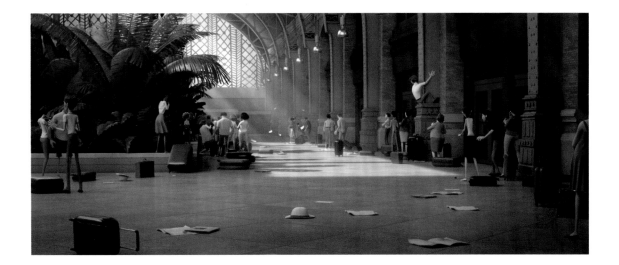

ABOVE:
Atocha Railway Station exterior turnaround: by Sandeep Menon

LEFT & BELOW:
The aftermath of the bulls running through the station concourse: Final digital art; Color key by Mike Lee

RIGHT:
Trainyard truck: Design notes by Sandeep Menon

FAR RIGHT:
Early concept art of heroic Ferdinand: Digital painting by José Manuel Fernández Oli

OPPOSITE BOTTOM:
The bulls in the trainyard: Final digital art

NEXT SPREAD:
Early concept art of heroic Ferdinand: Digital painting by Aidan Sugano

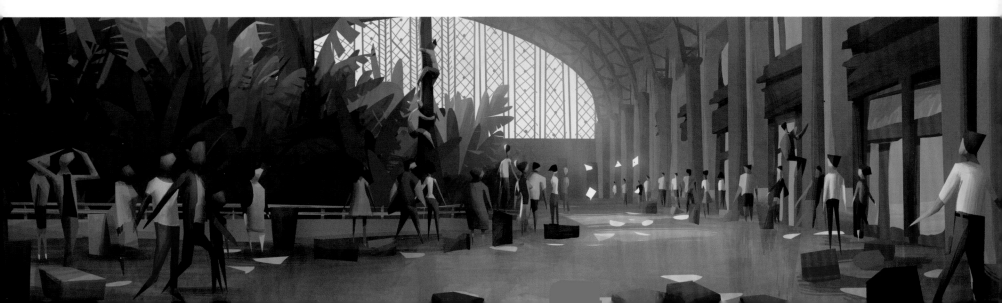

"We designed the train station set with the suspenseful sequence in mind. Ferdinand is at the end of his escape attempt and running through the Madrid Atocha Railway Station. He and his friends run right through the building and across the rail yard, trying to board a moving train to safety. Ferdinand selflessly sacrifices his freedom to help his friends escape. To enhance the emotional impact of this sequence, we created a stormy sky with grey clouds, so it feels slightly overcast and dramatic. There is a break in the clouds in the distance, which symbolizes where they want to go. The bulls stand out nicely in that light, and the colorful boxcars keep the scene from becoming too grey. The focal point of their freedom is a yellow flat-bed car, which provides a beautiful stage in this large, complex environment."

Thomas Cardone, Production Designer

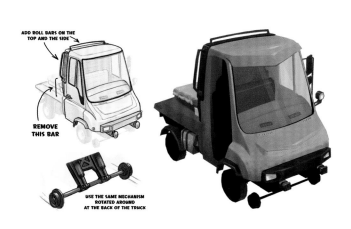

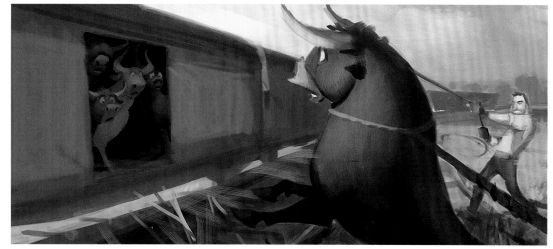

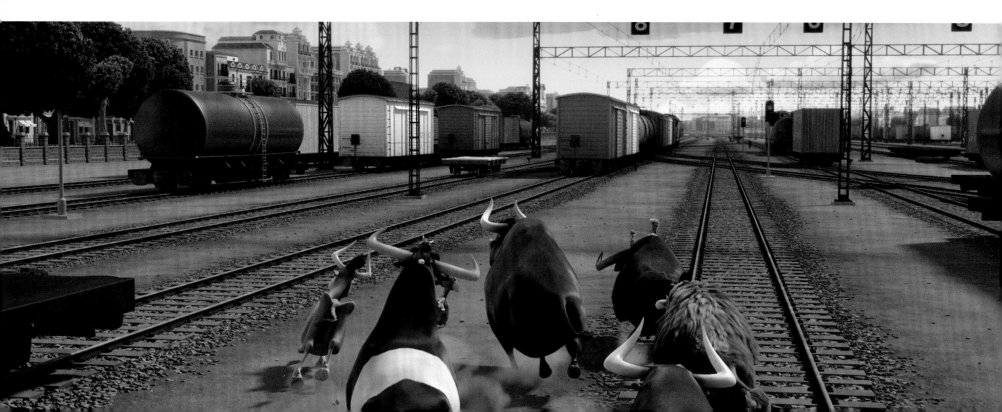

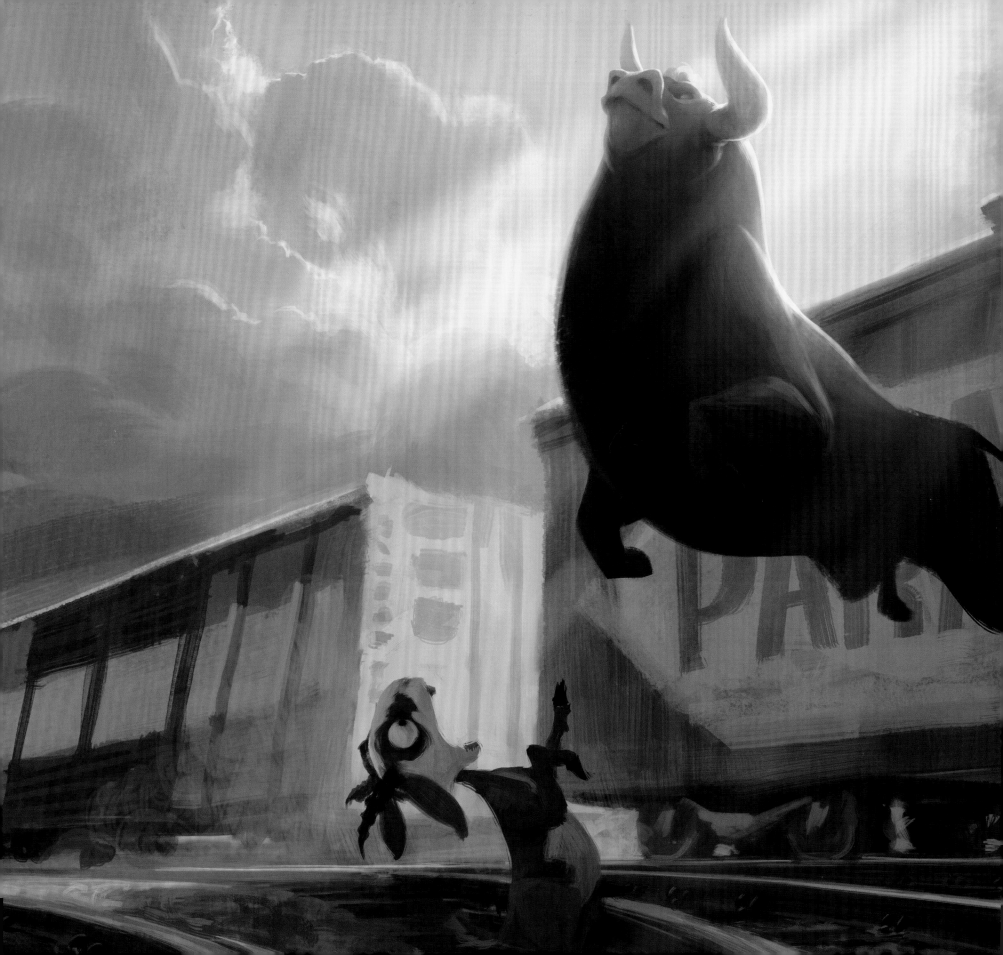

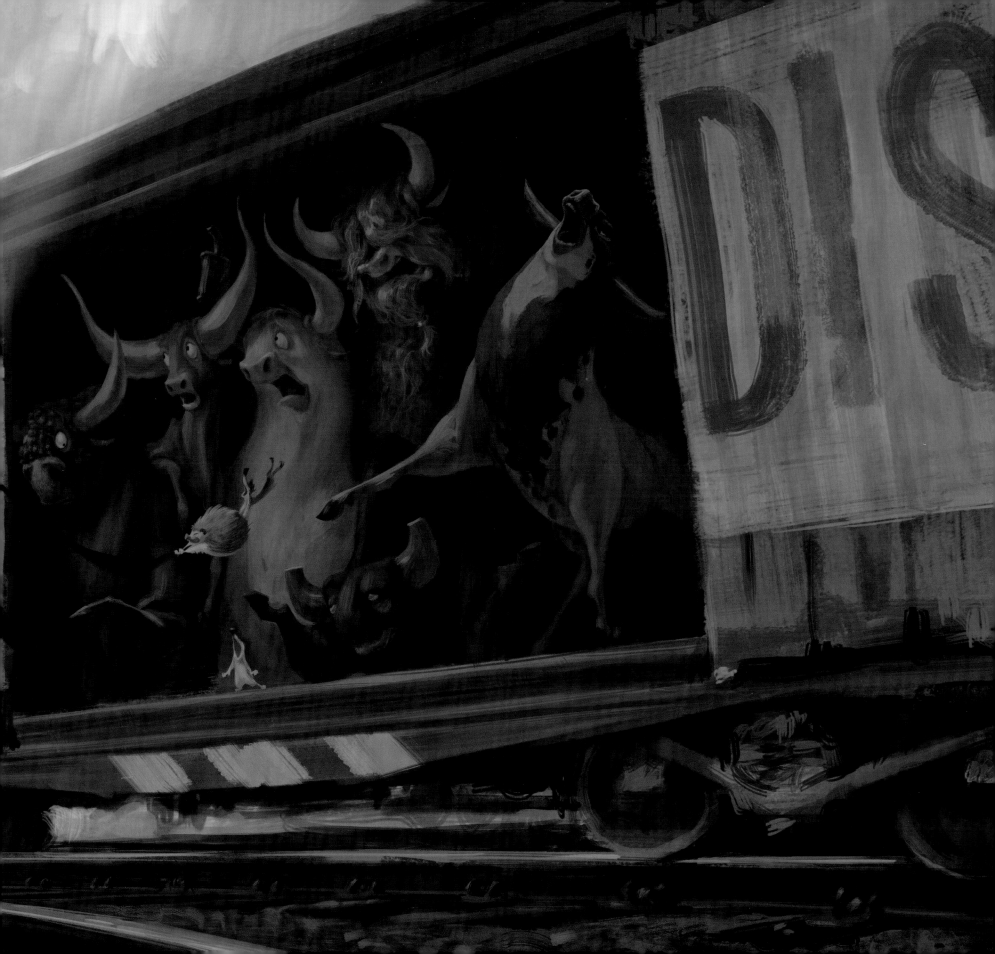

ARENA

For the climactic face-off between Ferdinand and El Primero in the famous Plaza de Toros de Las Ventas arena in Madrid, Blue Sky artists built a reproduction of the 20,000-seat stadium and its surroundings. "We built the Plaza and its surroundings true to the spirit of the landmark in Madrid," Saldanha confirms. "Of course, this is our version, so we stylized it."

Cardone continues, "As far as the stadium goes, it's very faithful to what the real place looks like. We were taken by the colors. The dirt is a saturated yellow-orange that gets really intense when hit by sunlight. I paid particular attention to how the light plays on it in the afternoon. If you think about it, it's a big open bowl. As the afternoon light rakes across it, it creates this half light and half shadow situation that makes a nice, graphic crescent shape across the whole arena.

RIGHT:
Plaza de Toros de Las Ventas arena: Drawing by Scott Caple, Painting by Ric Sluiter

BELOW:
Plaza de Toros de Las Ventas arena: Drawing by Scott Caple

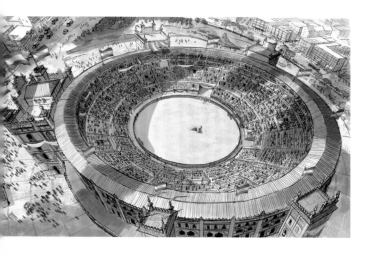

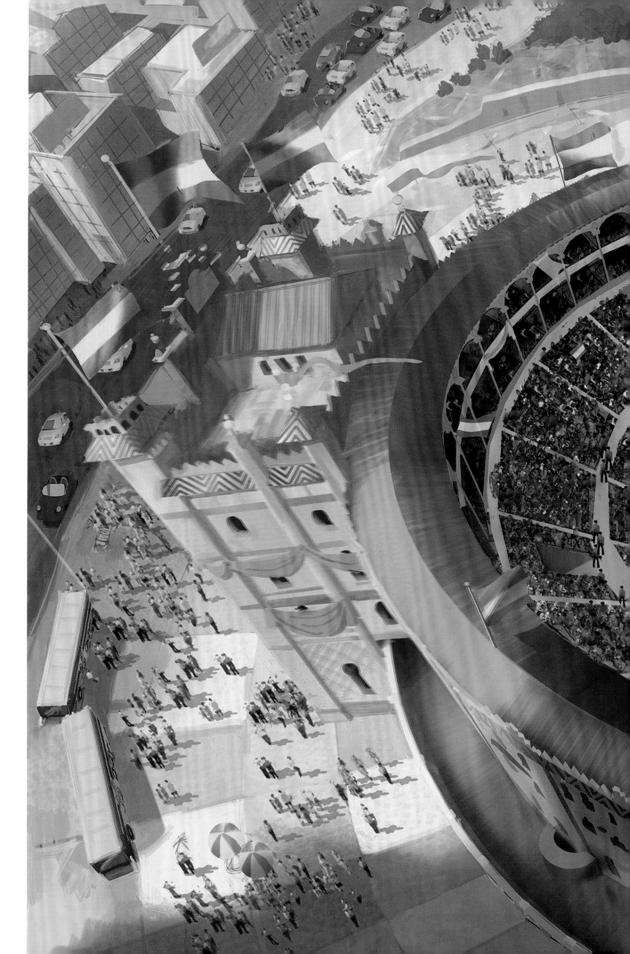

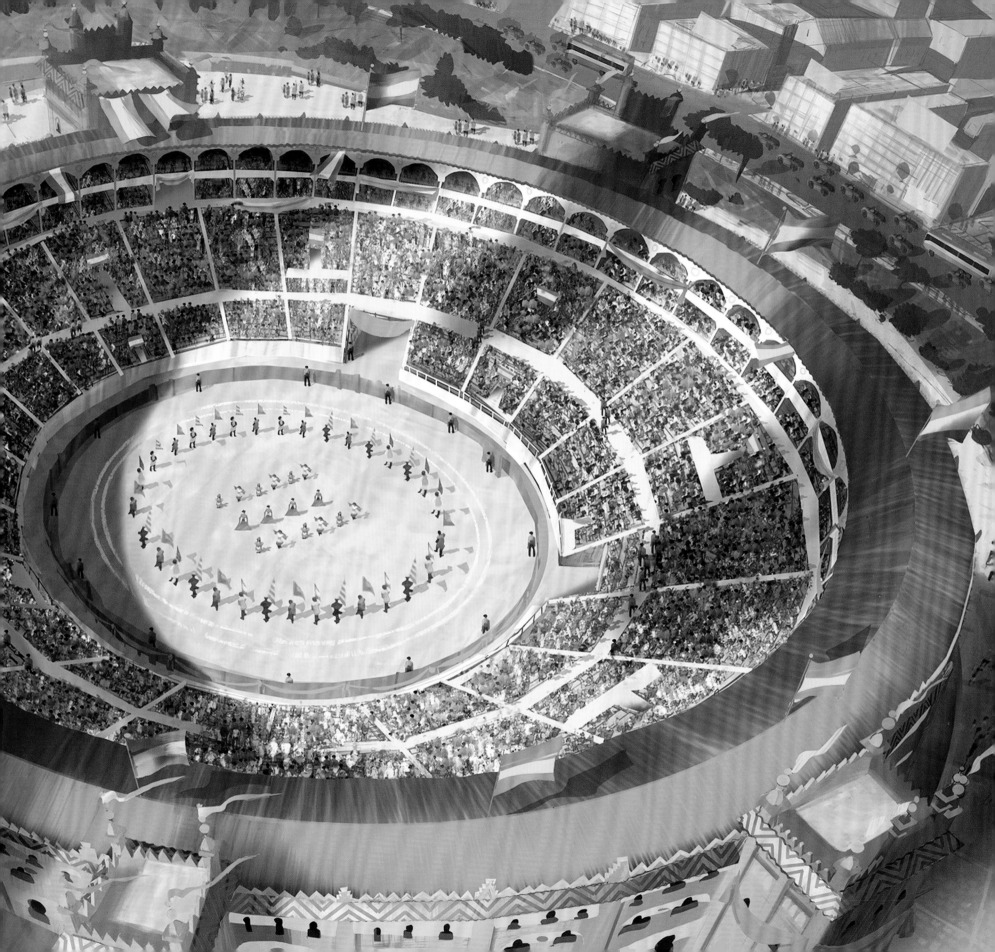

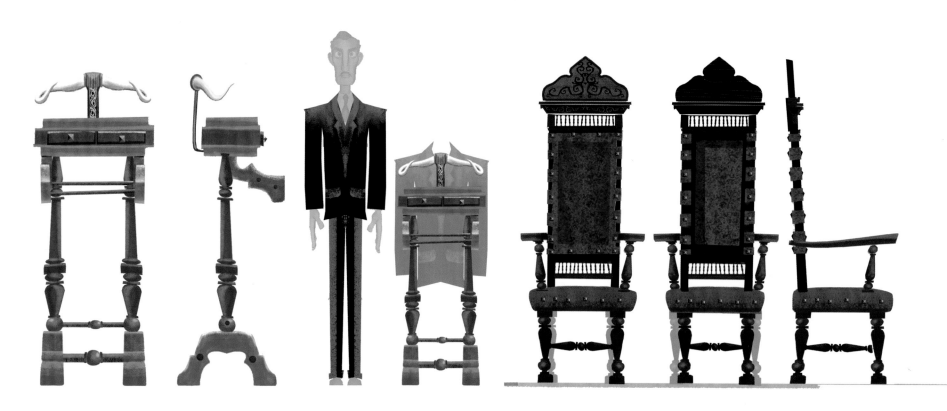

THE ART OF FERDINAND

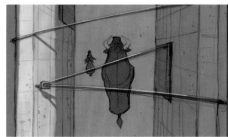

OPPOSITE:
The matador's dressing room: Set design by Andrew Hickson

ABOVE:
El Primero and Ferdinand prepare themselves before entering the arena: Color keys by Vincent Nguyen

BELOW:
Ferdinand and Lupe in the holding pen and the tunnel to the arena: Drawings by Arden Chan

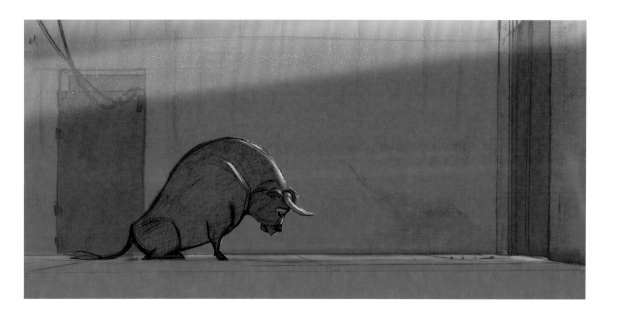

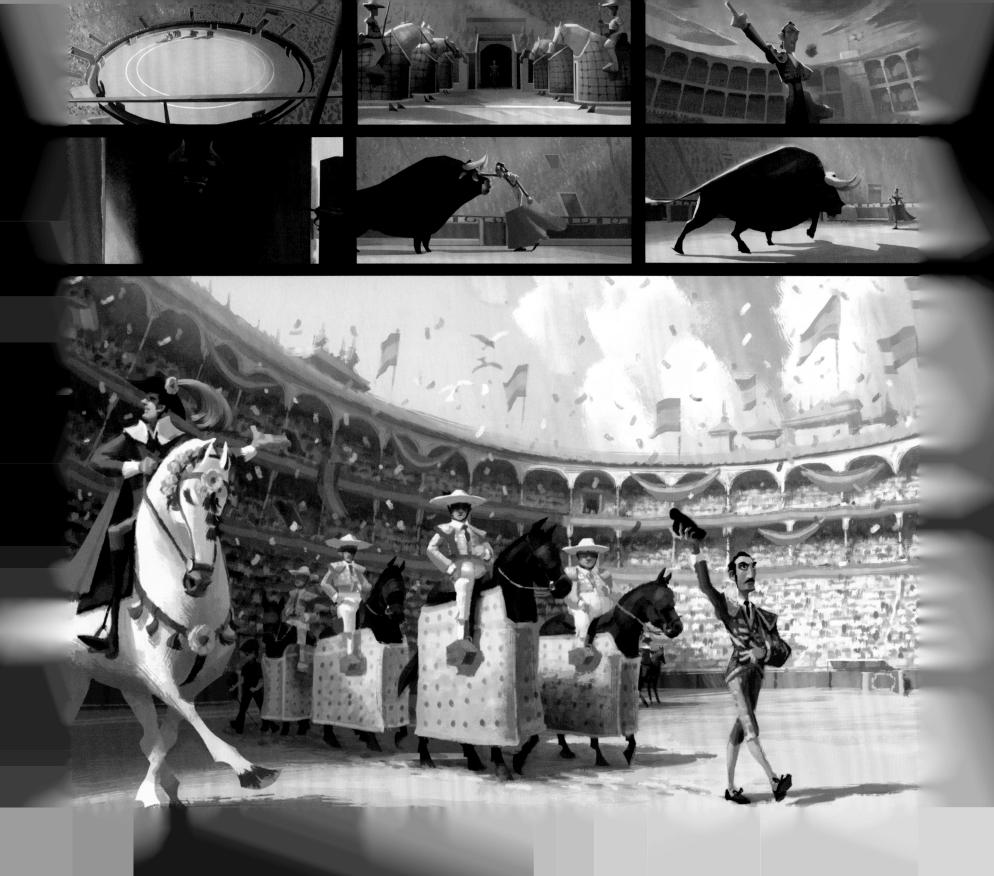

We wanted to use that to our advantage, to play Ferdinand against the matador and to have this separation between light and shadow enhance their opposition.

"When they first come out, they both emerge out of the dark tunnels, but on opposite sides of the arena. Ferdinand comes out of the dark tunnel and straight into the light. The matador walks out into shadow, but then as he keeps walking, he walks out of the shadow and into the light section of the arena," Cardone says of the final sequence. "The way we staged it, they oppose each other as they face off in the arena. The matador is playing light over the dark shadow of the stadium, which is behind him, while Ferdinand is playing as a dark shape over the light. There are a couple of key moments when they are standing face to face and there is a diagonal line of light and shadow between them."

In the context of the film, the setting in the arena is meant to be a stressful and dangerous place for Ferdinand, a natural pacifist. Because of that, Cardone says, the sequence required them to lean on visual cues, lighting and pacing, to tell the story in as non-violent but resonant a way as possible. "It is threatening, and the audience needs to feel for Ferdinand and to know that he is truly in danger at that moment in the story."

LEFT:
El Primero and Ferdinand enter the arena: Color keys by Robert MacKenzie

OPPOSITE BOTTOM:
El Primero's entrance: Drawing by Peter Chan, Painting by David Dibble

BELOW:
Plaza de Toros de Las Ventas arena exterior: Final digital art

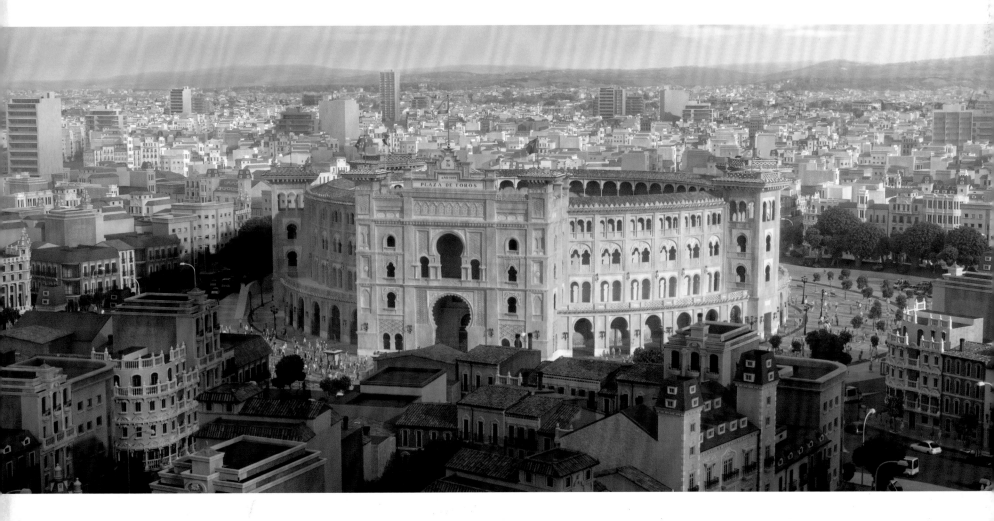

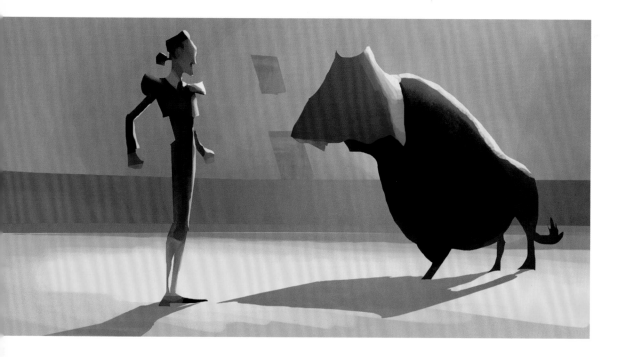

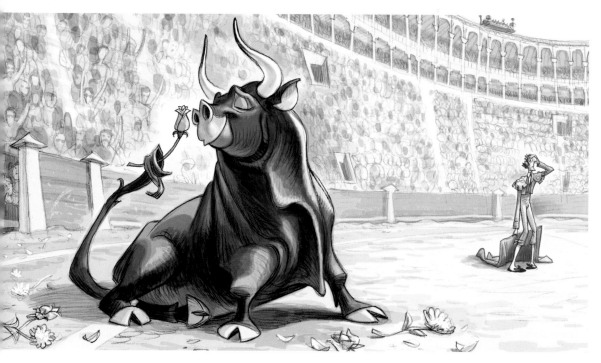

TOP:
El Primero and Ferdinand in the arena: Color key by Robert MacKenzie

ABOVE:
Early concept art of El Primero and Ferdinand in the arena: Drawing by Peter Chan

RIGHT:
Ferdinand triumphant: Digital painting by Nathan Fowkes

NEXT SPREAD:
Ferdinand triumphant: Digital painting by Nathan Fowkes

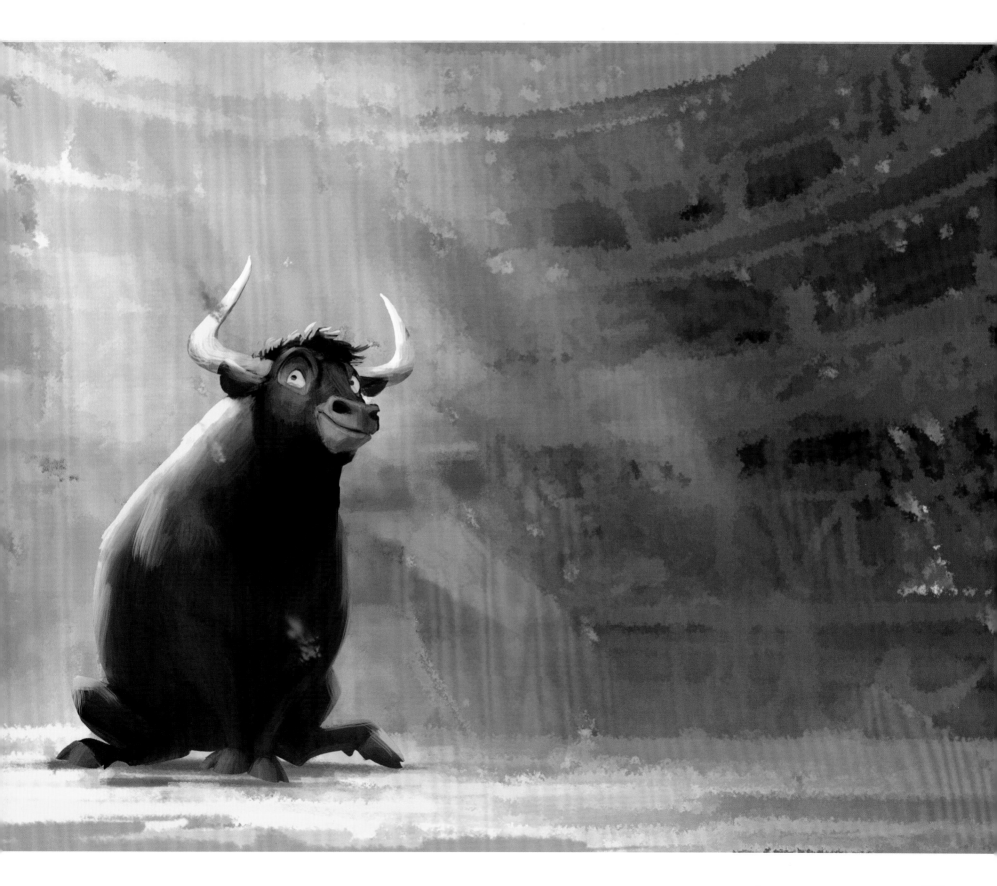

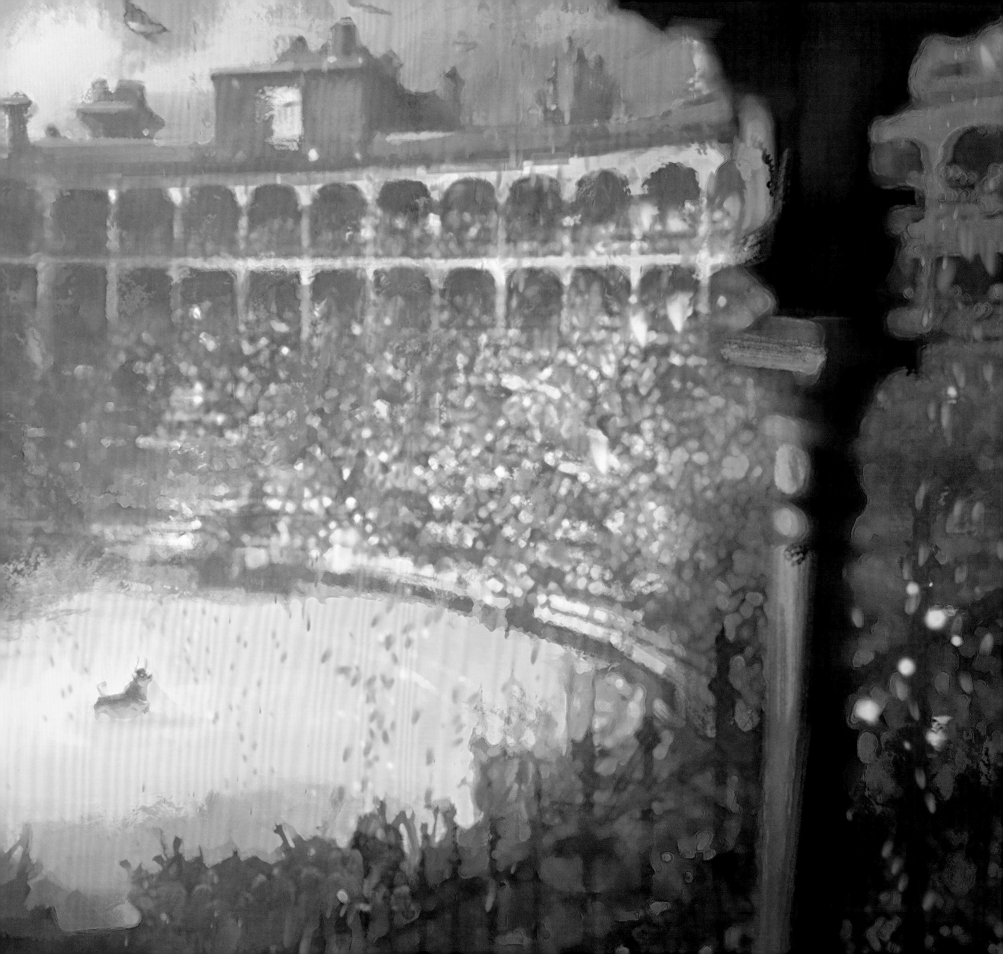

PATTERNS & TEXTURES

FAR LEFT:
 Production design patterns: by David Dibble

LEFT:
 Tile designs: by David Dibble

BELOW:
 Young Ferdinand under the cork tree: Final digital art; Tree
 texture by Baaron Schulte

RIGHT:
 Poster concepts: by Mike Lee

OPPOSITE BOTTOM:
 Banner concepts: by Peter Nguyen

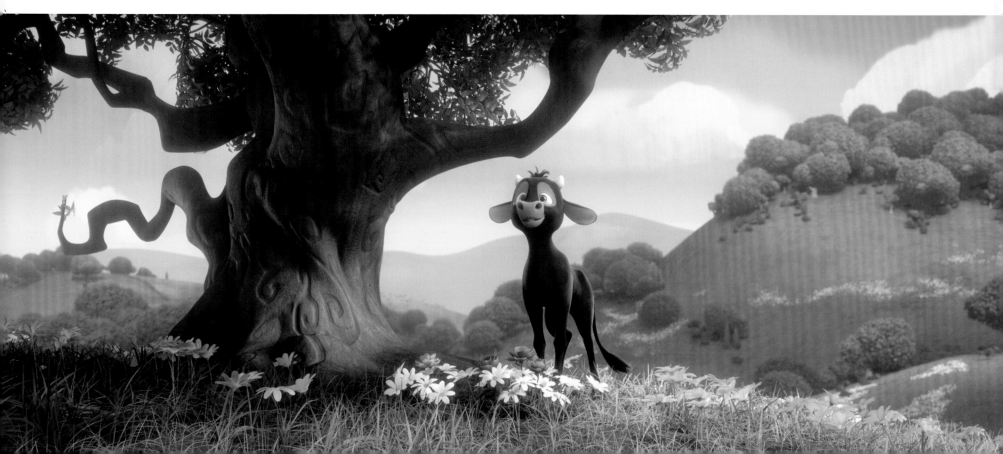

ATOMICO

ADEMÁS DE MUCHAS CORRIDAS EMOCIONANTES

INCLUSO:

Alejandro **RIVERA**

Daniel **GUTIERREZ**

Leonardo **ORTIZ**

TOROS DEL SUR

CON EL CAMPEÓN DEL SUR DE ESPAÑA

EL PANTERA

4 - 12
AUGOSTO
PLAZA DE
LOS TOROS

PRIMERA RONDA	TERCERA RONDA
Mateo Hernandez	Thiago Moreno
Matias Sanchez	Alexander Romero
Andres Lopez	Bruno Herrera
Nicolas Flores	Rodrigo Medina
Santiago Perez	Angel Aguilar
Martin Reyes	Emiliano Ramos

SEGUNDA RONDA	CUARTA RONDA
Benjamin Chavez	Felipe Gomez
Sebastian Ramirez	Emiliano Ramos
Mateo Torres	Martin Gonzalez
Alejandro Rivera	Alejandro Gonzalez
Leonardo Ortiz	Diego Diaz
Joaquin Morales	Daniel Gutierrez

PRESENTADO POR LA ASOCIACIÓN TAURINA DEL SUR DE ESPAÑA

FERDINAND

UN TORO BRAVO

CORRIDA DE TOROS EXTRAORDINARIA

Mateo **HERNANDEZ**

Ramon **LOPEZ "SUPREMO"**

Nicolás **SANTIAGO**

DIVISIÓN PARA PELEAS JUSTAS

"We started our research by looking at the Andalusian countryside. We also studied the motifs used in historic buildings in southern Spain, as well as embroidery and ironworks of that region whose patterns were inspired by nature. These gorgeous patterns can be seen everywhere in the architecture."

Jason Sadler, Character Designer

COLOR SCRIPT

Since computer-animated films are produced in non-linear sequences, the production designer needs to create a linear visual outline of all of those sequences, called a color script, which reflects the overall progression of the film from beginning to end. It allows the production designer and the director to design, keep track of and adjust the continuity and harmony of lighting, color and mood from sequence to sequence.

With *Ferdinand*, Tom Cardone says the color script was especially important for charting time of day and emotion. "The central story takes place over just a few days," he explains, "so time of day had to be represented properly while making sure it enhanced the emotional beats of the story. For example, when Ferdinand is being taken away from Nina and the village, he is put in a truck and taken to Moreno's ranch. He arrives at the ranch at night. So, in that journey sequence he goes from sentimental morning to a reflective sunset and then arrives at the ranch at intimidating night. It's a sad sequence that is made more dramatic by the passage of time across beautiful landscapes that change from green to arid and from day to night. His arrival at the ranch at nighttime with harsh floodlights adds to the drama of his being captured and brought there against his will.

"Another example is when tragedy strikes young Ferdinand in the beginning of the film and he runs away at night, alone in the world. It's a grey, desaturated palette. Juan finds him in the rain at his lowest moment and brings him to the farm. When he wakes up in the morning in a little cozy barn, Nina opens the door and the sunlight fills the room. It's a new day."

With the color script to reference, those beats work effectively, partly because the filmmakers can see which qualities of light will help an emotional moment land in the best way.

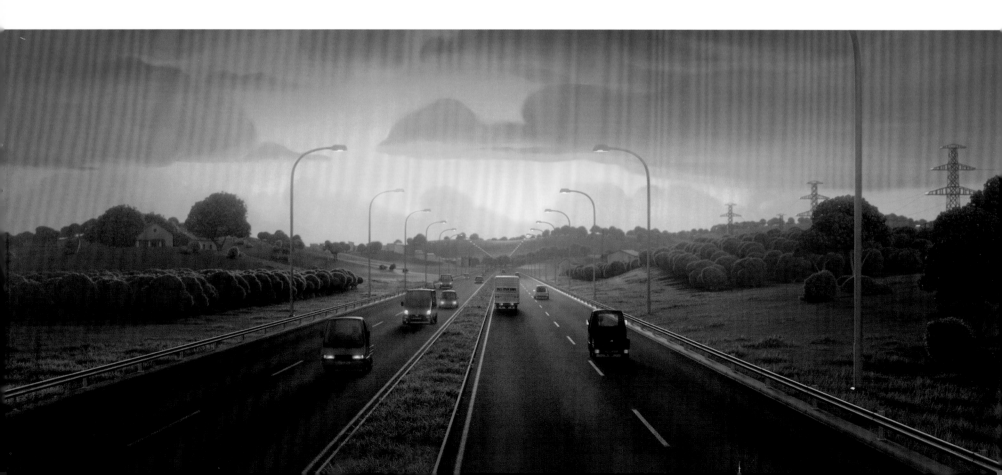

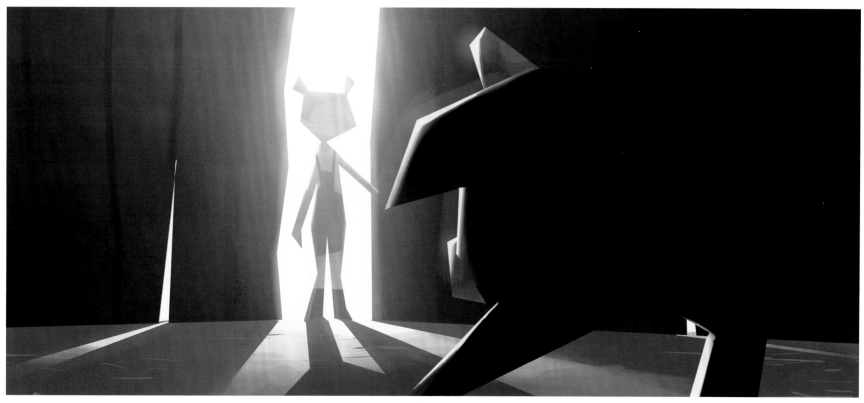

PREVIOUS SPREAD LEFT:
Ferdinand is driven to Casa del Toro: Final digital art

PREVIOUS SPREAD TOP RIGHT:
Ferdinand runs away: Color key by Mike Lee

PREVIOUS SPREAD BOTTOM RIGHT:
Ferdinand meets Nina: Color key by Mike Lee

THIS SPREAD:
Color script by Mike Lee and Thomas Cardone

CONCLUSION

Like the beautiful flowers dotted throughout Ferdinand's beloved Spanish countryside, so too does the gentle bull blossom over his epic journey in Blue Sky's gorgeous interpretation of Munro Leaf's timeless tale. Through determination, friendship and fortitude, Ferdinand comes to embrace who he truly is on the inside. His story encourages us all to find our inner strength, even when it feels like the whole world wants us to be something we're not.

The three-year journey of making this movie, led by director Carlos Saldanha and production designer Thomas Cardone, and executed with stunning detail by every single talented artist and technician on *Ferdinand*, was a passion project for them all. The artistry brought forth on the screen by the Blue Sky team reminds us to reach farther, be open to the unexpected, and to be brave when that seems like the scariest choice to make. From some distant scenic Andalusian overlook, surrounded by fragrant petals drifting in the wind, you can practically see Ferdinand smiling in agreement.

ACKNOWLEDGEMENTS

It was truly an inspiring few months working with Carlos Saldanha, Tom Cardone and some of the key *Ferdinand* creative team members, including Sang Jun Lee, Mike Lee, Jason Sadler, Vicki Saulls, and David Dibble, learning how this movie came to be. My thanks to all of them for their time and passionate expression of how they do what they do, and to Lorry Ann Shea, Sean O'Loughlin, and Christen Groves at Blue Sky, who also helped with this book. Special thanks for my Fox Animation team, including Melanie Bartlett and Laura Baltzer for all their tireless coordination and support.

As always, these Blue Sky Studios art books turn out so exquisite due to the editorial guidance of Jo Boylett, who is a dream to collaborate with, and our gifted designers, Tim Scrivens and Natasha MacKenzie, for laying out pages you want to look at for hours. And thank you again Twentieth Century Fox's Carol Roeder and Nicole Spiegel for allowing me to tell Blue Sky's stories.

On the personal side, as always a heartfelt thanks to my dear friend and transcriber Hope Willis for helping me accomplish my textual feats. And my forever appreciation to the person I call home: Paul Terry.

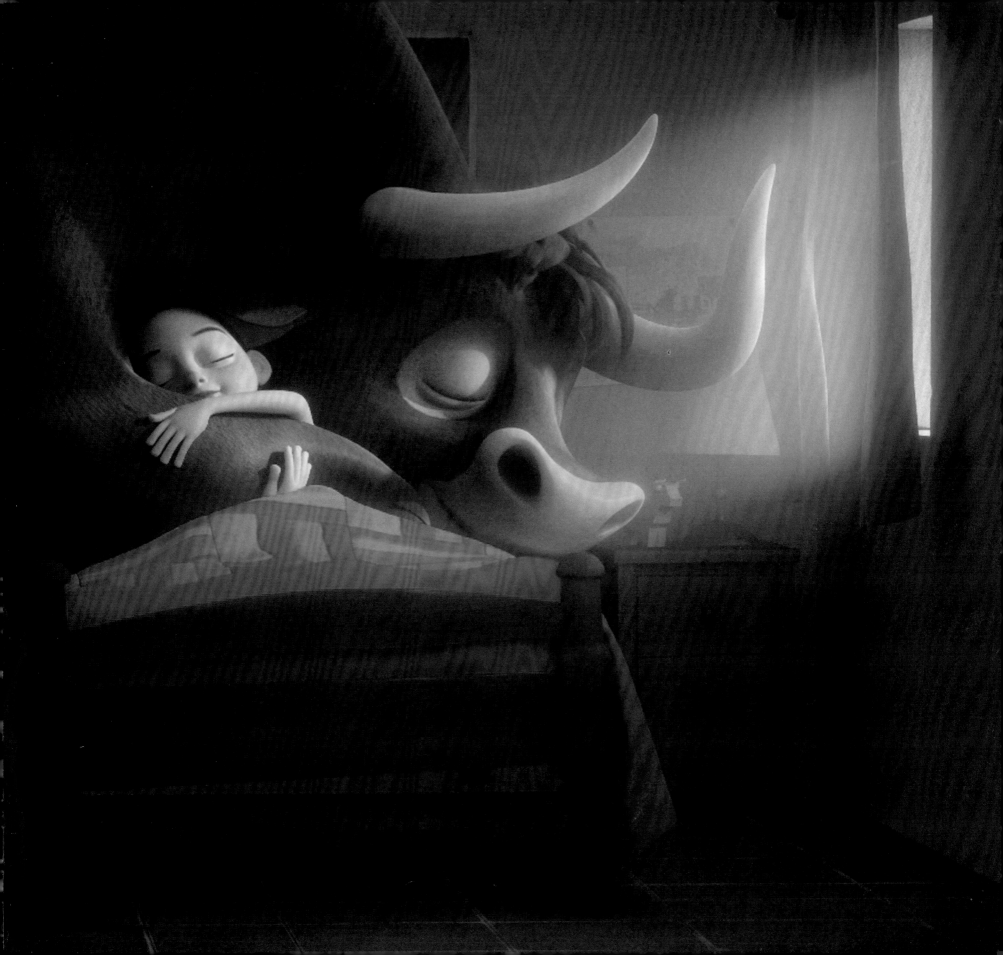

THE ART OF FERDINAND
ISBN: 9781785654183

Published by
Titan Books
A division of Titan Publishing Group Ltd
144 Southwark St
London
SE1 0UP

www.titanbooks.com

First edition: November 2017
10 9 8 7 6 5 4 3 2 1

Titan Books would like to thank Carlos Saldanha for the Foreword and taking time out of working on the movie to talk to us about *Ferdinand*, and many thanks for their time and input to Thomas Cardone and the team at Blue Sky Studios, in particular Sang Jun Lee, Mike Lee, Jason Sadler, Vicki Saulls, David Dibble, Lorry Ann Shea, Sean O'Loughlin, and Christen Groves. At Twentieth Century Fox thanks must go to Carol Roeder, Nicole Spiegel, Melanie Bartlett, and Laura Baltzer for their organization, enthusiasm, and support on this project.

Did you enjoy this book? We love to hear from our readers. Please e-mail us at: readerfeedback@titanemail.com or write to Reader Feedback at the above address.

To receive advance information, news, competitions, and exclusive offers online, please sign up for the Titan newsletter on our website: www.titanbooks.com

A CIP catalogue record for this title is available from the British Library.

Printed and bound in China.

PREVIOUS SPREAD:
Ferdinand and Nina: Final digital art

BELOW:
(left to right) Angus, Maquina, Bones, Ferdinand, Valiente, Guapo: Final digital art

FRONT & BACK ENDPAPERS:
End credit art: Digital painting by David Dibble

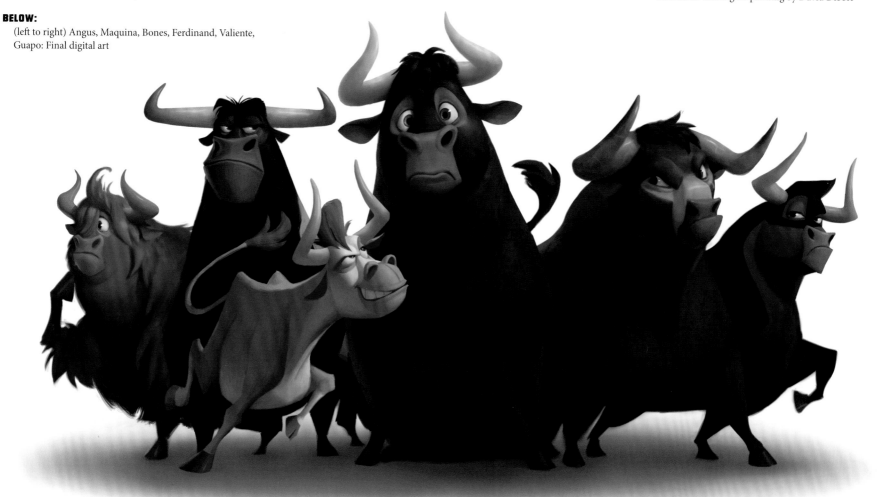